W9-BBA-430

COWPARADE HOUSTON

COWPARADE HOUSTON

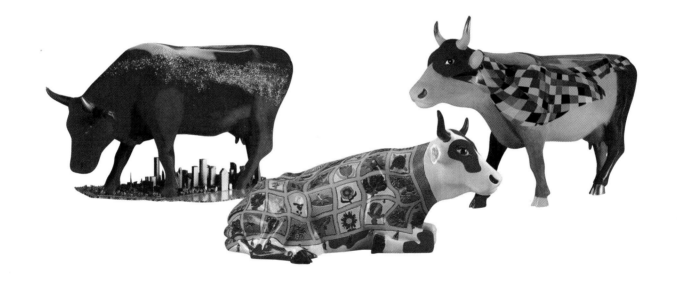

PHOTOGRAPHY BY ANTHONY LOEW, JIM OLIVE, ELLIS VENER, JOHN DeSALVO, CHRIS STANLEY, AND MICHAEL TEKLER

WORKMAN PUBLISHING • NEW YORK

cow ♣ parade™

Copyright © 2001 by CowParade Holdings Corporation

Text written by Tom Craughwell and Vicki Bomke Thomson.

Location photography by Anthony Loew, Jim Olive, and Ellis Vener.

Cow silhouettes by John DeSalvo, Chris Stanley, and Michael Tekler, CowParade Graphics.

Additional cow photography by Paul Kuntz and Jim DeLeon.

Cover cow, *Texas Historic Cow*, photograph by CowParade Graphics.

Cows on title page (l. to r.): *"Houston, You Have a Problem," Cozy Cow, Cow Bird.*

Historical photographs courtesy of Houston Public Library.

Library of Congress Cataloging-in-Publication Data is available.

ISBN 0-7611-2541-8

CowParade is a registered trademark of CowParade Holdings Corporation.

Texas Children's Cancer Center is a registered trademark.

Visit the CowParade website at www.cowparade.net

Workman books are available at special discounts when purchased in bulk for premiums and sales promotions as well as for fund-raising or educational use. Special editions or book excerpts can also be created to specification. For details, contact the Special Sales Director at the address below.

Workman Publishing Company, Inc.

708 Broadway

New York, NY 10003-9555

www.workman.com

Printed in the United States of America

First printing, October 2001

10 9 8 7 6 5 4 3 2 1

CONTENTS

FOREWORD

BY MAYOR LEE P. BROWN AND TEXAS CHILDREN'S HOSPITAL PRESIDENT AND CEO MARK A. WALLACE

This fall, the Bayou City becomes an urban range for a magnificent herd of cows. The sculptures of CowParade Houston 2001, painted and decorated by Texas artists, will graze in fields from Downtown to Uptown and roam in pastures from Memorial Drive to the Medical Center, transforming Houston into an open-air public art gallery.

CowParade Houston 2001 showcases Houston itself and the city's world-class cultural programs. More important, thanks to the work and collaboration of our city departments, corporate sponsors, charitable partners, and regional artists, it will also raise funds for Texas Children's Hospital and the Texas Children's Cancer Center.

Thank you for joining me in hosting this wonderful event. Enjoy the show!

Lee P. Brown

Mayor, City of Houston

6

Rainbovine

Texas Children's Hospital is thrilled to host CowParade Houston 2001. It seems only fitting to us that an animal so closely associated with the Lone Star State will return home this year in a blaze of colorful glory.

In addition to delighting visitors, our bold new breed of bovine will support our $80 million *Building for Children* capital campaign and the Texas Children's Cancer Center.

This book is a celebration of the creativity and generosity of the people who made CowParade Houston 2001 a reality: the volunteers, artists, sponsors, city officials, and many others.

Mark A. Wallace

President and CEO, Texas Children's Hospital

A BREED APART

BY EMILY CROSSWELL, CHAIRMAN OF COWPARADE HOUSTON 2001

An illusionist once noted that it is at the moment when you think something is possible that the magic starts. The magic of CowParade Houston 2001 started at the thought of an idea and continued beyond the end of the show.

On behalf of the CowParade Houston 2001 Executive Committee, I welcome you to this moovelous event. This extraordinary bovine bonanza, enjoyed by Houstonians and visitors, young and old, has galvanized the community for a good cause.

Launching a project of this magnitude takes the hard work of many people. Thanks go to the young, courageous patients at Texas Children's Hospital and the Texas Children's Cancer Center for providing inspiration and enthusiasm; to the artists whose talent and creativity ensured that this CowParade would be unlike all others; to the children and teachers of the 45 public and private school art classes that participated in the Cows in Schools project, involving their communities and extended school families; to the sponsors whose spirited support of Texas Children's Hospital and

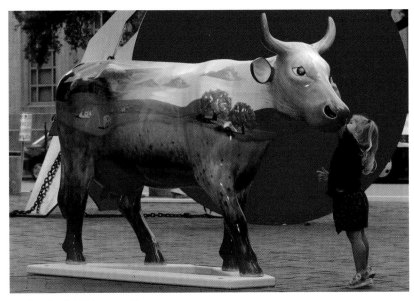

A Wonderful Life for a Cow

8

wholehearted involvement with the design selection made CowParade Houston so outrageously successful and fun; and to the City of Houston, whose collaboration, cooperation, and commitment ensured a success.

Special thanks go to our official ambassador, Mayor Lee P. Brown; Jordy Tollett of the Greater Houston Convention and Visitor's Bureau; Susan Christian of the Houston Parks and Recreation Department; Pam Ingersoll of the Municipal Arts Commission; and all the volunteers who supported this project in so many ways: as Cows in Schools chairpersons and mentors; artist liaisons; Cow Patrol; kickoff and auction teams; and through numerous other efforts that helped moove this whimsical event toward its dynamic launch.

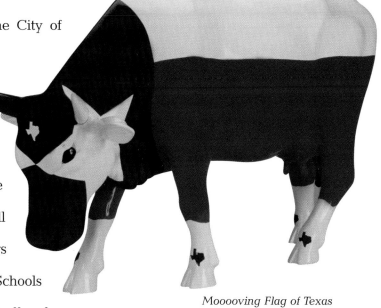

Mooooving Flag of Texas

Last, but far from least, thanks to the CowParade Houston 2001 Executive Committee members whose gifts of time, humor, and passion set the stage for this once-in-a-lifetime exhibition. It simply would not have happened without them.

And now, kick up your heels and savor the latest additions to our city's splendid landscape—the majestic herd of CowParade Houston 2001.

Emily Crosswell

Emily Crosswell

Chairman, CowParade Houston 2001

INTRODUCTION

BY JERRY ELBAUM, PRESIDENT OF COWPARADE

Welcome to CowParade Houston 2001. What you will see on the following pages are the spectacular creations of hundreds of artists who participated in this memorable event. Some are the works of preeminent artists, others the labors of aspiring student artists. Altogether, more than 320 original works of art were created for exhibition in a variety of public and private venues. CowParade Houston 2001 marks the first time a public art event of this magnitude has been staged in Houston. We are especially pleased that this exhibit benefits Texas Children's Hospital and particularly the world-renowned Texas Children's Cancer Center. The hospital is one of the largest and finest pediatric facilities in the world, and we at CowParade are very privileged to have been associated with it in this event.

One of the primary objectives of CowParade is to foster art and art programs in the schools, as we strongly believe that art helps schoolchildren better understand and relate to their environments, encourages the development of creative skills, and builds self-confidence. Hence the Cows in Schools program. EOG Resources, Inc., Reliant Energy, and The CowParade Foundation, Inc., sponsored an art contest for Houston public school-children. Winners were chosen from elementary, middle/junior high, and senior high school levels. Each school that submitted a winning design decorated a cow for display in CowParade Houston 2001, with exceptional results.

Tuco the Mootif Cow

Why the cows? The CowParade cow sculptures, the creation of the Swiss-born sculptor Pascal Knapp, are three-dimensional canvases to which the artist can easily relate. There is really no other animal shape that can adequately substitute for these sculptures and produce the level of artistic accomplishment evident in this book. The dimensions—the height and length, as well as surface areas and bone structures—are just right. And the cow is an animal we all love. One of the first

Miss Azalea

words most of us say in our infancy is "moo." Cows provide the milk that fosters our development, and milk is the basis of beloved childhood treats like ice cream. The cow is whimsical, quirky, and never threatening. That is why so much of the art in this exhibit causes us to laugh, smile, and just feel good.

I thank all the artists who participated in this undertaking and the many corporate, business, and individual patrons whose sponsorships helped underwrite the cost of the exhibit. Nothing would have been possible without the leadership of Emily Crosswell, together with the many volunteers associated with Texas Children's Hospital who assisted her; the involvement of Mr. Mark A. Wallace, President and CEO of Texas Children's Hospital; and the support of Mayor Lee P. Brown and the truly fabulous City of Houston.

Jerry Elbaum

President, CowParade

HISTORY ON THE HOOF

[THE STORY OF CATTLE IN TEXAS]

Since 1998, the fiberglass cattle of CowParade have stampeded through Chicago, New York, and Kansas City, and each location was great in its own way. But if there is any town where these cows will feel at home, it's Houston. Cattle are to Texas what taxis are to New York: you can't imagine the place without them.

The first cattle in Texas arrived on a spring day in 1541, when a herd swam across the Pecos River from the New Mexico side and scrambled up the bank into the Lone Star State. To

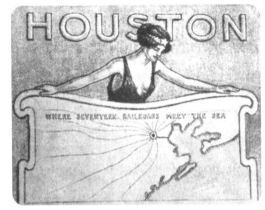

A promotional brochure for the city.

feed his expedition to the fabled Seven Cities of Cíbola, Francisco Vásquez de Coronado had brought with him 500 head of his own. The cattle kept coming as colonists and missionaries emigrated from Mexico to Texas, and by 1700 the Franciscans were teaching the Indians how to raise cattle. Seventy years later, the herd at Mission La Bahia del Espiritu Santo near Goliad numbered 40,000 head.

When the first Anglo settlers arrived in Texas in the early 19th century, they found herds of wild cattle on the plains. Some

The Bovine Timeline

c. 4000 B.C.
The first cheese is made in Switzerland.

c. 5000 B.C.
Farmers in Greece, Turkey, and Crete start domesticating wild cattle.

c. 3000 B.C.
Queen Hete-Phere of Egypt accepts the honorary title "Guardian of the Corporation of Butchers."

c. 2000 B.C.
When three angels appear at Abraham's tent, he serves them butter, milk, and a fatted calf.

c. 500 B.C.
Darius, a Persian gourmand, gives the first banquet in which the main course is a roasted whole ox.

c. A.D. 100
An anonymous poet creates *The Tain,* Ireland's national epic about a war that started over a cattle raid.

c. 850
Vikings bring the ancestors of British White cattle to England.

960
Monks from Brittany introduce the first dairy cows to the island of Guernsey.

1029
The Norse king Sitric hands over 1,200 cows to ransom his son, Olaf.

1493
The first cattle in the New World come ashore with Christopher Columbus on the island of Hispaniola.

of these were the classic Texas long-horns; there were also Spanish cows, brown cows, and curly-haired chinos. These herds supplied the first cattle ranches in Texas.

Large-scale trade in cattle began during the U.S.-Mexican War, when ranchers sold beef to the U.S. military. After the war, the ranchers began driving their herds to New Orleans, Kansas City, and even as far as Chicago to supply the cities of the East with beef.

The Civil War put an end to the cattle drives. A Union blockade made it impossible to get the herds out of Texas. In 1865, when the Confederate veterans returned home, they found 5 to 6 million longhorns running wild on the Texas plains. Meanwhile, the war had virtually exhausted the supply of beef cattle in the East. Ranchers found that cattle that cost $4 in

John Allen

Augustus Allen

Texas could be sold to the eastern markets for $40 or even $50 a head. And there were other markets for Texas cattle to the north and west: army outposts, Indian reservations, and mining towns. It was the beginning of Texas's cattle empire.

Of course, Houston was not founded as a cattle town. The Allen brothers, John and Augustus, who planned the city, intended it to be a commercial center. In August 1836, just four months after Texans had defeated General Santa Ana's Mexican army at San Jacinto, these two would-be real estate barons from New York purchased 6,642 acres on the west bank of Buffalo Bayou for $9,428 (they put up $1,000 in cash). They named the settlement in honor of General Sam Houston, the hero of San Jacinto.

1540
Coronado brings the first cattle into what will later become the United States.

1624
Devon cattle arrive at Plymouth Colony.

1690
The first Texas longhorns are driven north from Mexico onto land that will become Texas.

1817
Ohio livestock farmers begin grain-feeding their cattle and then driving them to market in New York.

1846
The first cattle drive on record travels from Texas to Missouri.

1521
The first longhorn cattle arrive in Mexico with Cortés.

1611
The first cows in English North America arrive at Jamestown.

1636
The first meatpacking plant is established in Springfield, Massachusetts.

1783
Shorthorn cattle, which can provide milk, meat, and labor, arrive in Virginia.

1845
Texas becomes the 28th state in the Union.

The town got off to a rocky start. Fires, floods, and cholera and yellow fever epidemics inhibited the growth of Houston. Then the town's leadership had an idea: they would promote Houston as an inland port city and a railroad hub. In 1844, the first large

An early illustration of Houston.

steamship, the *Constitution,* made its way from Galveston Bay up the Buffalo Bayou. It was a thrilling moment, marred by just one small problem: once the *Constitution* docked, the captain found there was no room to turn the steamship around; it had to back out of the bayou. In 1847, the Buffalo Bayou, Brazos & Colorado Railroad was founded; six years later, a second railroad, the Galveston and Red River line, was organized in Houston. That same year, the Texas legislature gave the city $4,000 to make the Bayou more navigable for ships.

Houston's town fathers had been right: the availability of transportation did attract industry. The first arrivals were iron and cotton, and it was cotton that would prove to be big money in Houston. The railroads brought the cotton into the city from the plantations, and ships in the bayou carried it to markets overseas.

Cotton dominated Houston's economy until January 10, 1910, when the Spindletop gusher erupted in an oil field near Beaumont. Within 20 years, many of the cotton warehouses that lined the Port of Houston were replaced by oil refineries. These were followed by petrochemical plants. Then Houston's petroleum barons started drilling offshore. Oil brought unprecedented prosperity to Houston, and oil

1860
A census shows that there are 31 million people in the United States and 26 million cattle in Texas.

1877
The Texas Stock Raisers' Association is organized.

1884
The use of barbed-wire fencing creates conflict between farmers and cattlemen. Fence cutting is made a felony.

1904
The hamburger is introduced to a hungry public at the St. Louis World's Fair.

1919
Torrington, Connecticut, becomes the first town in America to sell homogenized milk.

1866
The chuck wagon, a cowboy kitchen on wheels, is invented.

1880
Cattle ranches in the American West extend from the Rio Grande to the Canadian border.

1901
The Spindletop oil field gushes "black gold."

1911
The automatic rotary milk bottle filler and capper is perfected.

1929
Walt Disney's Clarabelle Cow makes her debut in the animated cartoon *The Plow Boy.*

money transformed the city. In the 1920s and 1930s, it built the Museum of Fine Arts, the University of Houston, and Memorial Park. The same period saw the transformation of the city skyline as the first sky-scrapers were built. Oil worked its magic again in the 1970s, when oil companies hired the architectural firms of Philip Johnson and Skidmore, Owings & Merrill to create a new Houston skyline of sleek, shining office towers.

Almost as unexpected as the oil boom was the selection of Houston as the site of the Apollo Mission Control Center for the U.S. space program. Houston's place in the history of the final frontier was assured at 3:17 on the afternoon of July 20, 1969, when Mission Control received the

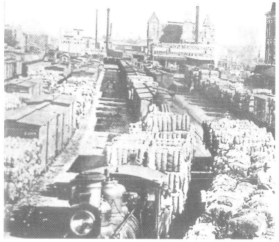

The railroads of Houston were crucial to the city's booming cotton trade.

first radio broadcast from the moon: "Houston, Tranquility Base here. The Eagle has landed."

And of course there are still cowboys in Houston. One of the biggest events of the year is the Houston Livestock Show and Rodeo, which draws about 2 million visitors. Since the first exhibition was held in 1932, the show, like everything in Texas, has just gotten bigger. Over the years, everything from parades to live performances by Elvis Presley to scholarships have been added to the program. The Houston Livestock Show and Rodeo has grown so popular that it will have its own building. The 70,000-seat Reliant Stadium, with a retractable roof, is slated to be ready in time for the 2002 football season and the 2003 Rodeo.

1931
The Houston Fat Stock Show and Livestock Exposition is established.

1933
Four Guernsey cows make the trip to Antarctica with Admiral Richard Byrd.

1938
Bulk tanks begin to replace the old milk cans.

1940
The Santa Gertrudis breed, developed by the King Ranch, is recognized; the American Quarter Horse Association organizes.

1948
The first plastic-coated paper milk cartons are introduced.

1961
The name of the Houston Fat Stock Show and Livestock Exposition is officially changed to the Houston Livestock Show and Rodeo.

1966
Eradication of the screwworm, a devastating cattle pest, is completed in the United States.

1974
Houston hosts the first World Championship Bar-B-Que Cook-off.

1993
Big Bertha, a Dremon cow, dies at age 48 years and nine months. She was the oldest cow on record.

2001
More than 320 whimsically designed fiberglass cows appear in CowParade Houston 2001, with proceeds benefiting Texas Children's Hospital *Building for Children* capital campaign and the Texas Children's Cancer Center.

Downtown

From the day the Allen brothers recruited Houston's first residents in 1836, Downtown has been prime real estate. Of course, the striking skyline of Houston today is a big change from the tents first pitched by those pioneering settlers.

Long gone are the days when cotton was delivered by rail and shipped down Buffalo Bayou. Today, Downtown is a tribute to the economic success and cultural richness of Houston. More than 150,000 people work in the central business district in industries from energy to banking to law. The impressive skyscrapers showcase public art installations by such artists as Miró and Dubuffet. The nearby theaters, presenting opera, ballet, symphony, and repertory, attract talent and art enthusiasts from around the world. The downtown business world lauds the tunnel system, measuring more than six miles, which connects many of the office buildings, restaurants, hotels, and stores.

Foley's, on Main Street between Dallas and Lamar, is one of Houston's most beloved landmarks. Launched in 1900 as Foley Bros. Dry Goods Store, Foley's is Houston's oldest department store. The store's previous building, located just up the street on Main, was much more to the city's residents than just a place to buy things: its auditorium served as the rehearsal hall for Houston's Symphony and the company sponsored many community events. Foley's moved to its current location in 1947, and, after having been through several acquisitions, was purchased by the May Department Stores Company in 1988.

MooBuffet's Mootif
Artist: Carlo Macaione of Gensler
Patrons: Trione & Gordon and Gensler Cow-Conspirators
Location: 1100 Louisiana (Louisiana and Lamar)

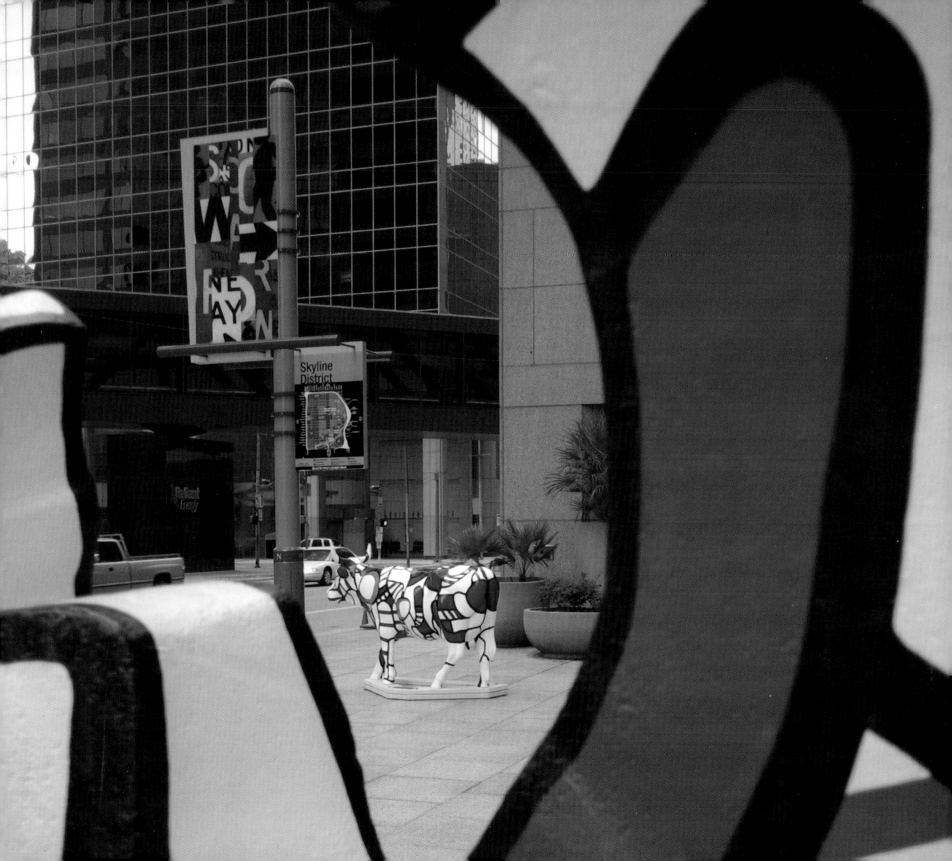

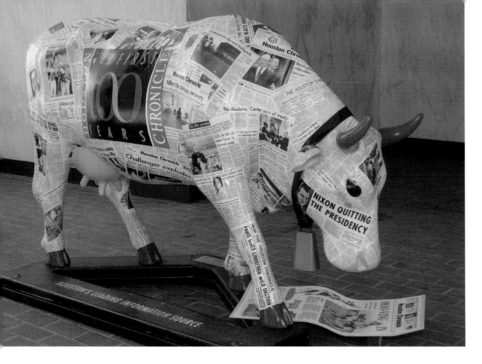

Houston Chronicow
Artist: Kellye Sanford and Terry Rountree
Patron: *Houston Chronicle*
Location: Houston Chronicle (Texas and Milam)

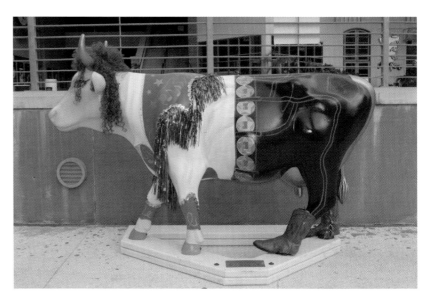

Cowntry Moosic Star
Artist: Kati Ozanic-Lemberger
Patron: FM 100 KILT
Location: Bayou Place (Smith and Texas)

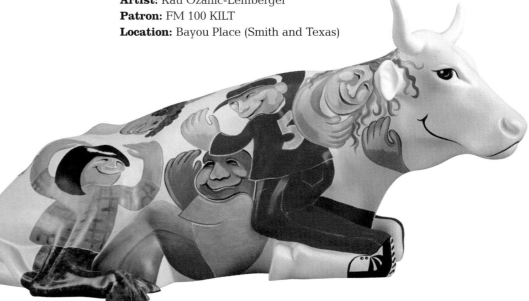

TEXAS TRIVIA

★

Houston has a theater district second only to New York City in its concentration of seats in one geographic area. The 17-block downtown Theater District has more than 12,000 seats in its eight performing arts organizations.

Moo-chas Gracias
Artist: Edwin R. Negron
Patron: Fayez Sarofim & Company
Location: Knot Garden at Houston Center (Austin and Lamar)

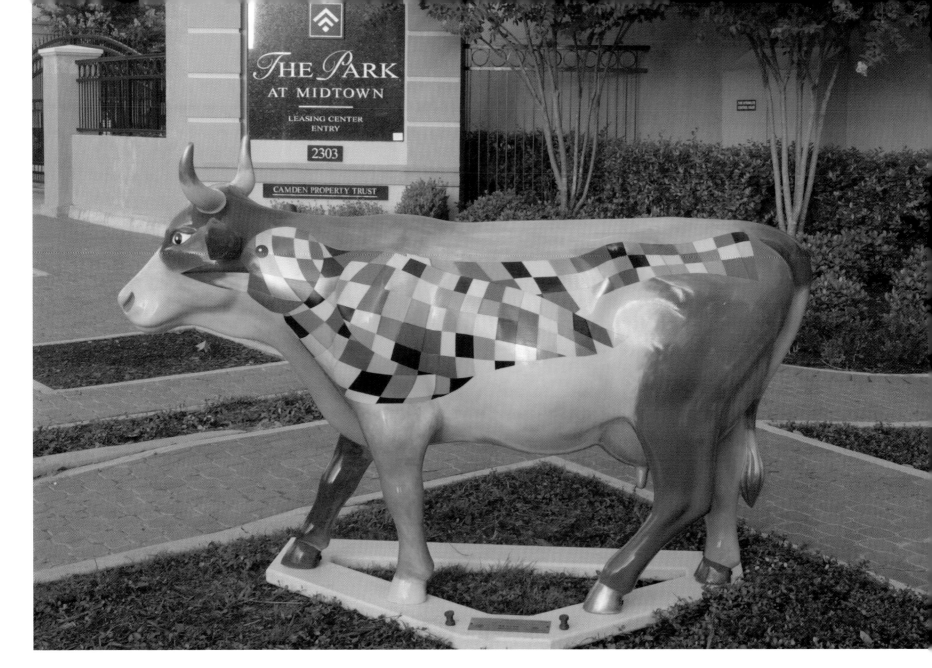

Cow Bird
Artist: Roberta Harris
Patron: camdenliving.com
Location: The Park at Midtown
(Midtown—Milam and Hadley)

Sea Cow

Artist: Valley West Elementary
Patron: EOG Resources, Inc.
Location: Wortham Center/Fish Plaza (Texas and Smith)

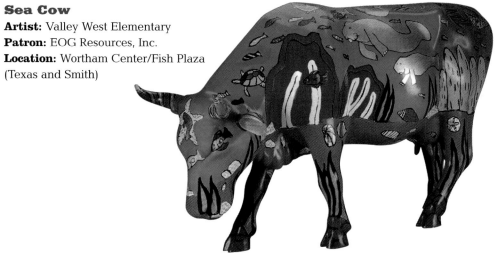

Remember the Alamoo

Artist: Ron Gordon
Patron: The Plank Companies, Inc.
Location: Knot Garden at Houston Center (Austin and Lamar)

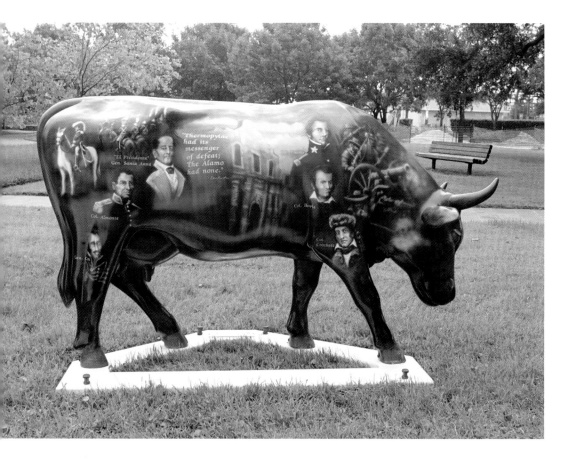

Gulf of Mooxico

Artist: Marketing Plus/XFactor Design
Patron: BP America, Inc.
An energy company going beyond.
Location: Bayou Place (Smith and Texas)

City of Gold Cow
Artist: Gary Tuttle
Patron: *Houston Chronicle*
Location: Houston Chronicle (Texas and Milam)

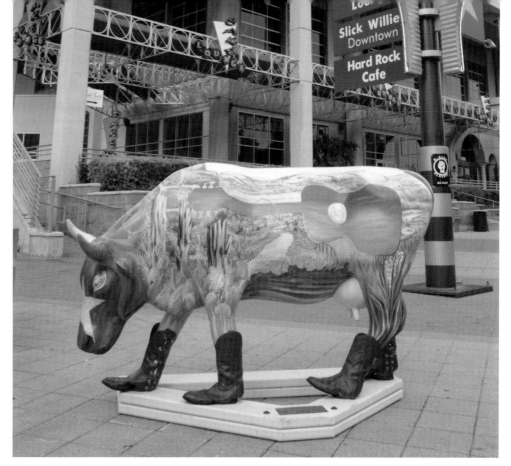

Texas Hill Country Moo-ntage
Artist: Kati Ozanic-Lemberger
Patron: 95.7 KIKK FM
Location: Bayou Place (Smith and Texas)

Clean Jean the Green Holstein
Artist: Marketing Plus/XFactor Design
Patron: BP America, Inc. An energy company going beyond.
Location: Bayou Place (Smith and Texas)

Moo Justice
Artists: Carol Slobin and Sylvia Trybek
Patron: Vinson & Elkins L.L.P.
Location: First City Tower
(Lamar and Fannin)

Steering Committee
Artist: Bruce Oren
Patron: *Houston Chronicle*
Location: Houston Chronicle
(Texas and Milam)

Cowsmic Cowlendar
Artist: B. Sheridan Phillips
Patron: CowParade Houston 2001
Location: Sam Houston Park—
Lower (Allen Parkway outbound at
St. John Church)

Tribal Funk!
Artist: Pasadena High School
Patron: Reliant Energy
Location: Sam Houston Park—Upper
(Bagby between McKinney and Lamar)

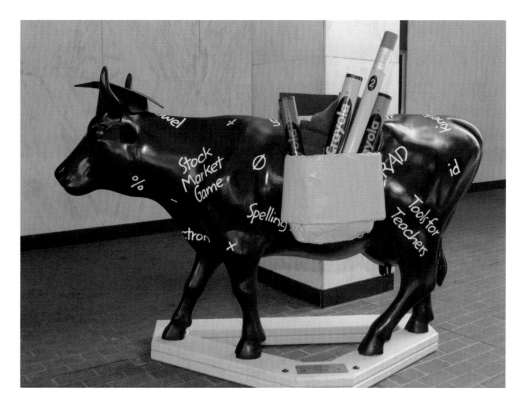

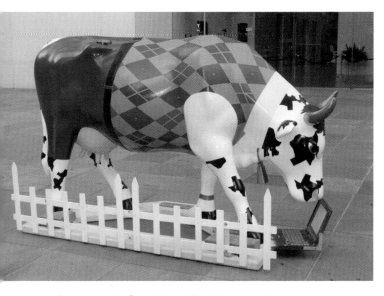

Cownsel for the De "Fence"
Artists: Sylvia Trybek and Carol Slobin
Patron: Vinson & Elkins L.L.P.
Location: First City Tower
(Lamar and Fannin)

Scholasticow
Artist: Justin Smith
Patron: *Houston Chronicle*
Location: Houston Chronicle (Texas and Milam)

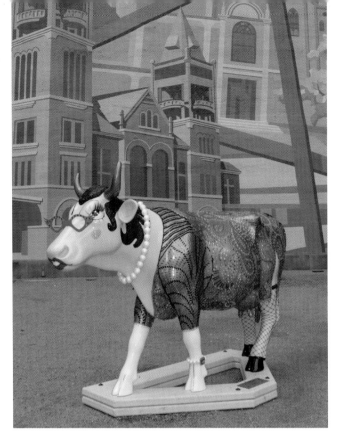

Udderly Beautiful
Artist: Collaboration of Designers
Patron: McCoy Workplace Solutions
Location: Chase Tower (Capitol and Milam—in the park)

Cowchip
Artist: Patrick J. Walker
Patron: *Houston Chronicle*
Location: Houston Chronicle (Texas and Milam)

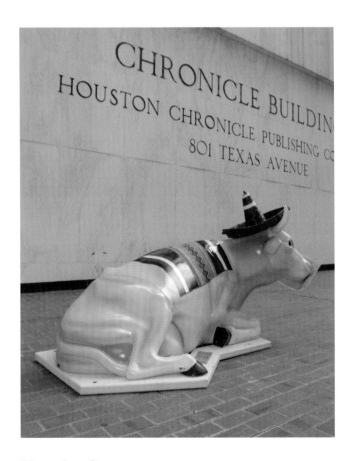

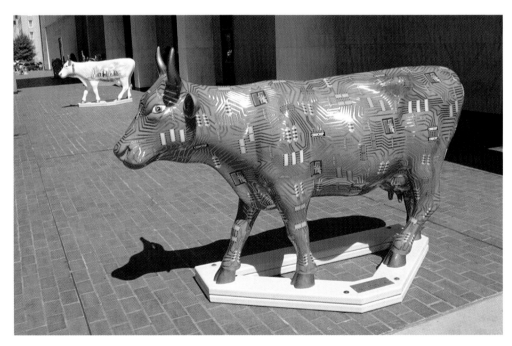

Moocho Cow
Artist: Ivan Galvan
Patron: *Houston Chronicle*
Location: Houston Chronicle (Texas and Milam)

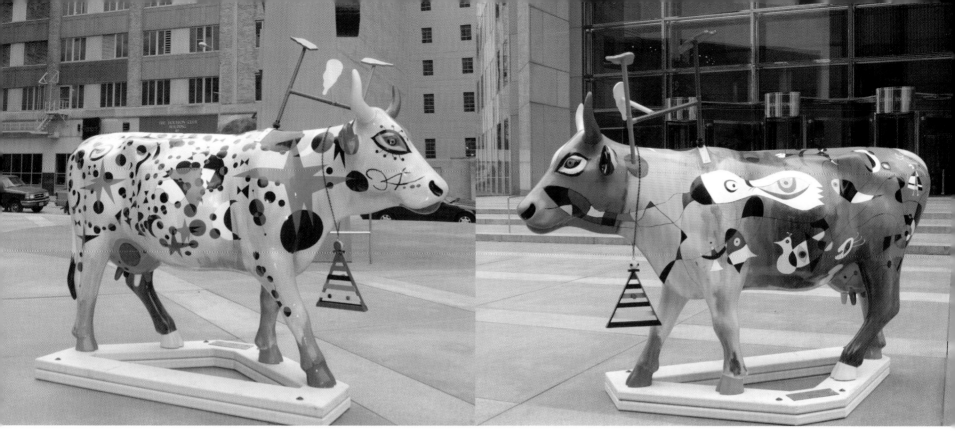

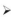
Moo-iro
Artists: Jose, Christy, Pam, Nick,
and Gabe Dumlao
Patron: Prime Asset Management—
Owner, Chase Tower
Location: Chase Tower
(Capitol and Milam—on the plaza)

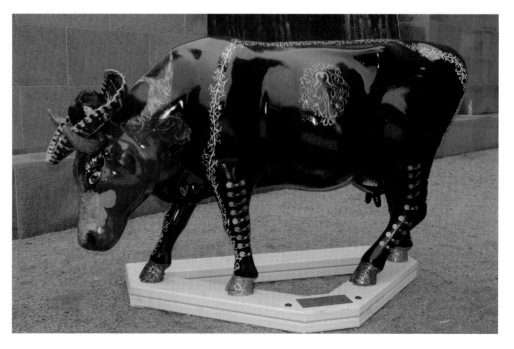

➢
Moo-riachi
Artists: Peter Parker/Meca Arts Students
Patron: EOG Resources, Inc.
Location: Chase Tower (Capitol and Milam—in the park)

Texas Moo Dog
Artist: George Rodrigue
Patrons: Chris and Don Sanders
Location: Chase Tower (Capitol and Milam— on the plaza)

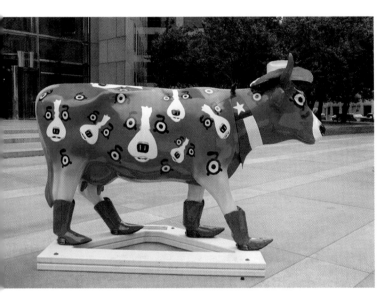

Texas Historic Cow
Artist: Maryellen Figinsky
Patron: *Houston Chronicle*
Location: Houston Chronicle (Texas and Milam)

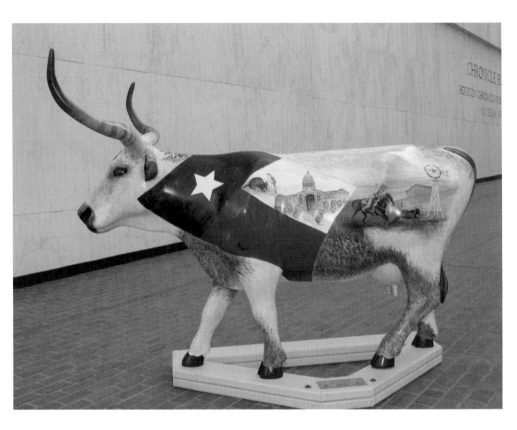

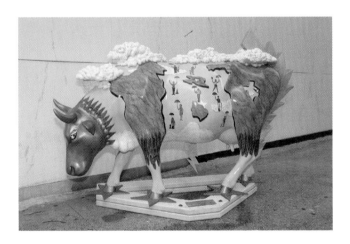

Moogritte Texas Cow
Artists: Bruce Monical and Art Square Studios
Patron: *Houston Chronicle*
Location: Houston Chronicle (Texas and Milam)

Bluebonnet Cow
Artist: Kermit Eisenhut
Patron: Crescent Real Estate
Equities Limited
Location: Knot Garden at Houston Center
(Austin and Lamar)

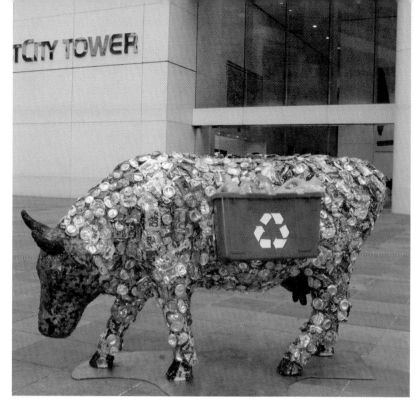

Waste Moover
Artist: Corporate Communications:
Angela Gass, Elaine Gracia, Maria
Thurow, Kristen Oland, and Chris Harness
Patron: Waste Management, Inc.
Location: First City Tower (Lamar and
Fannin)

The Earth Cow
Artist: Jackson Middle School
Patron: EOG Resources, Inc.
Location: Sam Houston Park—
Upper (Bagby between McKinney
and Lamar)

DONNA VADALA
*Forecowddie, French Moodle, and
Camp for Allasaurus*

This eclectic barnyard trio holds special significance for Donna Vadala. The Woodlands artist first became acquainted with Texas Children's Hospital in the early 1980s, when her son Alex's playmate was diagnosed with cancer.

"Ryan lived across the street and was Alex's dearest, very best friend from the time they were five years old," she said. "We spent many hours at the hospital before he passed away at the age of twelve. Alex was a pallbearer at the funeral and Ryan's death touched our entire family."

At one time, this mother of four and avid volunteer limited her artistic endeavors to making paintings and drawings for friends. Recently, however, she exhibited her works at a gallery in her community.

When she joined the artists' call for CowParade Houston 2001, Donna found strength and inspiration in the creation of her cows: "While I was on my back, perspiring and painting French Moodle's toenails, I thought about the children who would benefit from the CowParade. I prayed, 'Lord, help me do one more brush stroke. Maybe someone will pay more money for this cow because I've tried harder.'"

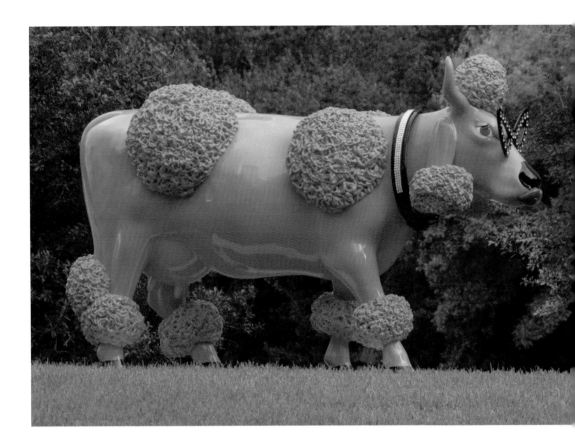

French Moodle
Artist: Donna Lane Vadala
Patron: Linda and Ken Lay Family
Location: Enron Building (Antioch Park—Smith and Andrews)

Mooost Immooovative
Artist: Jason C. Alkire/Craftsman Awards
Patron: Enron
Location: Enron Building
(Smith and Andrews)

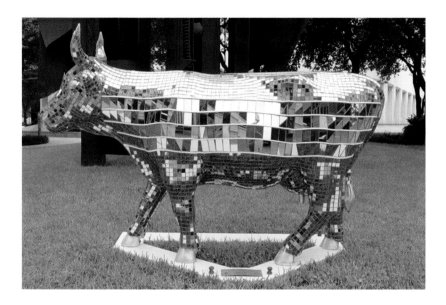

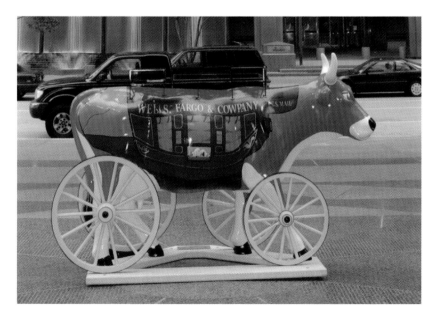

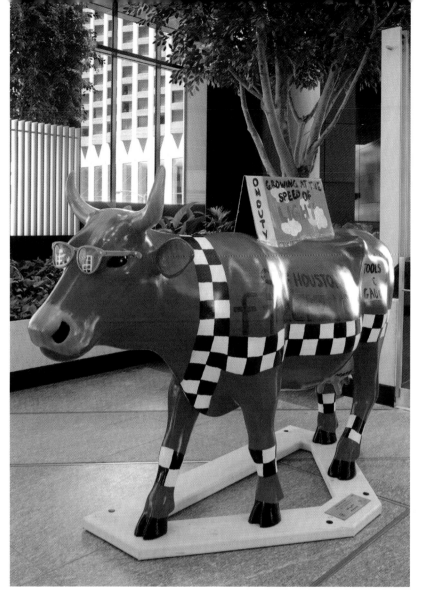

Sizzlin' City Cow
Artist: Riverwood Middle School
Patron: Reliant Energy
Location: Reliant Plaza (Louisiana and Lamar—inside)

stage COWch
Artists: Dean Barone and Barone Design Group
Patron: Wells Fargo
Location: Wells Fargo Plaza (Lamar and Louisiana)

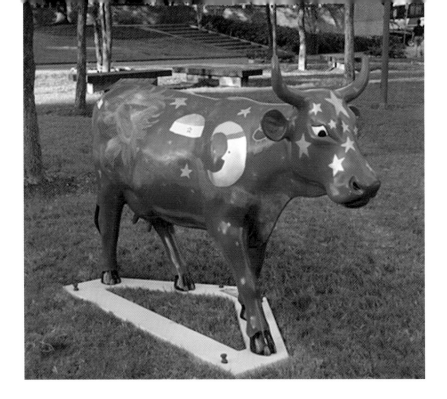

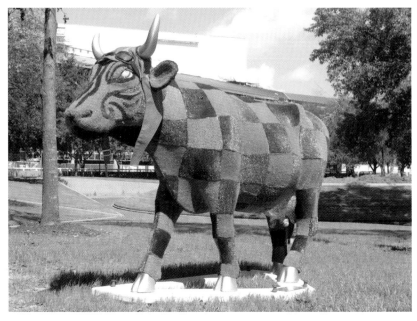

Exploring the Mooniverse
Artist: Ashford Elementary School
Patron: EOG Resources, Inc.
Location: Tranquility Park
(Smith and Walker)

Ms. Congrassiality
Artist: Santa Fe High School
Patron: EOG Resources, Inc.
Location: Tranquility Park (Smith and Walker)

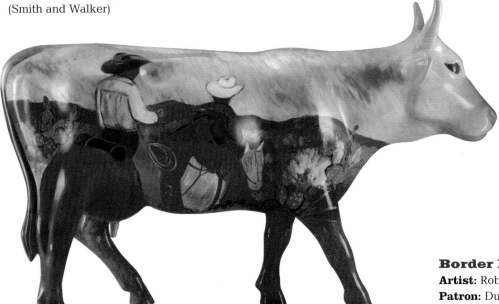

Border Bovine
Artist: Robin H. Roberts
Patron: Duke Energy
Location: City Hall (Smith and Walker)

Faux Cow
Artist: Deborah Horwitz
Patrons: Ownership One & Two Shell Plaza, Comerica Bank, Dr. McClellan, Goldking
Location: One Shell Plaza (Walker and Louisiana—inside)

Sunny Cowds, Sunset Cowds, Moonlit Cowds
Artist: Pamela Hoffer
Patron: CowParade Houston 2001
Location: Sam Houston Park—Lower (Allen Parkway outbound at St. John Church)

E moo ly, The Major Moo
Artist: Bruce Monical and the Art Square Studios
Patron: Emily's Moomettes
Location: City Hall (Smith and Walker)

31

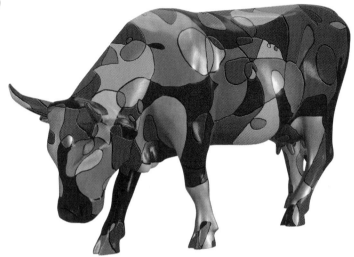

Abbie the Abstract Cow
Artist: Mark Twain Elementary School
Patron: EOG Resources, Inc.
Location: Tranquility Park (Smith and Walker)

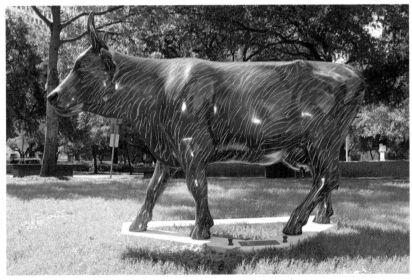

Persistence of Memoory (Dali Cow)
Artist: Chris Hedrick
Patron: Duke Energy
Location: City Hall (Smith and Walker)

Cow Twombly
Artist: Bexar
Patrons: Keith and Kathleen Vogel
Location: Tranquility Park (Smith and Walker)

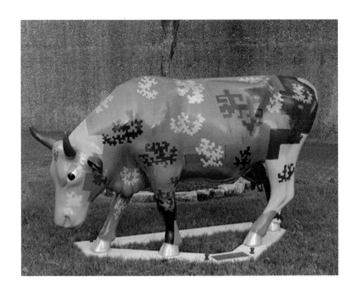

Moocho Colores
Artist: Cesar Chavez High School
Patron: EOG Resources, Inc.
Location: Tranquility Park (Smith and Walker)

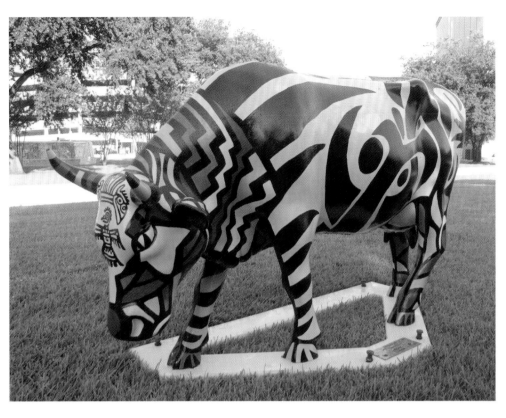

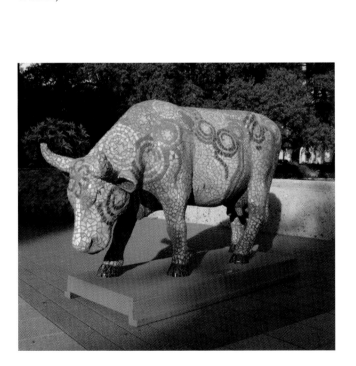

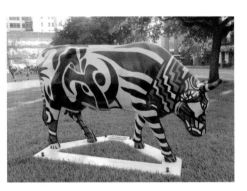

◄▲
Tuco the Mootif Cow
Artist: Hogg Middle School
Patron: Reliant Energy
Location: Market Square (Preston and Milam)

◄
A Starry Night in Texas
Artist: Janis L. Harper
Patron: Duke Energy
Location: City Hall (Smith and Walker)

Where Local Moos Comes First
Artist: Julianna Bray Hernandez
Patron: KPRC Channel 2 NBC
Location: Tranquility Park (Smith and Walker)

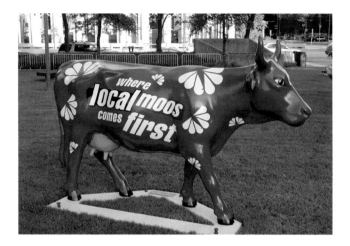

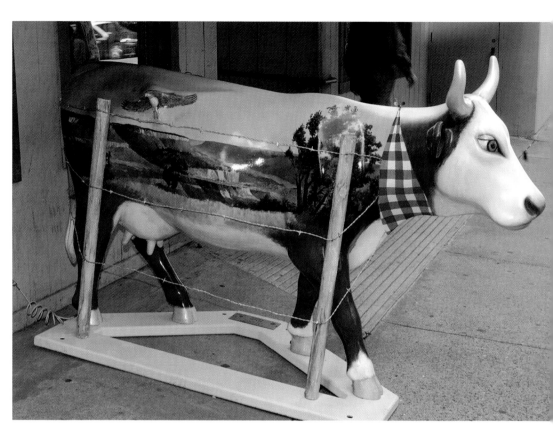

Let's Go to Moother's
Artist: Don Edelman
Patron: Luther's Bar-B-Q
Location: Luther's Bar-B-Q
(Smith and Lamar)

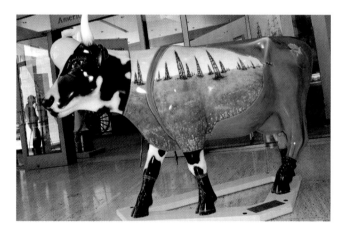

Rita Roughneck
Artists: Patrick Palmer and Jose Olvera
Patron: Shell Oil Company
Location: One Shell Plaza (Walker and Louisiana)

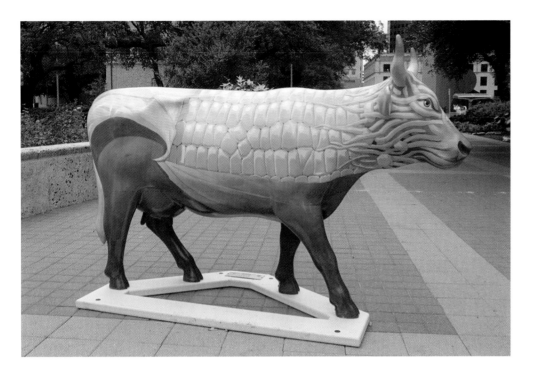

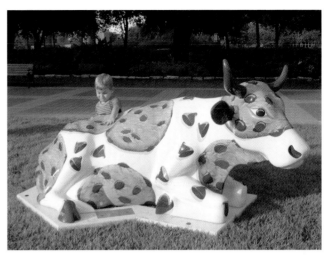

Cookies 'n' Cream
Artist: Dura Dittmar
Patron: Duke Energy
Location: City Hall (Smith and Walker)

Corn on the Cow
Artist: Brian Beck
Patron: Duke Energy
Location: City Hall (Smith and Walker)

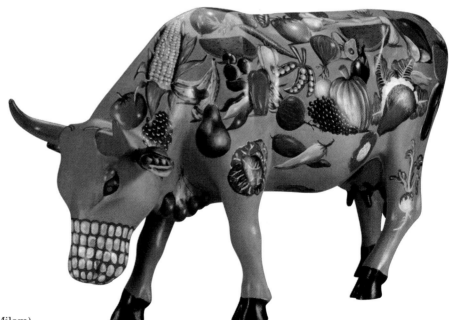

Veggie Cow
Artist: Robert E. Lee High School
Patron: EOG Resources, Inc.
Location: Market Square (Preston and Milam)

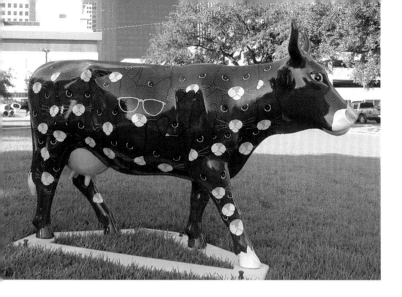

Moo-ow
Artist: Jim Tweedy
Patron: CowParade Houston 2001
Location: Market Square
(Preston and Milam)

MooZoo
Artist: Diana Selby
Patron: Duke Energy
Location: City Hall (Smith and Walker)

Udderfly
Artist: High School for Law Enforcement and Criminal Justice
Patron: EOG Resources, Inc.
Location: Tranquility Park (Smith and Walker)

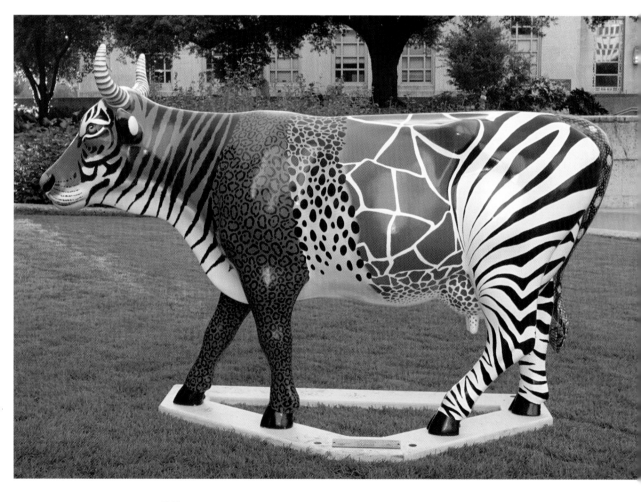

➢
Camoora Cow
Artists: Angie Watson and Karen Sachar
Patrons: Nancy and Jack Dinerstein and
Jack G. Lee
Location: Houston Downtown Library
Complex (McKinney and Bagby)

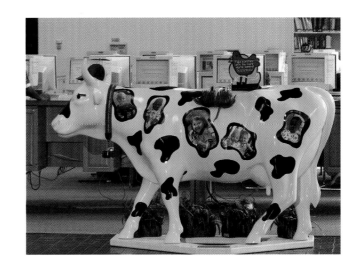

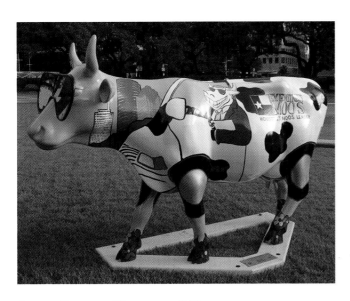

Eyewitness Moosmobile
Artist: Elizabeth F. Hornik
Patron: KTRK Channel 13 ABC
Location: City Hall (Smith and Walker)

Udderly Pumping Bovine
Artist: Alicia D. Gates
Patron: Conoco, Inc.
Location: Market Square
(Preston and Milam)

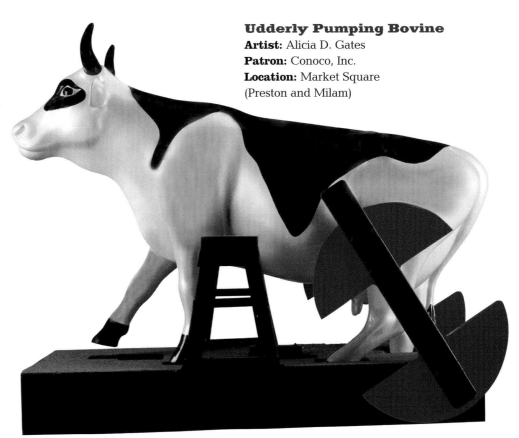

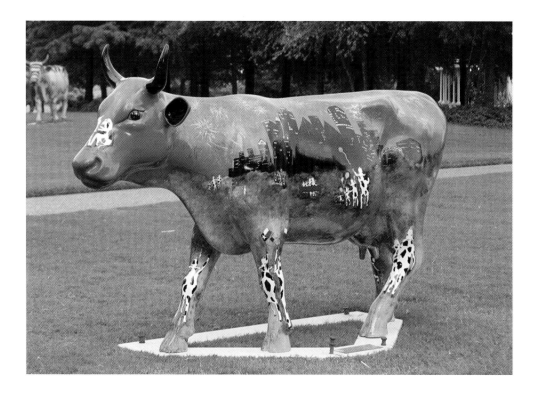

Grazin' in the Grove
Artist: Mary Cooley Craddock
Patrons: Allison and Louis Brandt
Location: Tranquility Park (Smith and Walker)

Cow Power of Houston
Artist: Salli Babbitt
Patron: Commonwealth Land Title Company of Houston
Location: Sam Houston Park—Upper (Bagby between McKinney and Lamar)

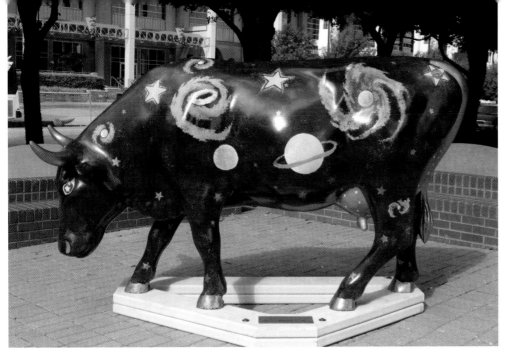

Out of this World Cow
Artist: Herod
Elementary School
Patron: Reliant Energy
Location: Wortham Center/
Fish Plaza (Texas and Smith)

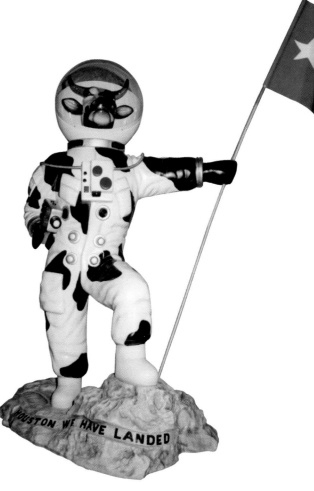

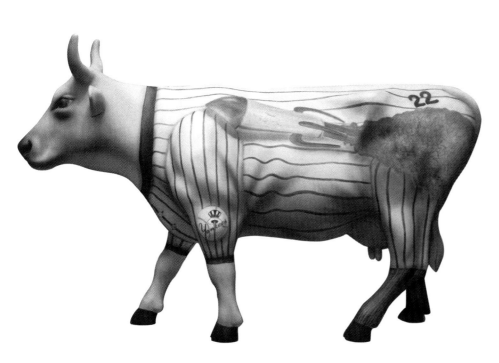

The Rocket Man
Artist: BeverlyHillSmith.com
Patron: The Roger Clemens Foundation
Location: Enron Field (Crawford between Texas and Congress)

Moonwalker
Artist: Silvestri California
Patron: Silvestri California
Location: Houston Downtown Library
Complex (McKinney and Bagby)

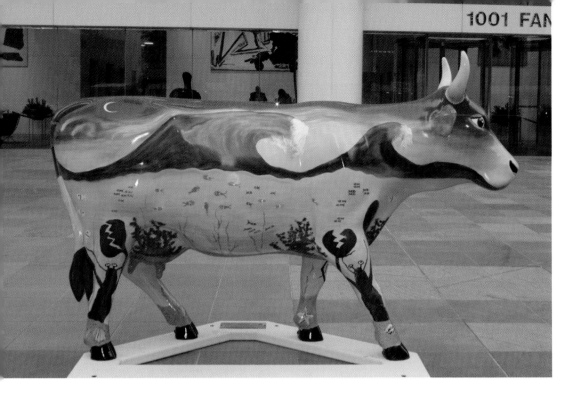

Moo-ving to New Depths
Artist: Kermit Eisenhut
Patron: Ocean Energy, Inc.
Location: First City Tower (Lamar and Fannin)

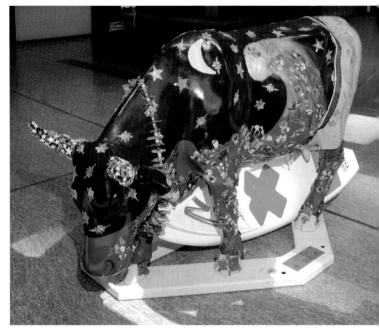

↖ Cowabunga!
Artist: Valley Oaks Elementary School
Patron: Reliant Energy
Location: Reliant Plaza (Louisiana and Lamar—inside)

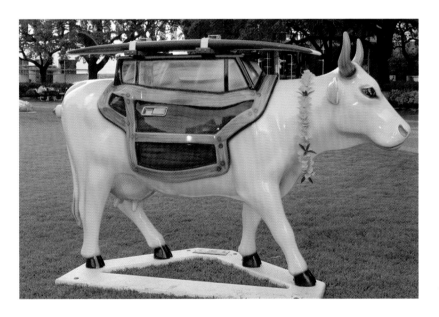

↙ Cow-a-bunga!
Artist: Curtis Cameron and Chris Hedrick
Patron: Duke Energy
Location: City Hall (Smith and Walker)

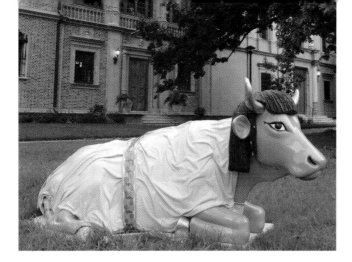

Heffertity
Artist: High School for the Performing and
Visual Arts
Patron: EOG Resources, Inc.
Location: Houston Downtown Library
Complex (McKinney and Bagby)

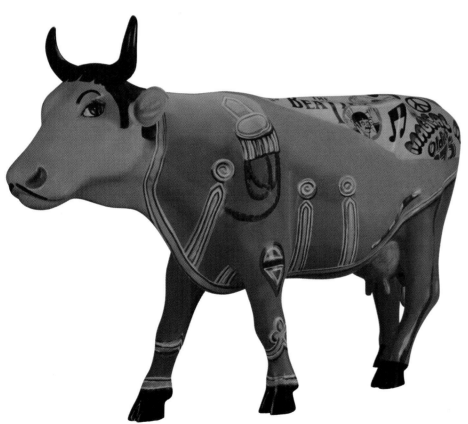

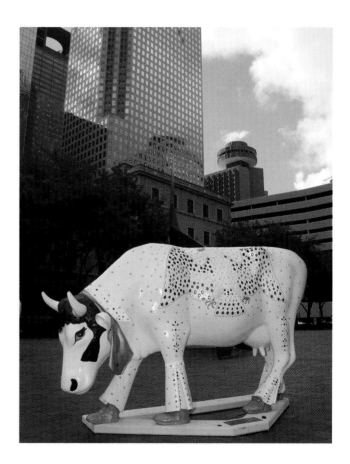

Paul MooCartney
Artist: Nextwave Art/David C. James
Patron: Oldies 107.5 KLDE
Location: Sam Houston Park—Upper
(Bagby between McKinney and Lamar)

Elvis Cowsley in Grazeland
Artist: Patricia A. Hilton
Patrons: Sara and John H. Lindsey
Location: Houston Downtown Library
Complex (McKinney and Bagby)

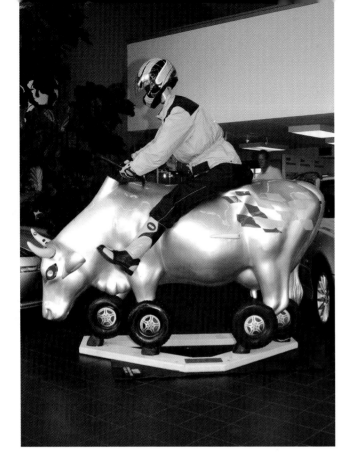

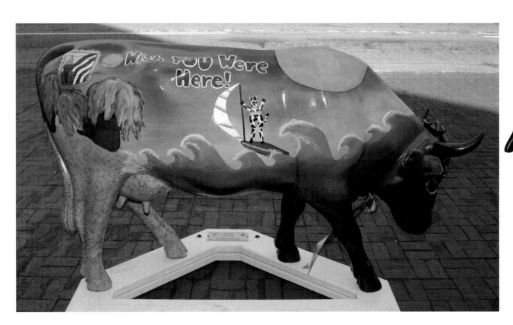

The Ultimate Mooing Machine
Artist: Rajan Sedalia
Patron: The Houston BMW Group
Location: Advantage BMW (Midtown—San Jacinto and W. Gray)

Cow Town
Artist: McNamara Elementary School
Patron: Reliant Energy
Location: Sam Houston Park—Upper (Bagby between McKinney and Lamar)

Postcow from Cowveston
Artist: Spring Branch Middle School
Patron: Reliant Energy
Location: Houston Downtown Library Complex (McKinney and Bagby)

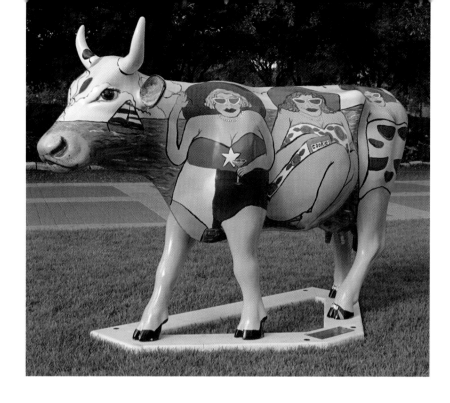

Funseekers
Artist: Janice Joplin
Patron: Duke Energy
Location: City Hall (Smith and Walker)

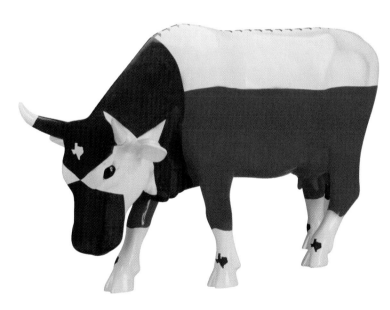

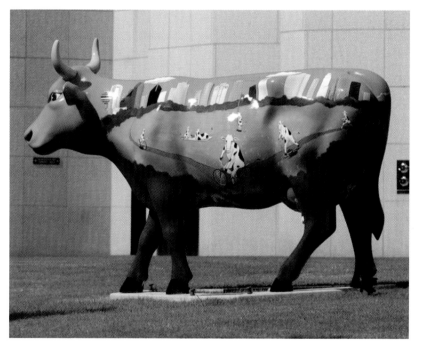

Mooooving Flag of Texas
Artist: Dottie Erwin
Patron: Robert and Janice McNair Foundation
Location: Pennzoil Place (Milam and Rusk—inside)

Cowing Around Houston
Artist: Kermit Eisenhut
Patron: Whitney National Bank
Location: Whitney National Bank (Smith and Pease)

Lovely Guadalupe
Artist: Robert Louis Stevenson
Elementary School
Patron: EOG Resources, Inc.
Location: Market Square
(Preston and Milam)

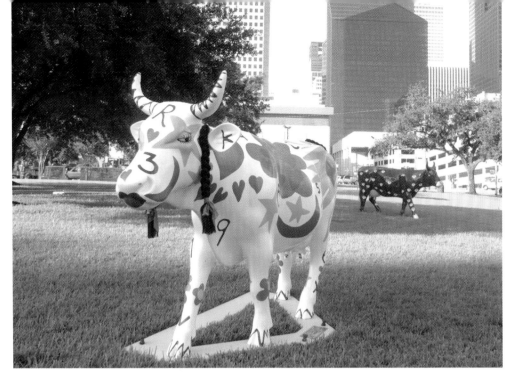

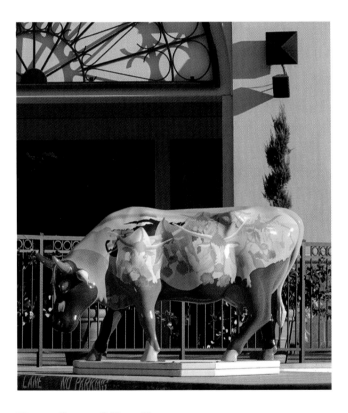

Running of the Cows
Artist: John McCarty
Patron: Ibiza Food and Wine Bar
Location: Ibiza Food and Wine Bar
(Midtown—Louisiana and McGowan)

Flamen-cow
Artist: Nancy Conrad
Patron: CowParade Houston 2001
Location: Houston Downtown Library
Complex (McKinney and Bagby—inside)

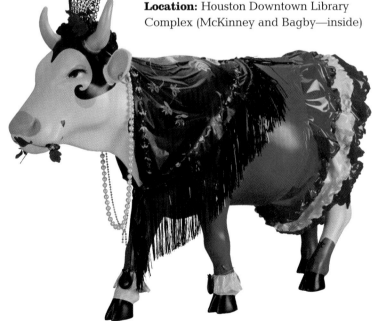

44

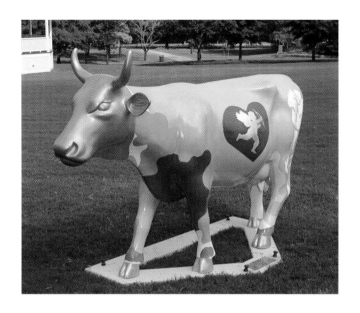

Moocho Amor
Artist: Jose Figueroa
Patron: KLOVE 93.3 FM/104.9 FM
Location: Sam Houston Park—
Lower (Allen Parkway outbound at
St. John Church)

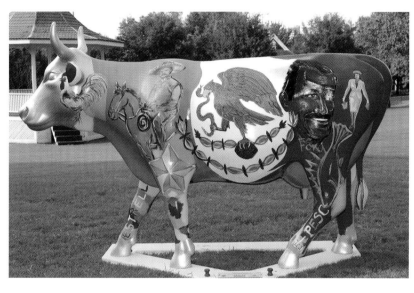

Fiestas Patrias
Artist: Jose Figueroa
Patron: KLTN Estereo Latino 102.9
Location: Sam Houston Park—Lower
(Allen Parkway outbound at
St. John Church)

Si-si (the yes cow)
Artists: George Sacaris and Lisa Waering
Patron: Duke Energy
Location: City Hall (Smith and
Walker—rotunda)

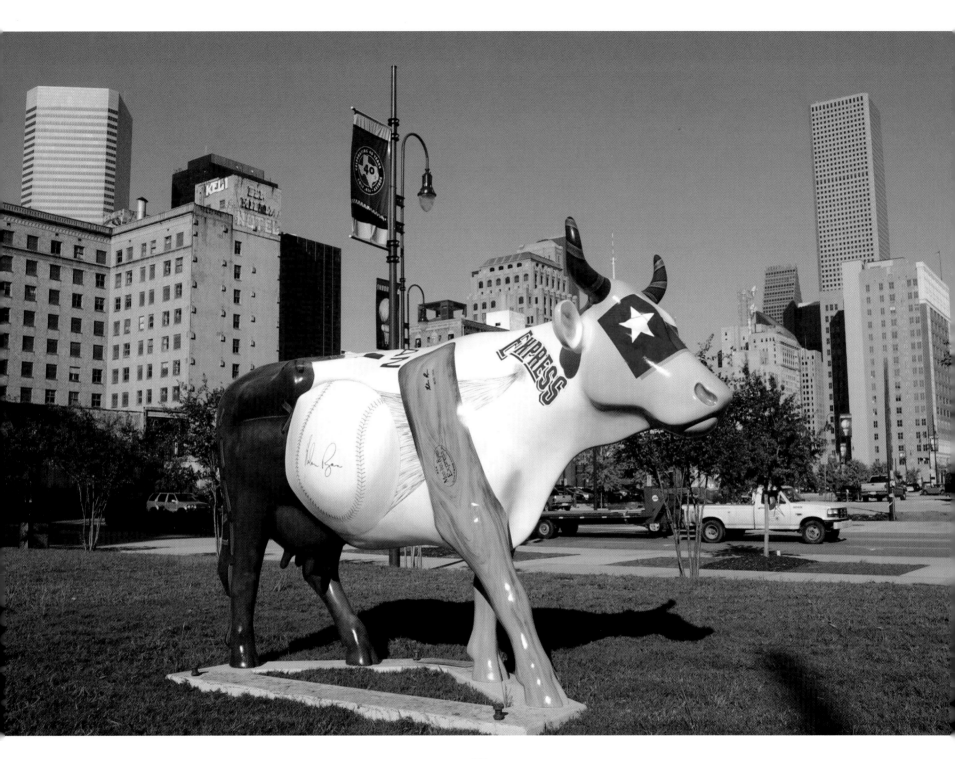

46

Moo-lan Ryan Express
Artists: Diana Selby and Dura Dittmar
Patrons: Ruth and Nolan Ryan
Location: Enron Field (Crawford between
Texas and Congress)

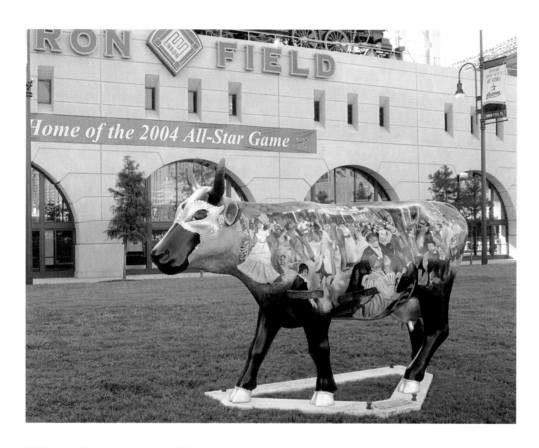

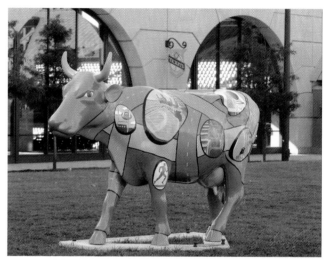

Holy Cow, Let's Play Ball
Artist: Suzanne E. Sellers
Patron: The Board of Directors of the
Greater Houston Convention and Visitors
Bureau
Location: Enron Field (Crawford between
Texas and Congress)

"Moos-Cowrade Ball" Cow
Artists: Marilyn Guerinot and Spring Woods High
School Art Department
Patron: Lance and Pat Livingston, Lance Livingston
Productions
Location: Enron Field (Crawford between Texas and
Congress—inside)

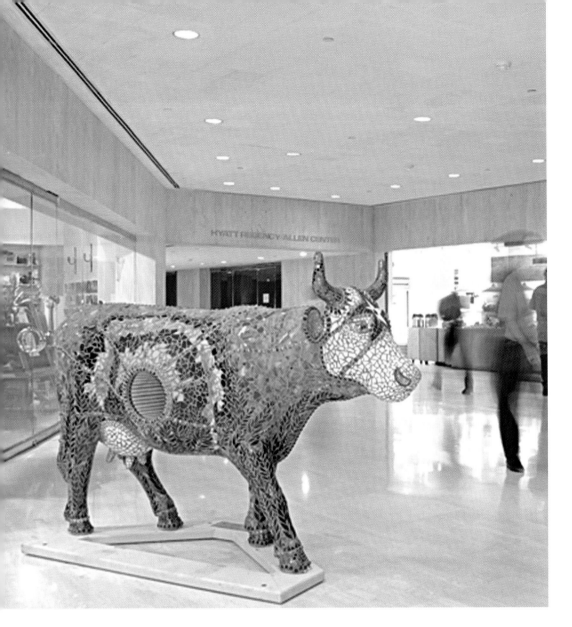

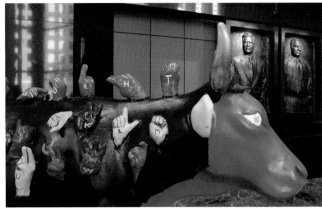

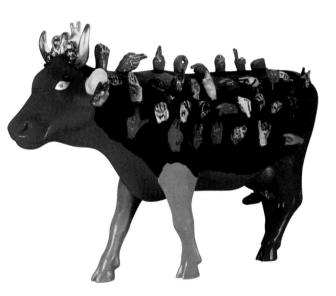

Deep in the Art of Texas
Artist: Elizabeth F. Hornik
Patron: Jackson Walker L.L.P.
Location: 1100 Louisiana (Louisiana and Lamar—tunnel)

The T. H. Rogers Cow Hands
Artist: T. H. Rogers School
Patron: Reliant Energy
Location: Reliant Plaza (Louisiana and Lamar—inside)

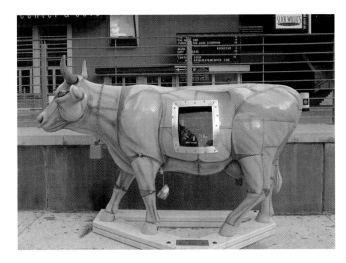

Udderly Innovative
Artist: Marketing Plus/XFactor Design
Patron: BP America, Inc. An energy
company going beyond.
Location: Bayou Place (Smith and Texas)

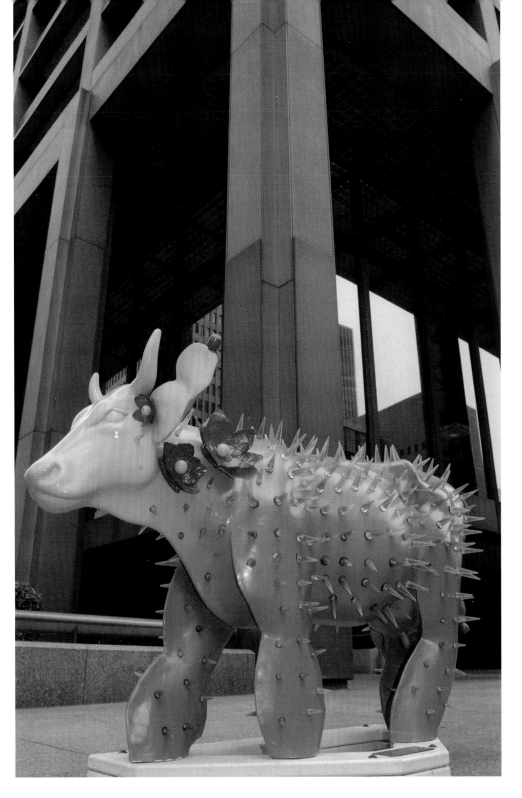

Cactow
Artist: Minor Design Group
Patron: El Paso Corporation
Location: El Paso Corporation Building
(Louisiana and Lamar)

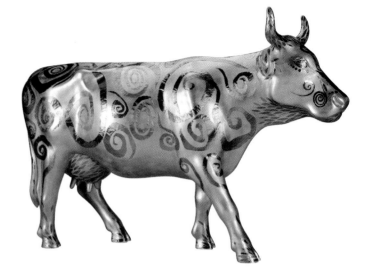

Metallicow
Artist: Heather N. Griffin
Patron: Virginia & L. E. Simmons
Foundation
Location: Market Square
(Preston and Milam)

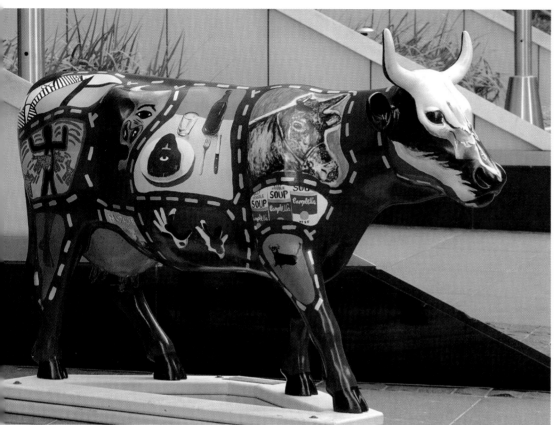

Twentieth Century Cow
Artist: Westside High School
Patron: Reliant Energy
Location: Reliant Plaza (Louisiana and
Lamar)

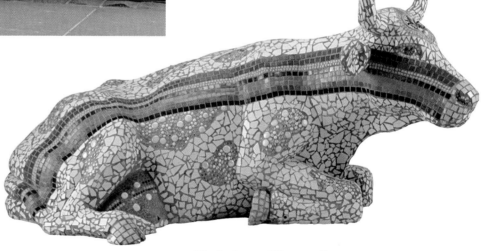

Rainbow Moosaic
Artist: Denise Hinds Cartwright
Patron: CowParade Houston 2001
Location: Sam Houston Park—Lower (Allen
Parkway outbound at St. John Church)

Buena Vista Vaca

Artist: Beverley A. Whitworth
Patrons: Hughes and Betsy Abell
Location: Alley Theatre (Smith and Texas)

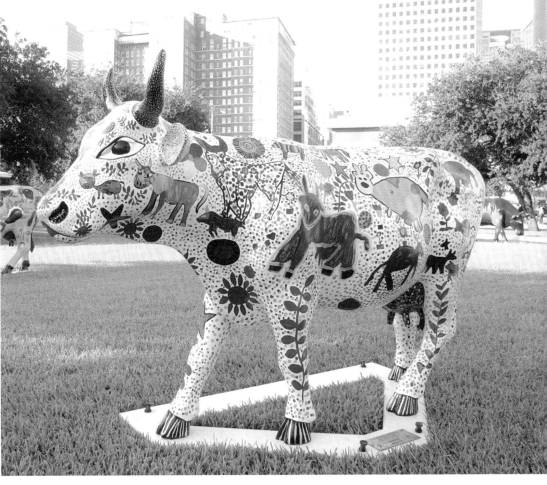

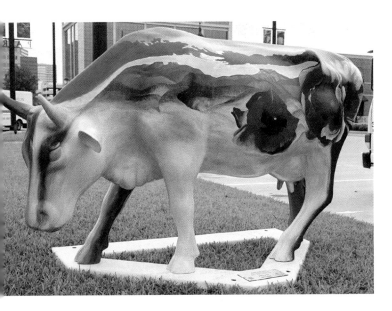

Cows of Pat Neff Elementary

Artist: Pat Neff Elementary
Patron: EOG Resources, Inc.
Location: Market Square
(Preston and Milam)

"Moo-ve Over for Minnie"

Artist: Cisco Tucker Kolkmeier
Patrons: John and Triphene Middleton
Location: Tranquility Park
(Smith and Walker)

Mooving Energy Around the World

Artist: Marketing Plus/XFactor Design
Patron: BP America, Inc. An energy company going beyond.
Location: Bayou Place (Smith and Texas)

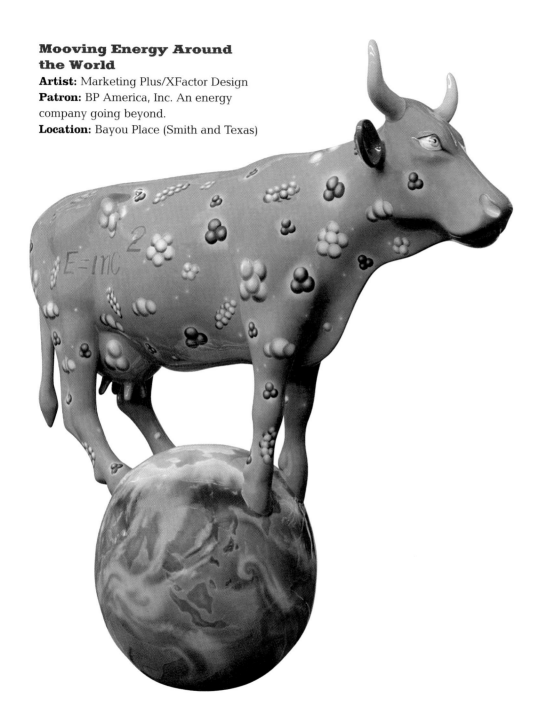

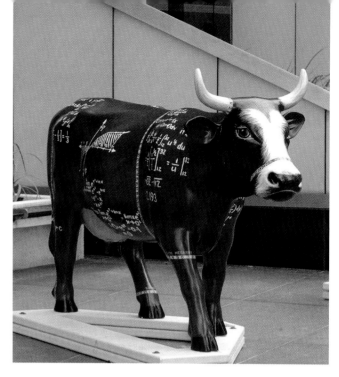

Cowculus

Artist: Jesse Jones High School
Patron: Reliant Energy
Location: Reliant Plaza (Louisiana and Lamar)

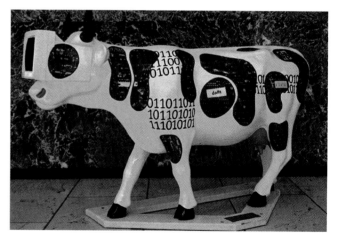

Udder Dada

Artist: dadaNet.Circus
Patron: EDS
Location: One City Centre (Main and Lamar—inside)

Picowso's Moosicians
Artist: Clear Lake High School
Patron: Reliant Energy
Location: Reliant Plaza
(Louisiana and Lamar)

Cow of Lilies
Artist: Hastings Ninth Grade Center
Patron: EOG Resources, Inc.
Location: Market Square
(Preston and Milam)

TEXAS TRIVIA

★

Considered by many to be the
energy capital of the world,
Houston is home to 18 Fortune 500
companies and more than 5,000
energy-related firms.

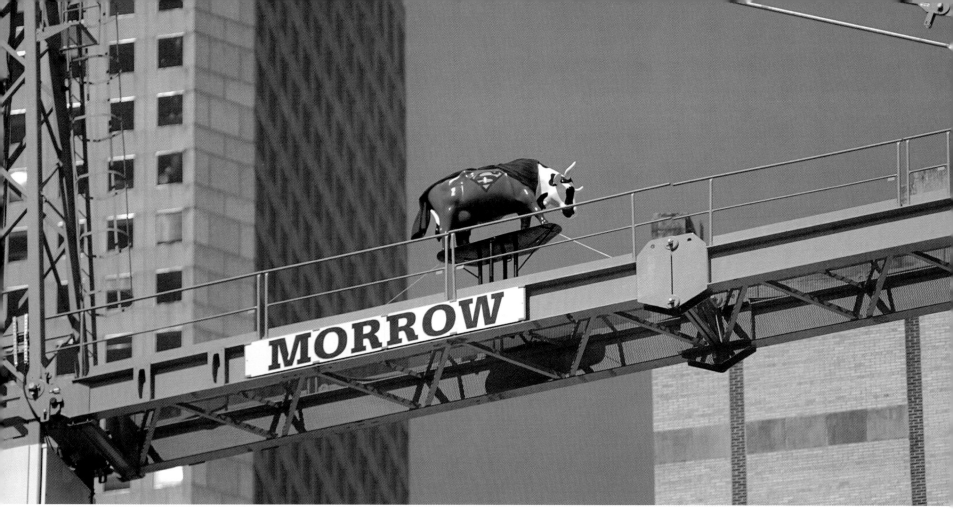

Super Cow
Artist: Stuff Creators
Patron: 1000 Main, a project of
Century Development
Location: Reliant Energy Construction
Site (McKinney and Travis)

Gladiator—Russell Cow
Artist: BeverlyHillSmith.com
Patron: The Readers of
maximumcrowe.com
Location: Tranquility Park
(Smith and Walker)

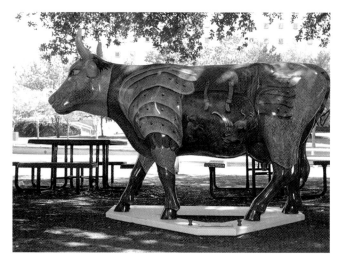

Simplicow
Artist: Sarah Nix Ginn
Patron: BP America Billboard
Location: BP America Billboard
(Louisiana and Franklin)

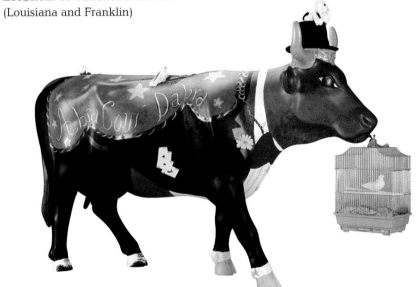

AbraCowDabra
Artists: Julie and Amy Alexander
Patron: Texas Children's Cancer
Center Staff
Location: Pennzoil Place (Milam and Rusk)

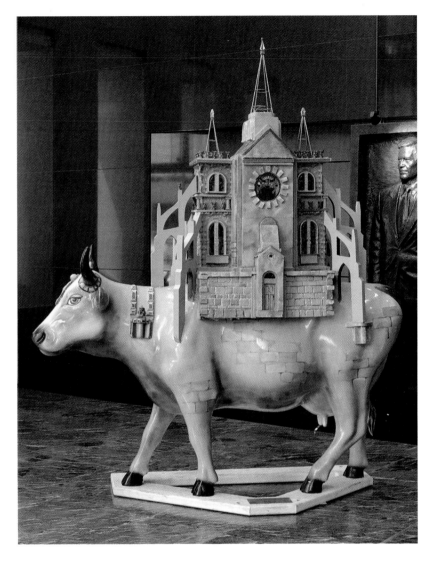

Holy Cowthedral
Artist: Sterling High School–Baytown Art Department
Patron: Reliant Energy
Location: Reliant Plaza (Louisiana and Lamar—inside)

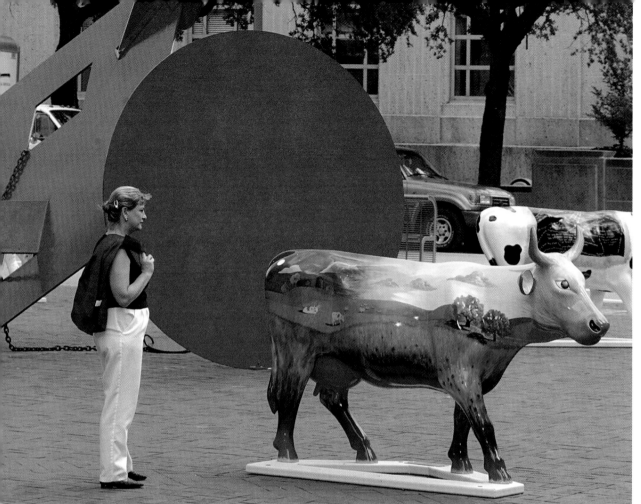

It's a Wonderful Life for a Cow
Artist: Catherine White-Swan
Patrons: Hughes and Betsy Abell
Location: Houston Downtown Library Complex (McKinney and Bagby)

Cowalillies
Artist: Roberta Alvarez Smith
Patron: Duke Energy
Location: City Hall (Smith and Walker)

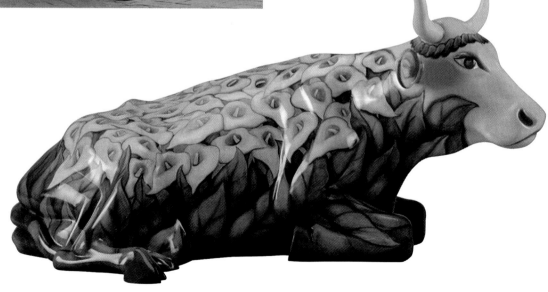

TEXAS TRIVIA
★

On his third cattle drive, cattleman Oliver Loving was fatally wounded in an Indian attack. His dying words to his cowboys were, "Don't bury me in foreign soil— take me back to Texas."

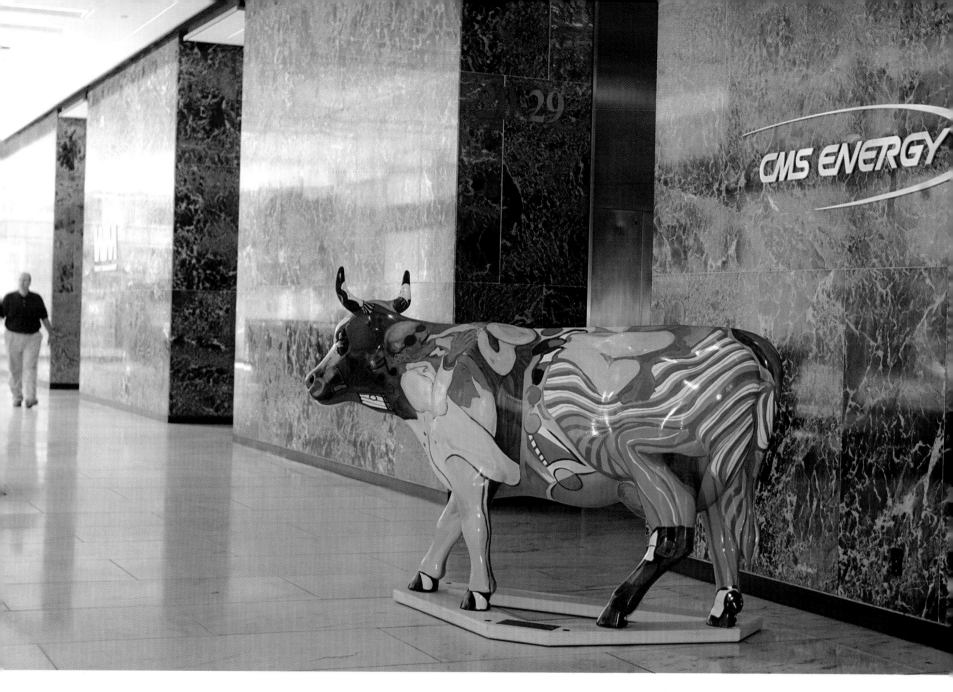

**Swingin' 'til the Cows
Come Home**
Artist: Bonnie Lambourn
Patron: CMS Energy Corporation
Location: One City Centre
(Main and Lamar)

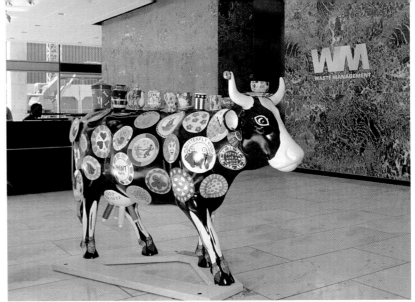

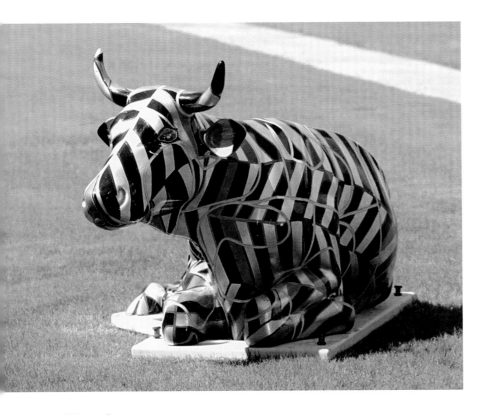

The Moo Potter
Artist: Meredith J. McCord
Patron: McCord Development, Inc.
Location: One City Centre (Main and Lamar—inside)

Glossie
Artist: H. J. Bott
Patron: Skadden, Arps, Slate, Meagher & Flom L.L.P.
Location: Whitney National Bank (Smith and Pease)

Moostown
Artist: Bricker Cannady Architects
Patron: The Board of Directors of the Greater Houston Convention and Visitors Bureau
Location: City Hall (Smith and Walker—GHCVB Gift Shop)

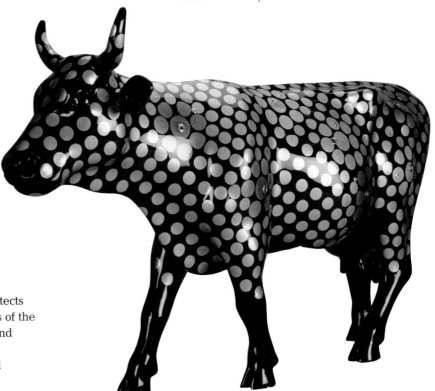

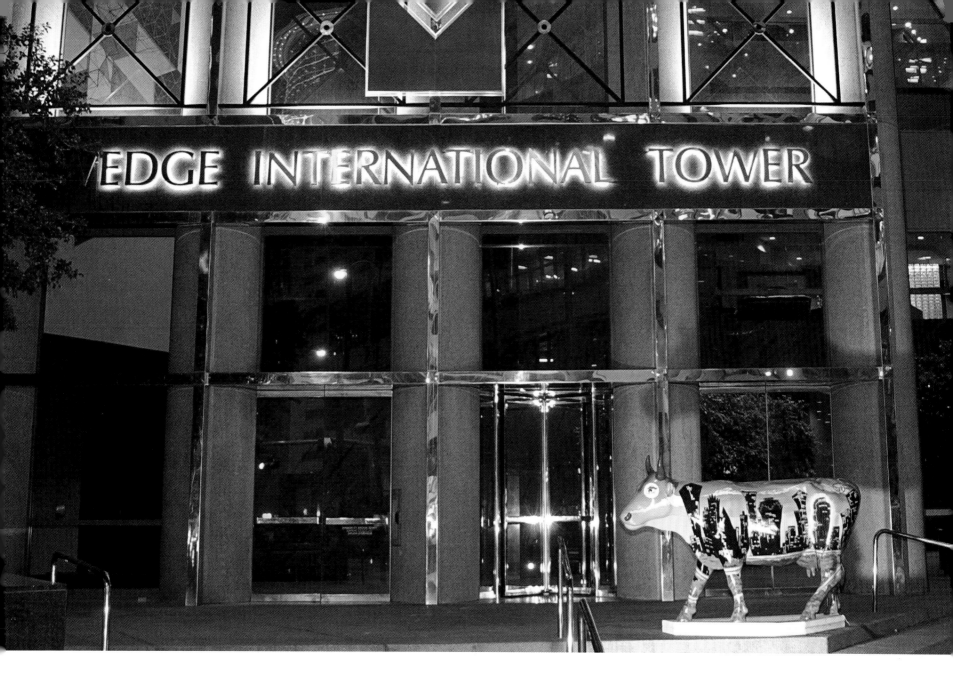

Cowers of Mooston in Memory of R. E. Blohm
Artist: Creative Alternatives
Patron: WEDGE Group Incorporated
Location: Wedge Building
(Bell and Louisiana)

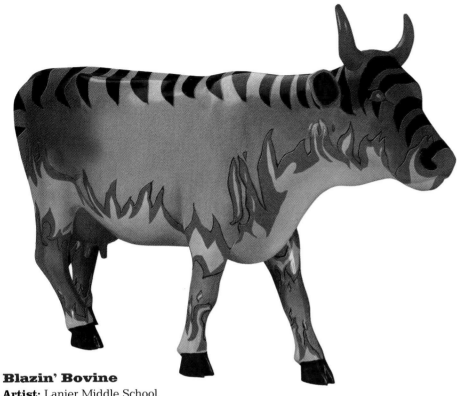

Blazin' Bovine
Artist: Lanier Middle School
Patron: Reliant Energy
Location: Market Square (Preston and Milam)

Moo-maid
Artist: Stratford Senior High School
Patron: Reliant Energy
Location: Reliant Plaza (Louisiana and Lamar—inside)

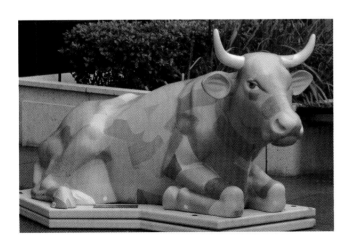

Medicow
Artist: DeBakey High School for Health Professionals
Patron: Reliant Energy
Location: Reliant Plaza (Louisiana and Lamar)

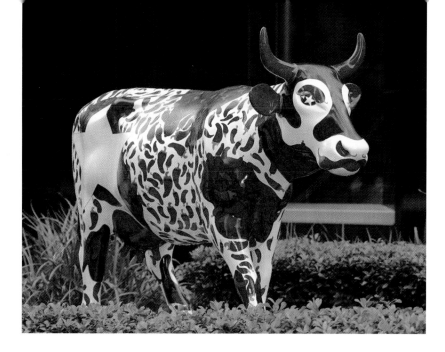

Hot Milk
Artist: Browning Elementary School
Patron: Reliant Energy
Location: Reliant Plaza (Louisiana and Lamar)

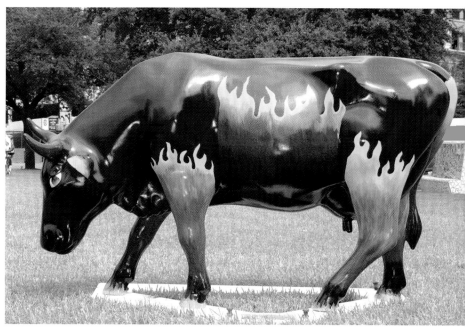

One Swell Cow
Artist: Joseph Galluccio
Patron: Insurance Alliance Foundation
Location: Sam Houston Park—Upper
(Bagby between McKinney and Lamar)

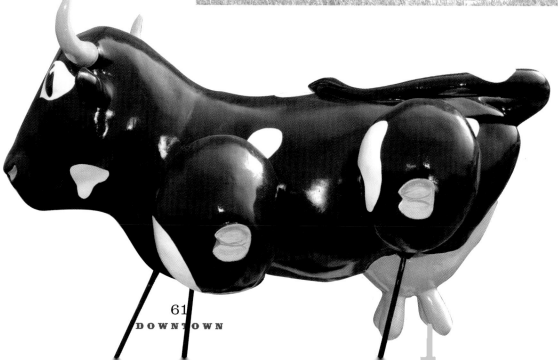

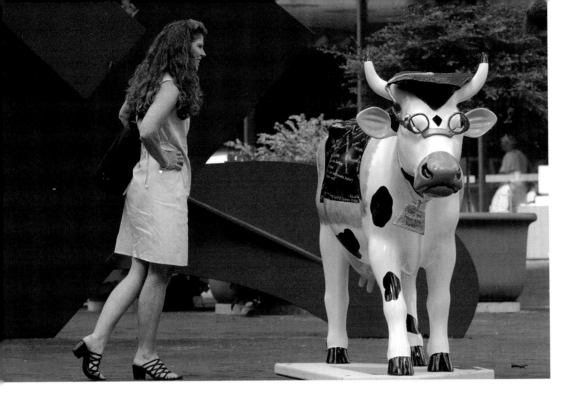

Cowllege Bound
Artist: Kipp Academy/Laura S. Gonzalez
Patrons: Diana Hudson and Dillon Ferguson
Location: Houston Downtown Library
Complex (McKinney and Bagby)

Dr. Moody Brown
Artist: Blackshear Elementary School
Patron: Reliant Energy
Location: Houston Downtown Library Complex
(McKinney and Bagby)

Drink Responsibly. Get the Moo-sage?
Artists: Charleston/Orwig, Inc. and XFactor Design
Patron: Faust Distributing Company, Inc.
Location: Sam Houston Park—Lower (Allen Parkway outbound at St. John Church)

City Cow
Artist: Christian J. Navarrete
Patron: City of Houston
Location: Wortham Center/Fish Plaza (Texas and Smith)

Cowgirl
Artist: Rives Carlberg for the *Houston Chronicle*
Patron: *Houston Chronicle*
Location: Houston Chronicle (Texas and Milam)

Cowboy
Artist: Rives Carlberg for the *Houston Chronicle*
Patron: *Houston Chronicle*
Location: Houston Chronicle (Texas and Milam)

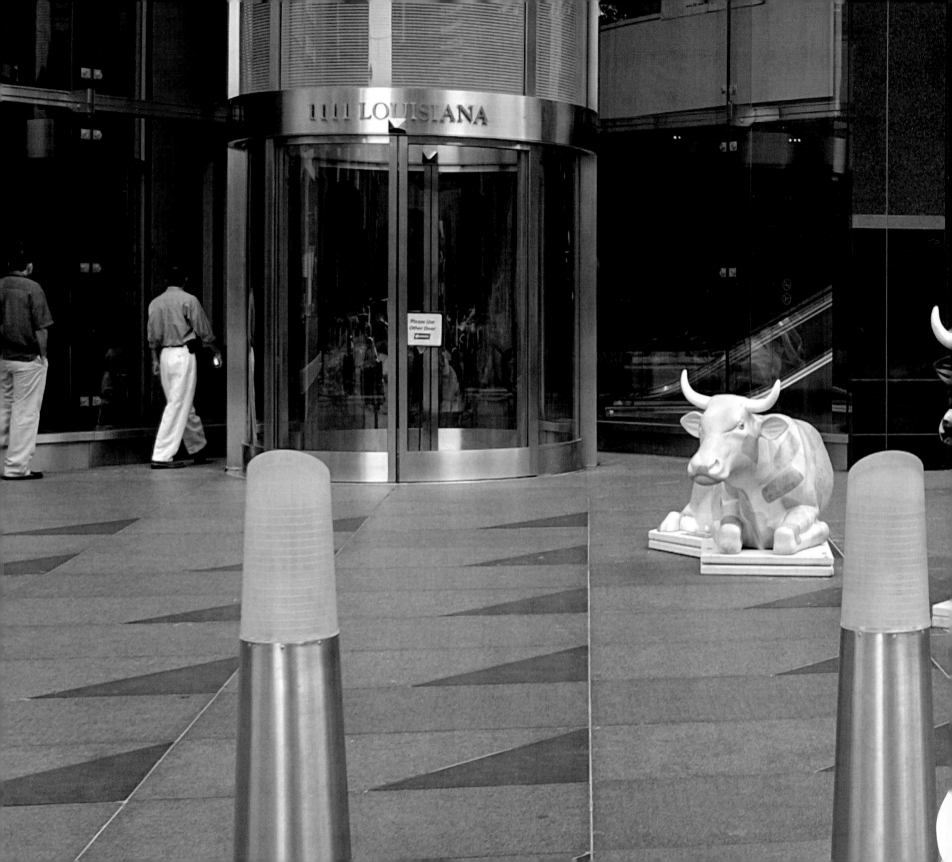

Allen Parkway/ Memorial Park

The winding thoroughfare formerly known as Buffalo Drive was renamed Allen Parkway in 1961 in tribute to Augustus and John Allen, the founders of Houston. The street, which borders Buffalo Bayou to the south and parallels Memorial Drive, provides a picturesque gateway to downtown Houston.

Spanning approximately 1,500 acres nearby is Memorial Park. Opened in 1925 and named in honor of those killed in World War I, the park is now best known for its stunning recreational amenities. Year-round attractions include the nationally recognized Memorial Park Golf Course as well as the Seymour-Lieberman Jogging Trail, a lighted three-mile crushed granite jogging course that annually draws nearly 3.5 million users. There are six miles of off-road biking trails, five softball/baseball fields, a rugby/soccer field, an enclosed croquet court, two sand volleyball courts, picnic facilities, a tennis center, and a swimming and fitness center. The Houston Arboretum & Nature Center is an urban nature sanctuary and learning center located in the park, and the George and Barbara Bush Presidential Grove features numerous species of native Texas trees.

Bayou Bend, the American decorative art center of the Museum of Fine Arts, Houston, can also be found in the area. Visitors can tour the home and magnificent gardens of the late philanthropist Ima Hogg, which is one of the city's premier attractions.

"Cow"mmunity in the Spirit of Texas
Artists: Hughes, Gerakis, McElroy
Patron: KHOU Channel 11 CBS
Location: Eleanor Tinsley Park (Allen Parkway and Buffalo Bayou)

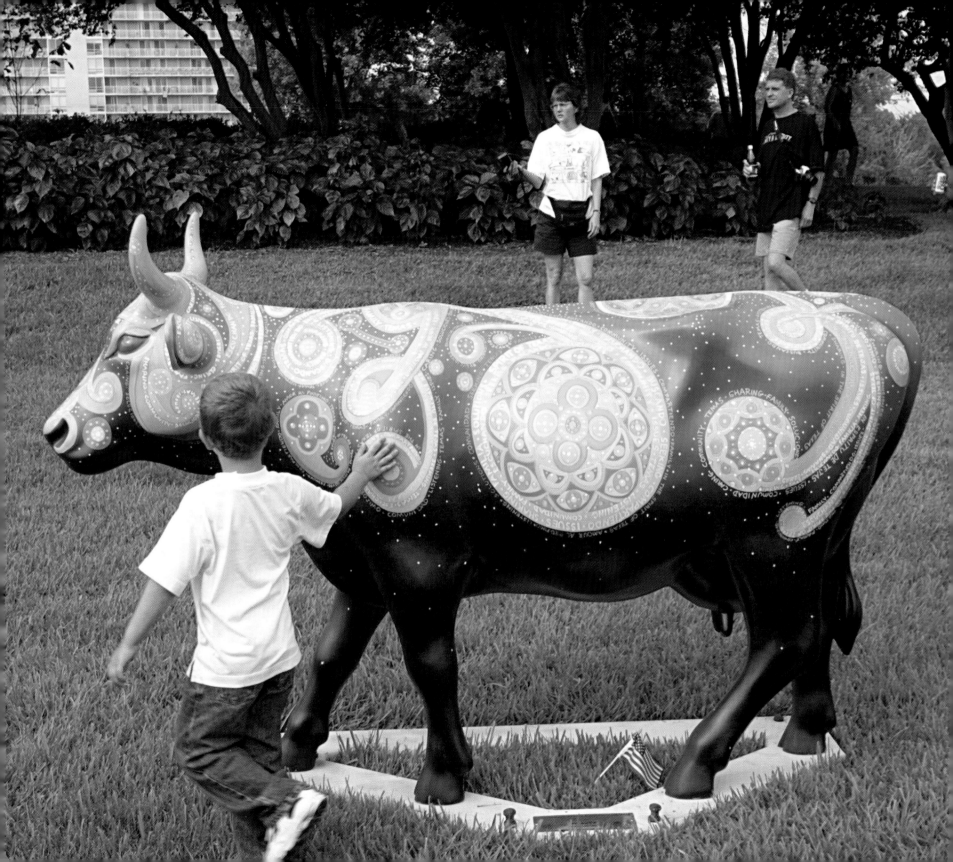

www.ecow.com
Artist: American General
Web Services Team
Patron: American General
Location: American
General Center (Allen
Parkway and Waugh
Drive)

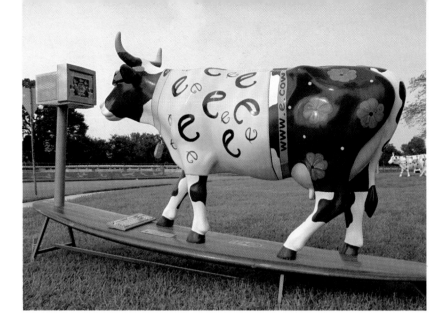

Ms. Pearsonality Cow
Artist: Sylvia Angeli
Patron: King Investment Advisors, Inc.
Location: Eleanor Tinsley Park (Allen
Parkway and Buffalo Bayou)

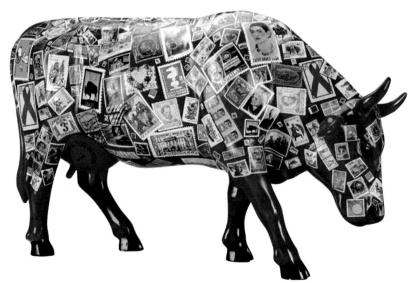

Stampede
Artist: Joyce Gold
Patrons: Glen and Blair Waltrip
Location: SCI (Allen Parkway and Taft)

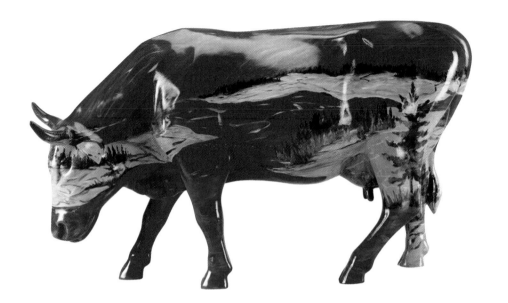

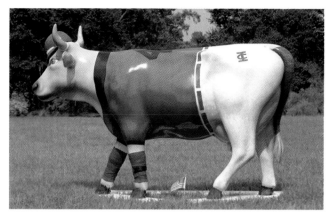

IC Polo Cow
Artist: BeverlyHillSmith.com
Patrons: John and Carroll Goodman
Location: Eleanor Tinsley Park (Allen Parkway and Buffalo Bayou)

Cowscape
Artist: D. Ainslie Ellington
Patron: Stewart Title/Shannon, Martin, Finkelstein & Sayre
Location: Eleanor Tinsley Park (Allen Parkway and Buffalo Bayou)

Holsteen Cowlajuwan
Artist: Steve Neihaus
Patron: Gracely Footprints Foundation
Location: Eleanor Tinsley Park (Allen Parkway and Buffalo Bayou—Henry Moore Sculpture)

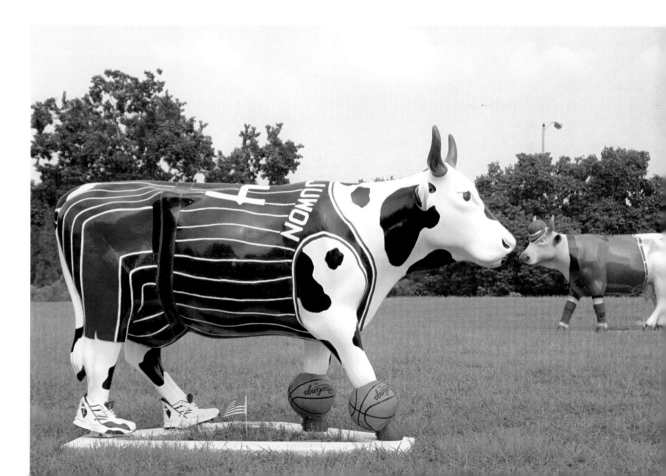

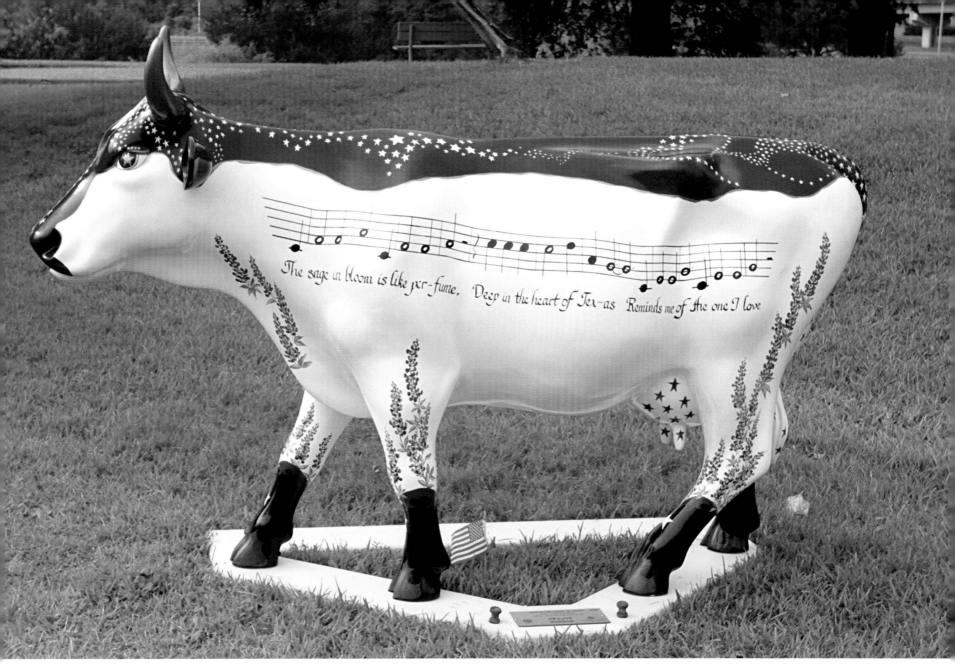

Deep in the Heart of Texas
Artist: Gayle F. Boggess
Patrons: John and Carroll Goodman
Location: Eleanor Tinsley Park (Allen Parkway and Buffalo Bayou)

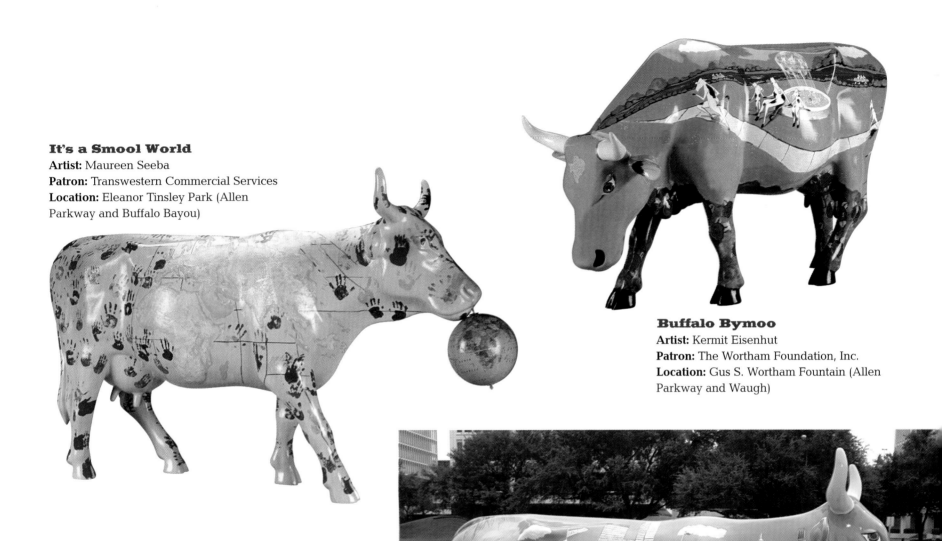

It's a Smool World
Artist: Maureen Seeba
Patron: Transwestern Commercial Services
Location: Eleanor Tinsley Park (Allen Parkway and Buffalo Bayou)

Buffalo Bymoo
Artist: Kermit Eisenhut
Patron: The Wortham Foundation, Inc.
Location: Gus S. Wortham Fountain (Allen Parkway and Waugh)

Insuracow
Artist: Kermit Eisenhut
Patron: John L. Wortham & Son, L.L.P.
Location: Gus S. Wortham Fountain (Allen Parkway and Waugh)

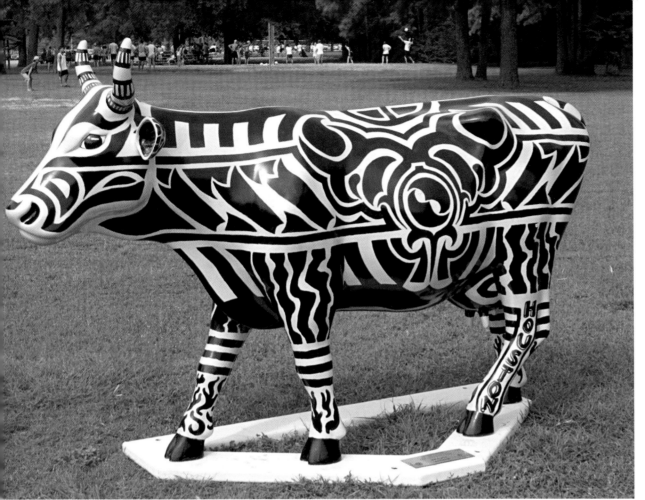

Tattooed Bovine
Artist: Georges Le Chevallier
Patron: CowParade Houston 2001
Location: Memorial Park (Memorial Drive—Southside Ballpark Entrance)

Georgia O'Beefe
Artist: Daniel L. Kallio
Patrons: John and Carroll Goodman
Location: Eleanor Tinsley Park (Allen Parkway and Buffalo Bayou)

TEXAS TRIVIA

In 1779, Francisco Garcia led Texas's first official cattle drive. With his vaqueros he herded 2,000 head of cattle east to Louisiana.

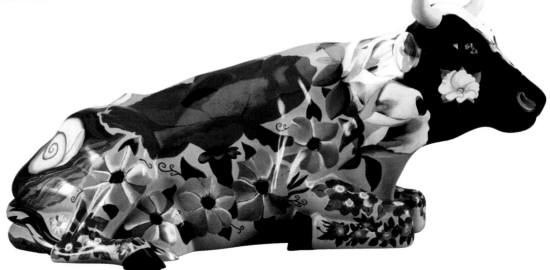

To the Moo and Beyond!
Artist: Erik M. Stolz
Patron: CowParade Houston 2001
Location: Eleanor Tinsley Park (Allen Parkway and Buffalo Bayou)

Miss Azalea
Artist: Molieve Null
Patrons: John and Carroll Goodman
Location: Eleanor Tinsley Park (Allen Parkway and Buffalo Bayou)

Moondrian
Artist: Woodrow Wilson Elementary School
Patron: American General
Location: American General Center (Allen Parkway and Waugh Drive)

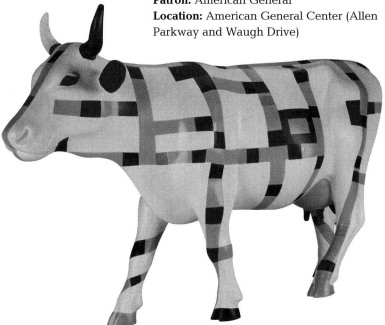

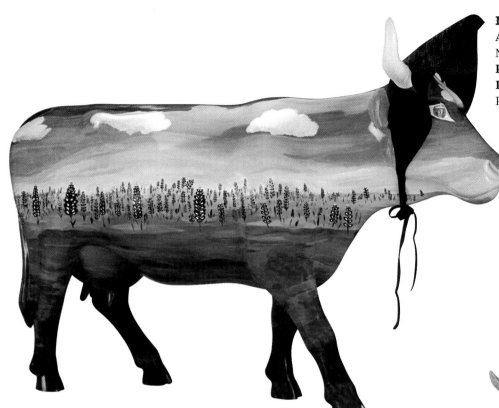

Moo-bonnets

Artists: Bridgett Vallery, Casey and Michael Farris
Patron: American General
Location: American General Center (Allen Parkway and Waugh Drive)

Moobonnet

Artist: MacGregor Elementary School
Patron: EOG Resources, Inc.
Location: Memorial Park (Memorial Drive—Southside Ballpark Entrance)

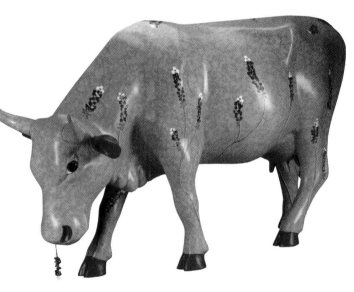

Texas Moo-bonnets

Artist: Camille R. Culbertson
Patrons: John and Carroll Goodman
Location: Eleanor Tinsley Park (Allen Parkway and Buffalo Bayou)

Cowdy Y'all

Artist: Pershing Middle School
Patron: EOG Resources, Inc.
Location: Memorial Park
(Memorial Drive—Southside
Ballpark Entrance)

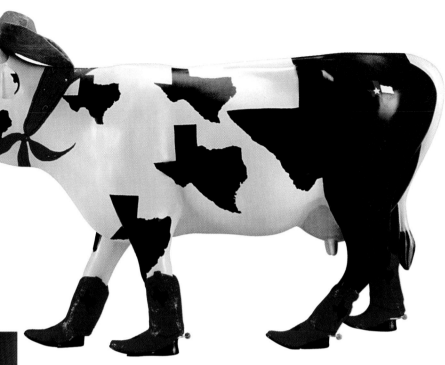

The Spirit of Texas

Artist: John H. Reagan High School
Patron: American General
Location: American General Center (Allen
Parkway and Waugh Drive)

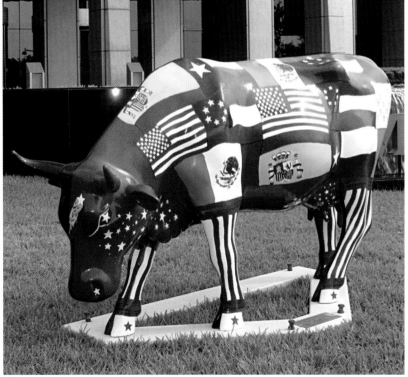

Biotech Bovine

Artists: Randy Yost and Michael Goodner
Patron: The Lowe Foundation
Location: Woodway and Loop 610
(Southwest Corner)

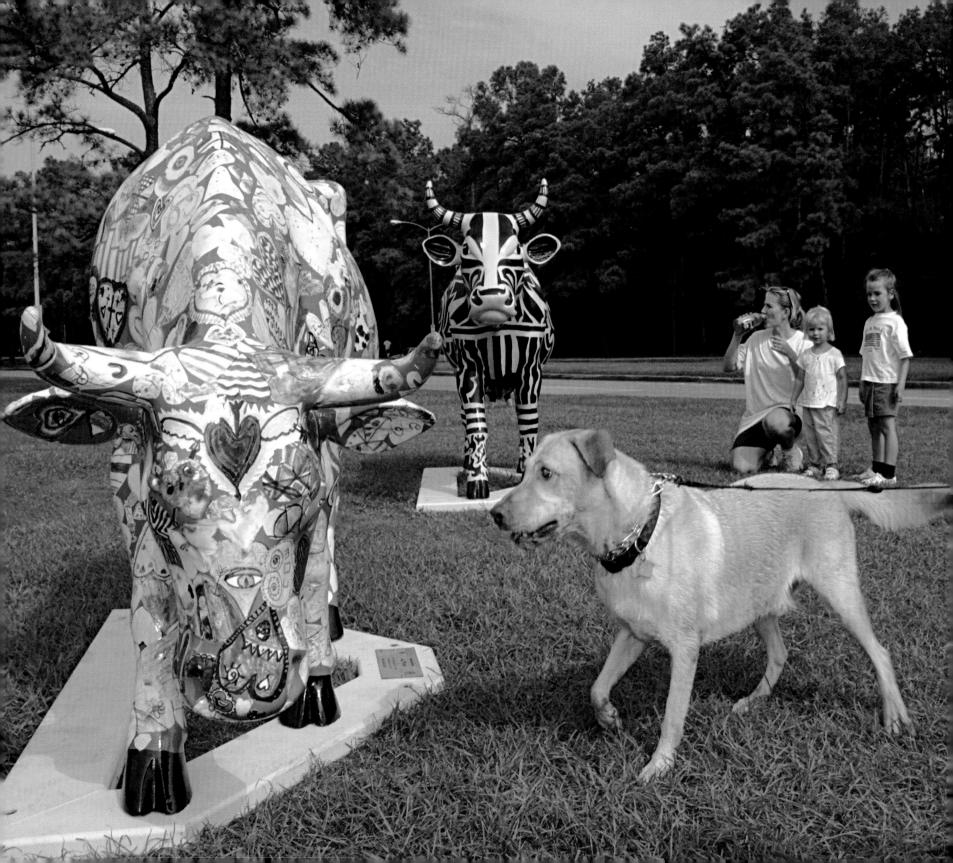

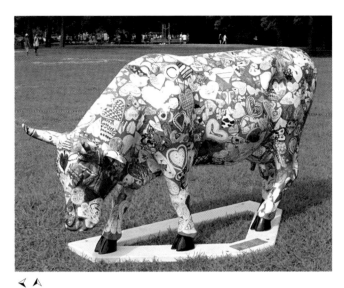

◄ ⋏

Cupid the Cow
Artist: Poe Elementary School
Patron: EOG Resources, Inc.
Location: Memorial Park (Memorial Drive—Southside Ballpark Entrance)

Amooity
Artist: Valic—Acceptance Test Team
Patron: American General
Location: American General Center (Allen Parkway and Waugh Drive)

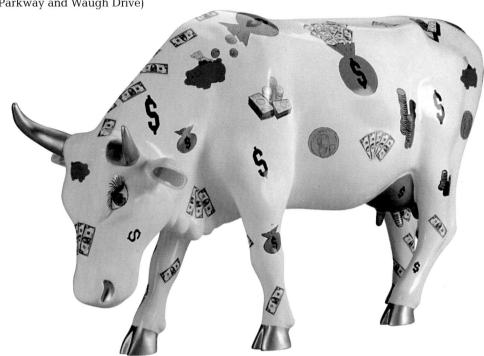

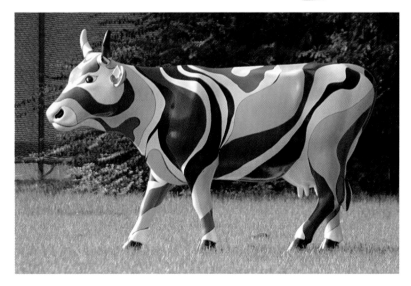

Vogue a la Moode
Artist: J. Seyler
Patron: Ray C. Fish Foundation
Location: Memorial Park (Memorial Drive—Croquet Fields by Tennis Center)

Uptown

Settled in the 1880s, the hub now known as Uptown Houston started as a small farming community. Even then, Post Oak, dubbed for the native post oak trees preferred for fence posts, was a main road. When the City of Houston banned horses in the 1920s, many residents built spacious "country" estates in nearby areas like Post Oak, which at that time was not a part of the city itself. Developer William Farrington's Tanglewood, the first of a series of suburban subdivisions, was opened in 1949 and Post Oak Road soon became a 120-foot-wide thoroughfare.

In 1970, developer Gerald Hines introduced the area's first retail center of more than one million square feet, the Galleria. Anchored by the high-fashion Neiman-Marcus store, the Galleria has spawned the growth of several other shopping areas in Uptown Houston.

Today, Post Oak Boulevard is the central artery for all types of offices, restaurants, retail establishments, hotels, and high-rise residences. Uptown's profile boasts designs by some of the country's most prestigious architectural talents: Philip Johnson & John Burgee; Hellmuth, Obata & Kassabaum; and Cesar Pelli. Among the notable landmarks are the 64-story Williams Tower, the tallest building in the United States outside of a traditional downtown; the Galleria complex, with its 300-plus stores, which attracts more than 17 million visitors from around the world a year; and the area's largest office complex, Four Oaks.

Miss Cowsmoopolitan the Divine Bovine
Artist: Michelle Brown
Patron: The Houstonian Hotel, Club and Spa
Location: The Houstonian (111 N. Post Oak Lane)

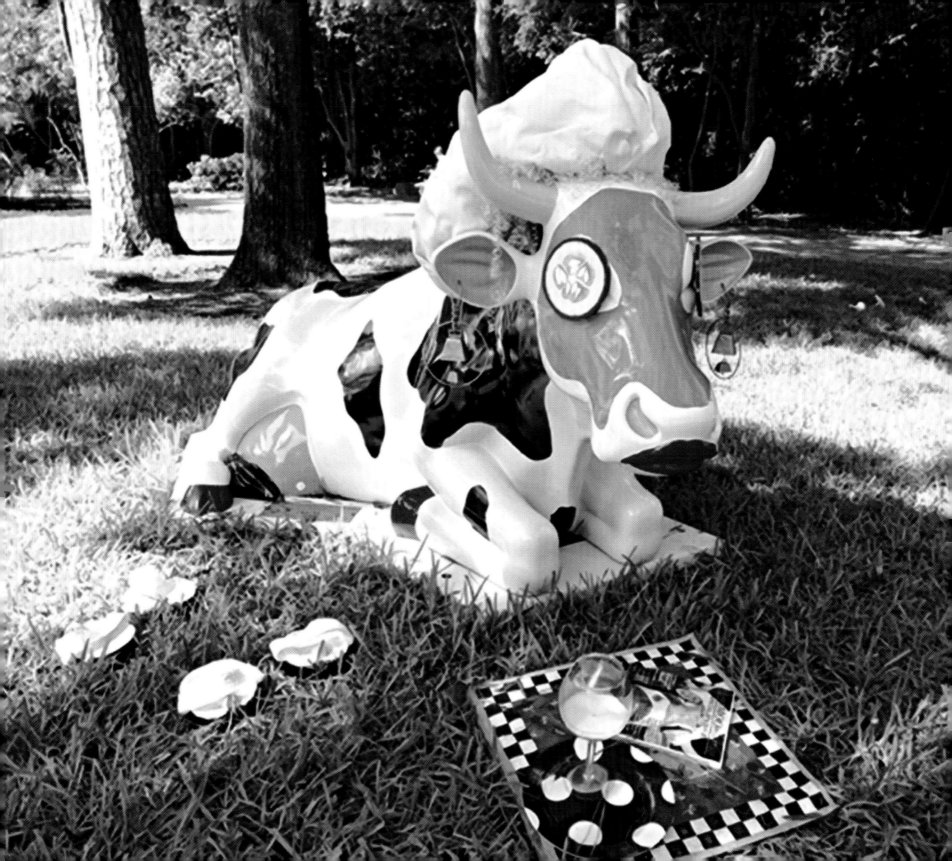

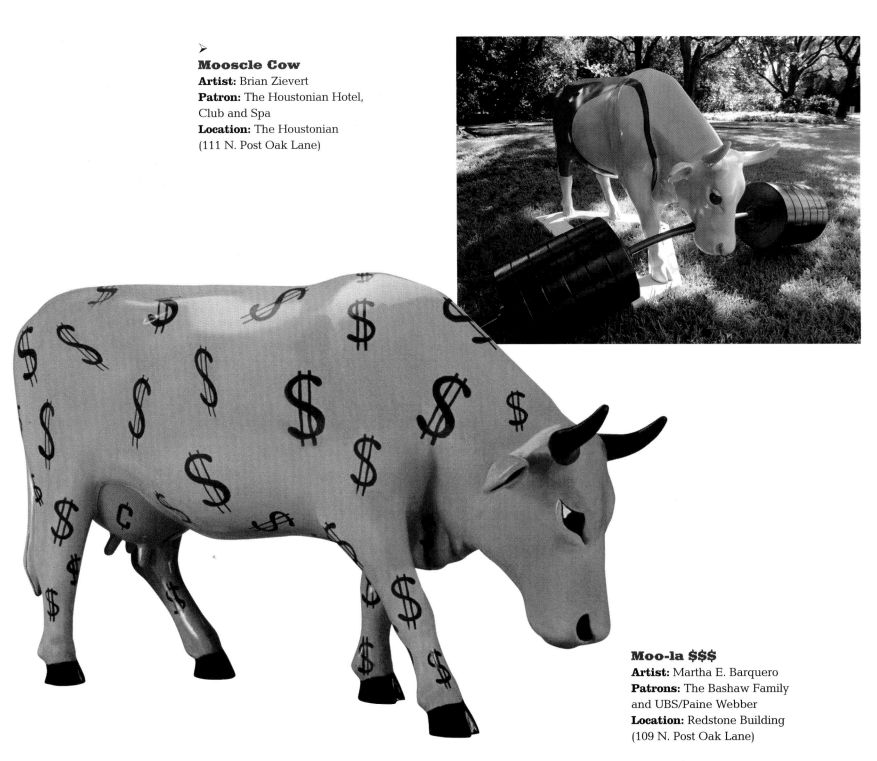

Mooscle Cow
Artist: Brian Zievert
Patron: The Houstonian Hotel,
Club and Spa
Location: The Houstonian
(111 N. Post Oak Lane)

Moo-la $$$
Artist: Martha E. Barquero
Patrons: The Bashaw Family
and UBS/Paine Webber
Location: Redstone Building
(109 N. Post Oak Lane)

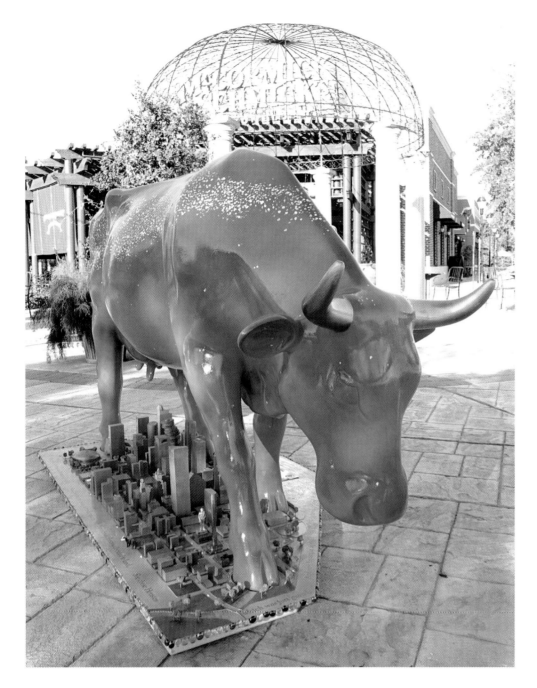

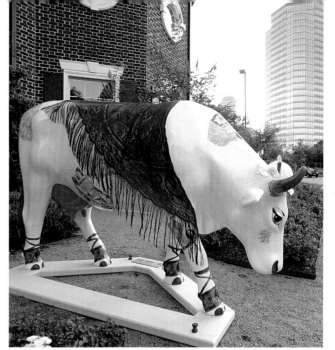

"Houston, You Have a Problem"
Artist: Helen R. Peter
Patron: J. A. Elkins, Jr. Family
Location: Uptown Park
(Post Oak and West Loop South)

The Cow Product
Artist: Scott C. Dadich
Patron: *Texas Monthly*
Location: Uptown Park
(Post Oak and West Loop South)

▲
Captain Hoof
Artist: Elkins High School
Patron: Reliant Energy
Location: Uptown Park
(Post Oak and West Loop South)

The Few, The Proud, The Moorines
Artist: R. P. Harris Elementary School
Patron: EOG Resources, Inc.
Location: The Galleria (Westheimer and Post Oak)

Miss Moola Attha Bank
Artist: Carlotta Barker
Patron: Southern National Bank of Texas
Location: Southern National Bank of Texas (1101 Post Oak Boulevard)

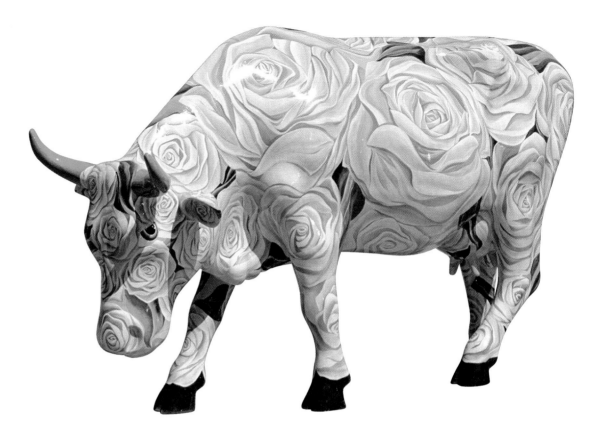

Yellow Rose
Artist: Candida Bayer
Patrons: Meg Goodman and Mike Bonini
Location: Williams Tower (Post Oak and Hidalgo)

Cowmeleon
Artist: Westside Lexus Body Shop
Patron: Westside Lexus–Northside Lexus
Location: Uptown Park (Post Oak and West Loop South)

Cowrova Fabmooge
Artist: Averil Gleason
Patron: Alexia Camil
Location: The Galleria (Westheimer and Post Oak)

Four Seasons
Artist: Candida Bayer
Patron: Bob and Vivian Smith Foundation
Location: Uptown Park (Post Oak and West Loop South)

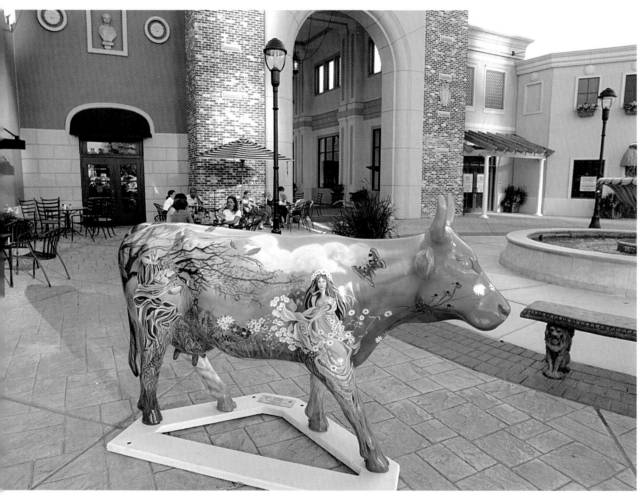

Mooscowrade
Artist: Ms. Karen B. Balzer
Patrons: Meg Goodman and Mike Bonini
Location: Williams Tower
(Post Oak and Hidalgo)

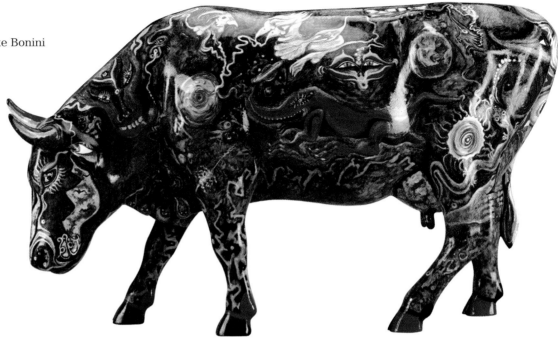

Moo-net
Artist: Nancy McMillan/Kinkaid School
Patron: John and Mildred Holmes
Family Foundation
Location: Williams Tower
(Post Oak and Hidalgo)

Picowsso's Eyes
Artist: John Bruce Berry
Patron: CowParade Houston 2001
Location: The Post Oak Shopping Center
(Post Oak between Westheimer and San
Felipe)

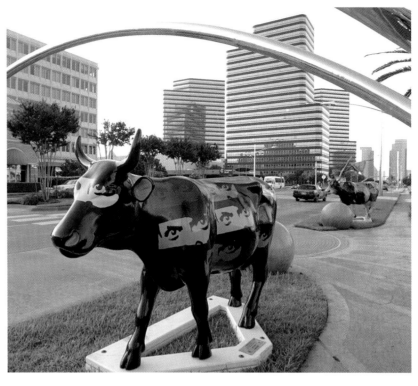

Fabulosus Moo Palma
Artist: Gayle Reynolds
Patrons: Meg Goodman and Mike Bonini
Location: Williams Tower
(Post Oak and Hidalgo)

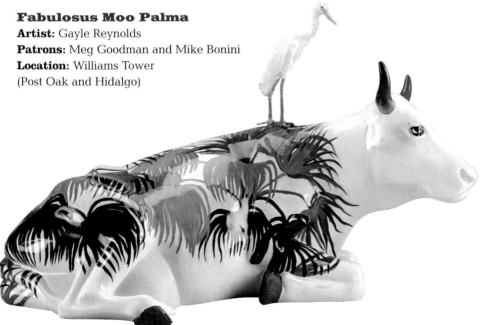

➤
Salvador Cowli
Artist: Merry Calderoni
Patrons: Jessica Younger,
Lynda Underwood, and Ann Trammell
Location: The Post Oak Shopping
Center (Post Oak between Westheimer
and San Felipe)

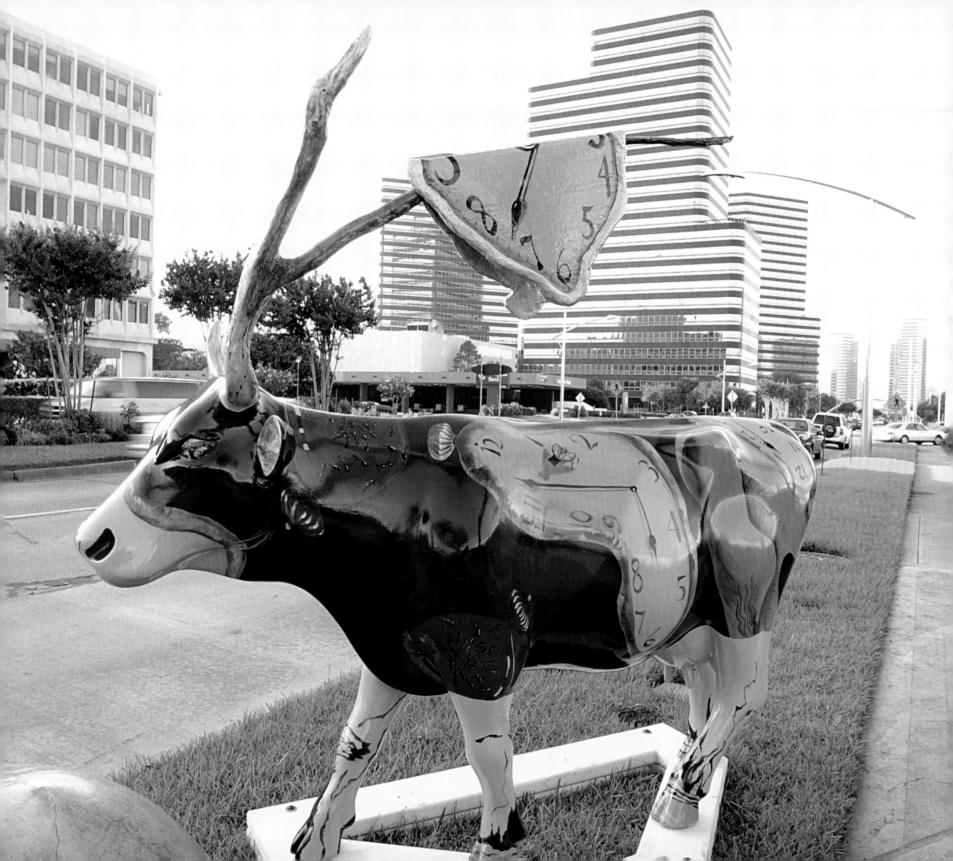

The Cowlleria

Artists: Jana Stiffel, Carolyn Holmes,
Maureen Suhendra, and Jeannie McKetta
Patrons: The Galleria/
Urban Retail Properties
Location: The Galleria
(Westheimer and Post Oak)

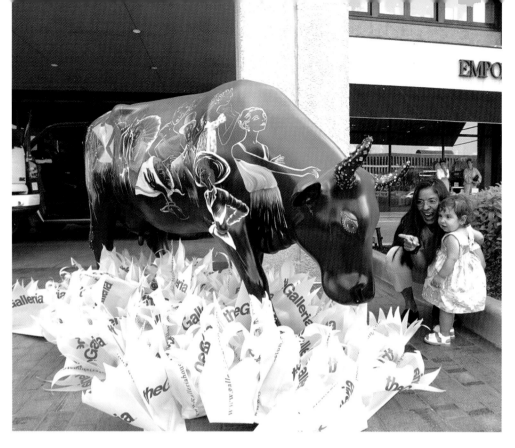

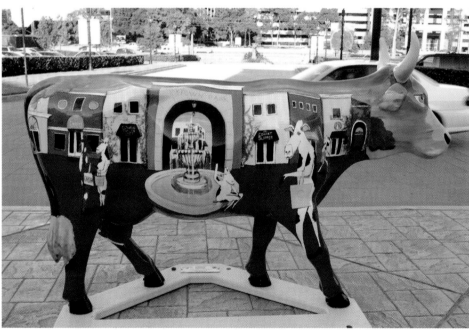

Uptown Cow

Artist: Kermit Eisenhut
Patron: The Interfin Companies
Location: Uptown Park (Post Oak and
West Loop South)

UTopian Steer
Artists: Debbie Maddox Harsch &
Paula P. Winter
Patron: UT Friends of Bevo
Location: Uptown Park (Post Oak and
West Loop South)

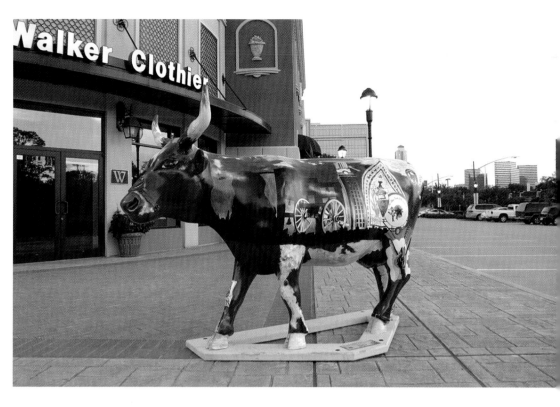

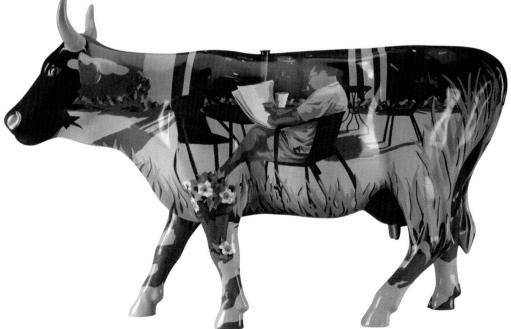

It's a Cowpuccino Morning
Artist: Suzanne E. Sellers
Patron: Starbucks Coffee Company
Location: The Post Oak Shopping Center
(Westheimer and Post Oak—Starbucks)

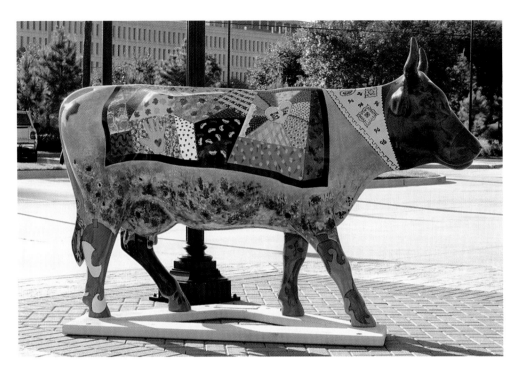

Hill Country Cow
Artist: Eva Felder
Patron: The Reckling Family
Location: Uptown Park
(Post Oak and West Loop South)

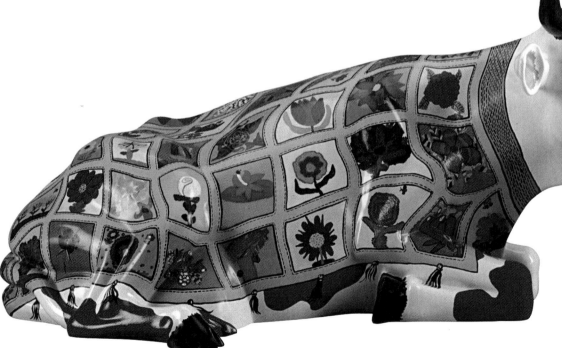

Cozy Cow
Artist: Creative Alternatives
Patron: EOG Resources, Inc.
Location: Uptown Park
(Post Oak and West Loop South)

Not a Creature Was Stirring
Artist: Prudence Becker Allwein
Patron: Bob and Vivian Smith Foundation
Location: Uptown Park (Post Oak and West Loop South)

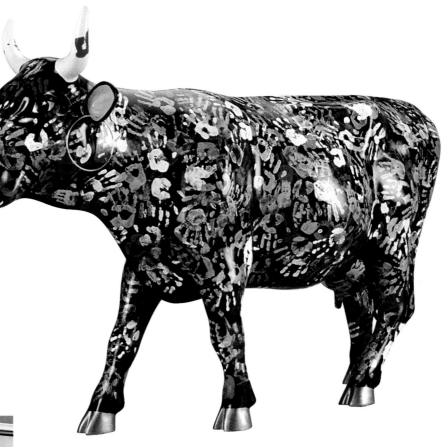

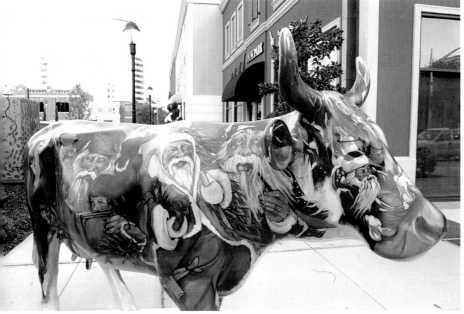

Let's Hand It to the Cows!
Artist: Patricia Marie Glaeser
Patron: The Holthouse Foundation for Kids
Location: 1800 West Loop South (San Felipe and West Loop South—inside)

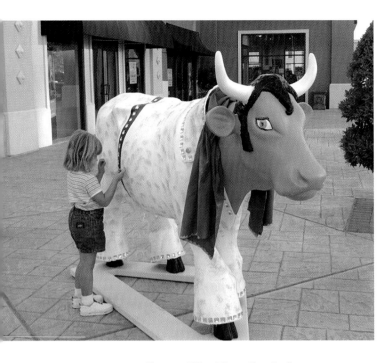

Love Me Tenderloin
Artist: Leanna Applegate
Patron: Applegate Salon on the Bayou
Location: Uptown Park (Post Oak and West Loop South)

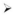
Ginger Rhinestone
Artist: Linda Dolack
Patron: Stuart Weitzman, Inc.
Location: The Galleria (Westheimer and Post Oak)

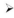
Frida Stare
Artist: Linda Dolack
Patron: Stuart Weitzman, Inc.
Location: The Galleria (Westheimer and Post Oak)

**Houston, My How
You've Grown**
Artist: Donna Lewis
Patrons: Judy O. and Kenneth Margolis
Location: Williams Tower
(Post Oak and Hidalgo)

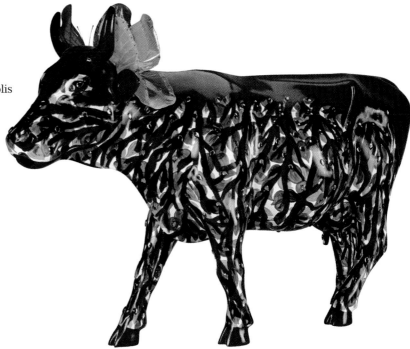

Moo De Gras
Artist: Bellaire High School with
Rebecca Bass, teacher
Patron: KRIV Channel 26 Fox
Location: The Galleria
(Westheimer and Post Oak)

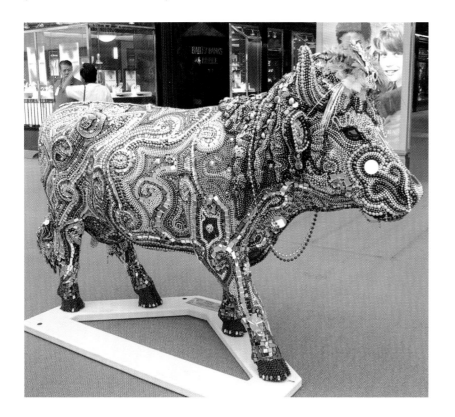

Ms. Piñata
Artist: Gayle Lauderdale
Patron: Williams
Location: Williams Tower
(Post Oak and Hidalgo)

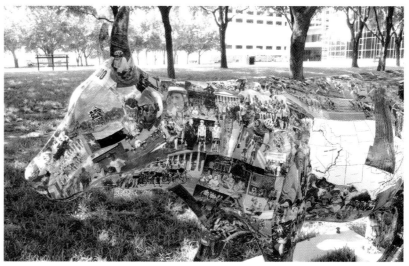

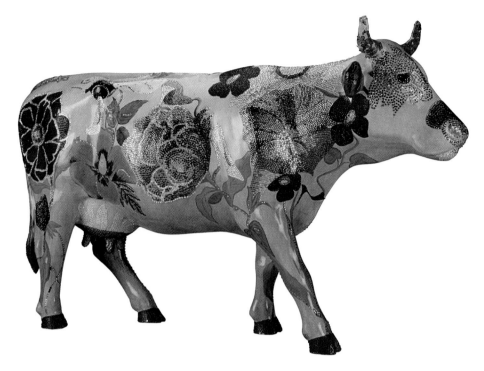

Rhinestone Cowgirl
Artist: Linda Dolack
Patron: Stuart Weitzman, Inc.
Location: The Galleria
(Westheimer and Post Oak)

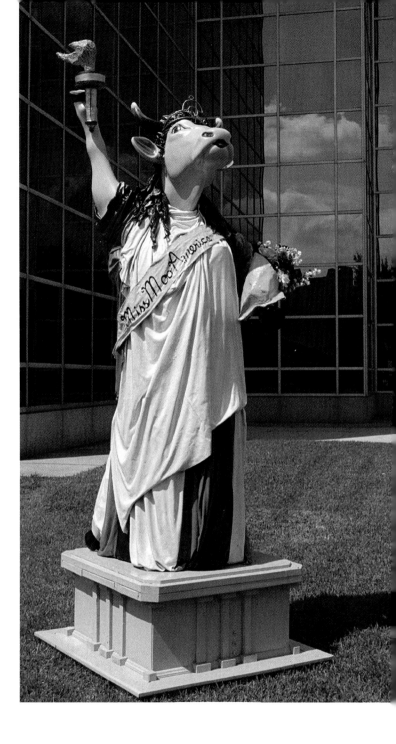

Miss Moo America
Artist: Chad Thome
Patrons: Dede and Clarence
Mayer/Sylvia, Ron, Zoe, and Zach Baker/
Laura and Jarrod Cyprow
Location: Williams Tower
(Post Oak and Hidalgo)

MOO-ty Fruity
Artist: Patricia Marie Glaeser
Patron: Jamba Juice
Location: The Post Oak Shopping Center
(Westheimer and Post Oak—Jamba Juice)

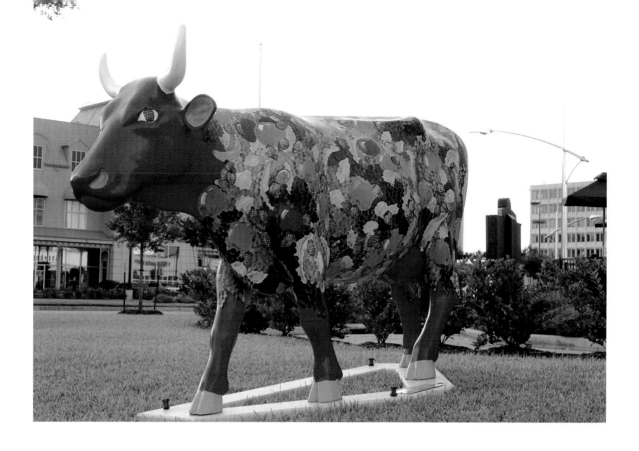

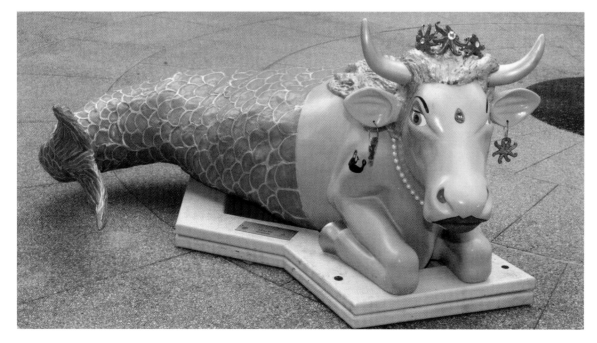

TEXAS TRIVIA

★

In 2001, 2,327 foreign visitors
from 44 countries attended the
Houston Livestock Show and Rodeo
and went home with a great impres-
sion of the United States'
fourth largest city.

Mooisha the Moomaid
Artist: Shelley Buscher
Patron: Municipal Pipe
Location: Williams Tower
(Post Oak and Hidalgo)

Bullfighting Bossie
Artists: Susie Austin and May Bentley
Patron: Houston Livestock
Show and Rodeo
Location: The Galleria
(Westheimer and Post Oak)

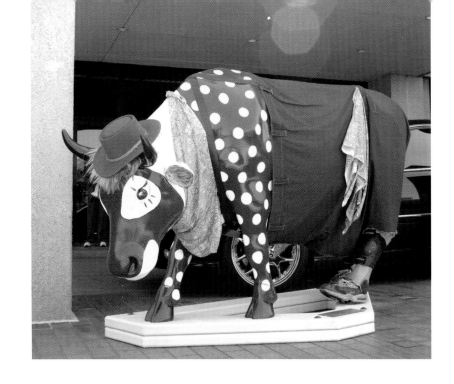

Texas Hot Mama
Artist: Ann "Sole Sister" Johnson
Patron: American Express
Location: The Galleria
(Westheimer and Post Oak)

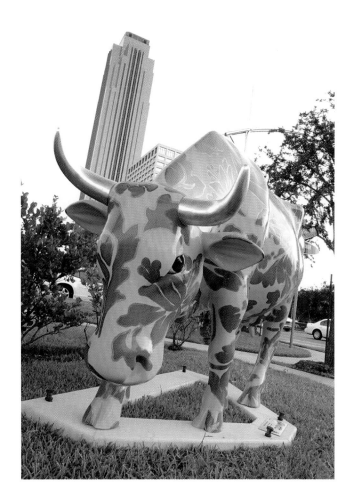

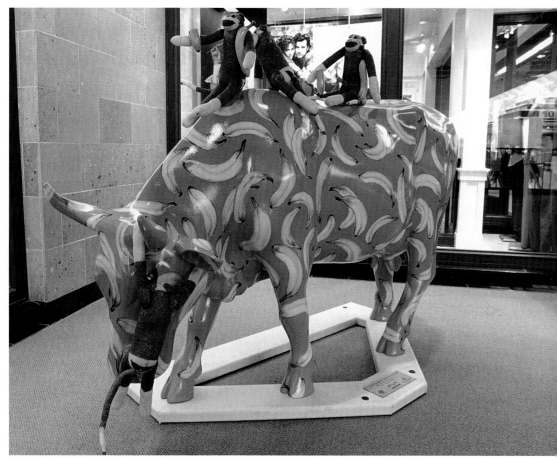

Greener Pastures
Artist: David Lozano
Patron: Dillard's
Location: Westheimer and
Post Oak (Dillard's)

**Five Little Monkeys
Jumping on a Cow**
Artist: Gloria Becker Rasmussen
Patron: Banana Republic
Location: The Galleria
(Westheimer and Post Oak)

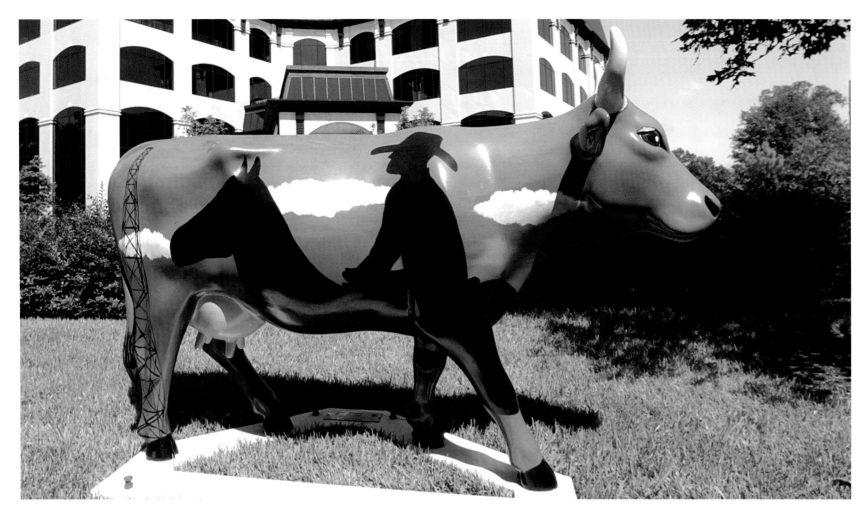

Lonesome Cowboy
Artist: Kermit Eisenhut
Patrons: Dede and Clarence Mayer/
Sylvia, Ron, Zoe, and Zach Baker/
Laura and Jarrod Cyprow
Location: Redstone Building (109 N. Post
Oak Lane)

Shew Fly
Artist: Paul Kittelson
Patron: CowParade Houston 2001
Location: The Galleria (Westheimer and
Post Oak)

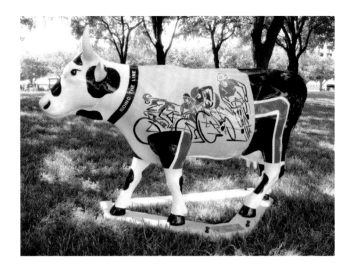

Sweet Charity
Artist: Gayle Lauderdale
Patron: Williams
Location: Williams Tower
(Post Oak and Hidalgo)

Kinara the Kwanzaa Cow
Artist: Project Row Houses
Patron: The Mithoff Family Foundation
Location: The Galleria
(Westheimer and Post Oak)

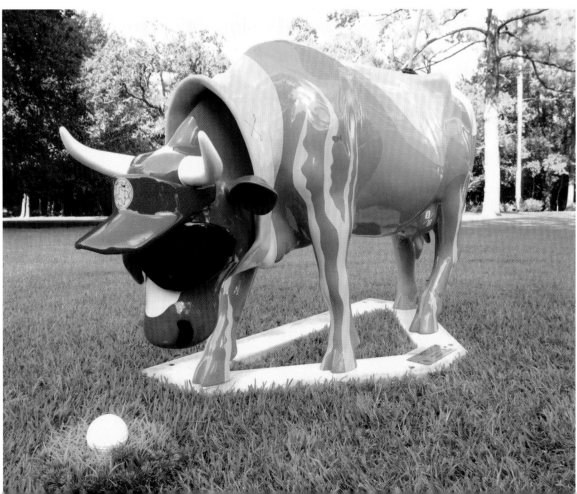

Forecowddie
Artist: Donna Lane Vadala
Patron: The Houstonian Hotel,
Club and Spa
Location: The Houstonian
(111 N. Post Oak Lane)

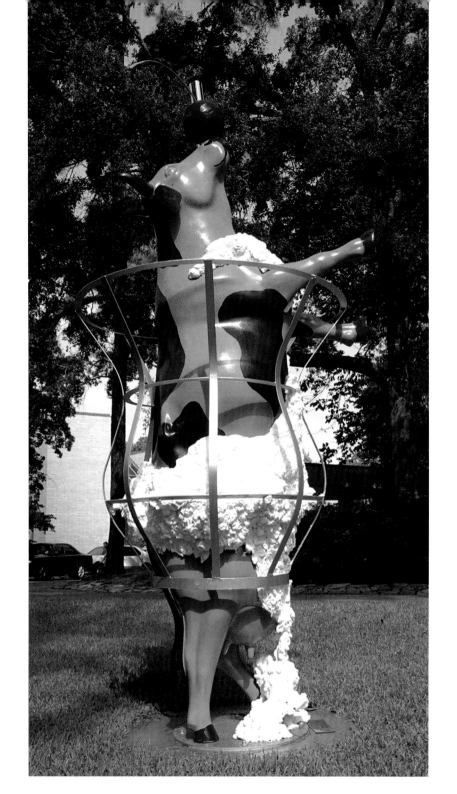

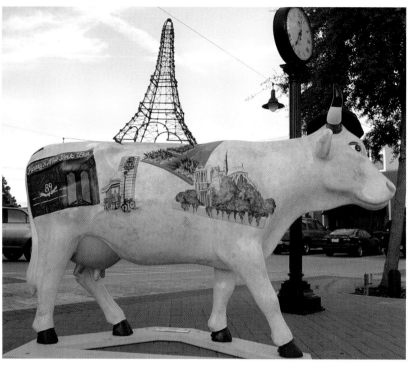

Eiffel Cower
Artist: Sondra Mullenax
Patron: The Reckling Family Francophiles
Location: Uptown Park (Post Oak and West Loop South)

Chocolate Moo-se
Artists: Michelle O'Michael and Salli Babbitt
Patron: The Houstonian Hotel, Club and Spa
Location: The Houstonian (111 N. Post Oak Lane)

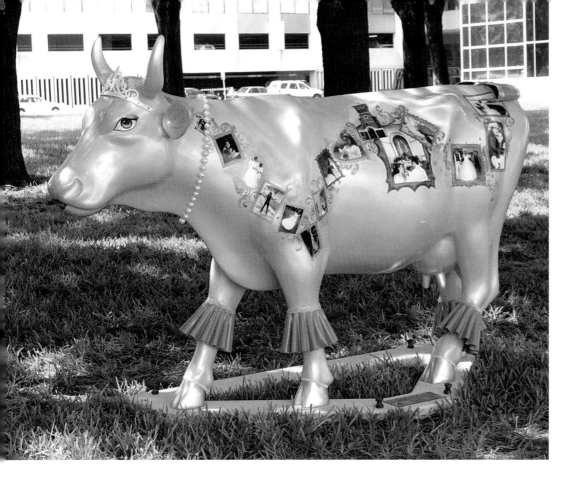

The Cowntessa Checks In
Artist: Ramona Rojas
Patron: The Houstonian Hotel,
Club and Spa
Location: The Houstonian
(111 N. Post Oak Lane)

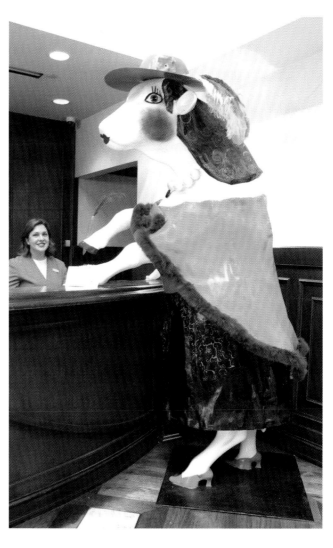

◄ ∧

Quinceñiera Cow
Artist: HCP/El Centro de Corazón
Patron: Houston Center for Photography
Anonymous Friend
Location: Williams Tower (Post Oak and
Hidalgo)

101

Vaca Piñata
Artist: Cookie Ashton
Patron: The Center at Post
Oak/Weingarten Realty
Location: Westheimer and Post Oak

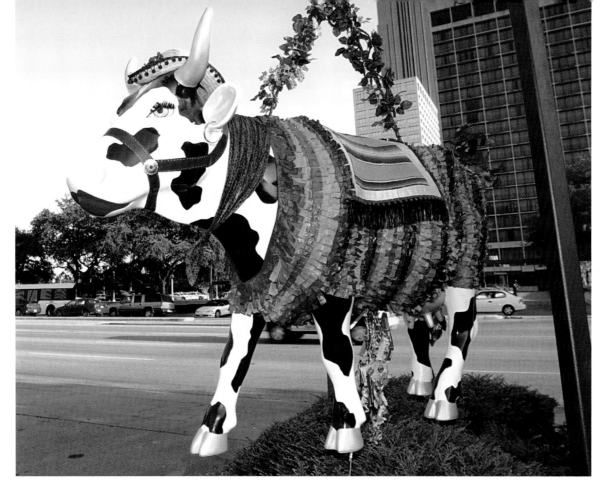

Spider Cow
Artist: Stuff Creators
Patrons: Meg Goodman and Mike Bonini
Location: Williams Tower (Post Oak and
Hidalgo—inside)

BR Yellow Rose
Artist: Kermit Eisenhut
Patron: Burlington Resources
Location: The Galleria
(Westheimer and Post Oak)

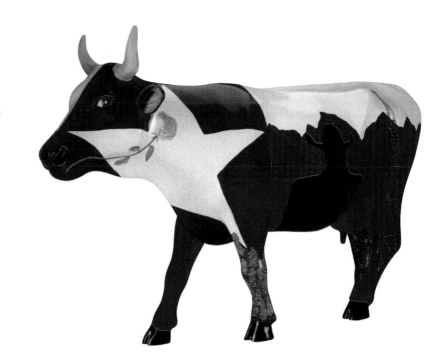

American Cowthic
Artists: Christopher Lewis and
Nadja Pollard
Patron: Bob and Vivian Smith Foundation
Location: The Galleria
(Westheimer and Post Oak)

Custom Cowch
Artists: Judy Elias and Susan Elias
Patrons: Mr. and Mrs. John W. Elias
Location: The Galleria (Westheimer and Post Oak)

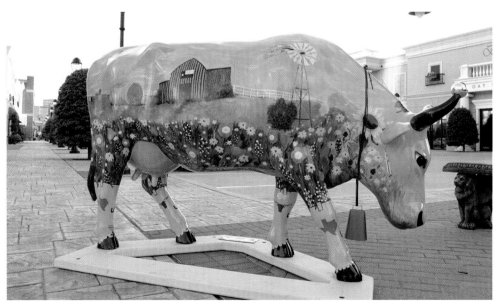

Little Jean Moorie
Artist: Kathryn A. Friedman
Patron: Friends of Jean Burke
Location: Uptown Park (Post Oak and West Loop South)

Dutchess
Artist: Sandi Seltzer Bryant
Patrons: Hughes and Betsy Abell
Location: Uptown Park
(Post Oak and West Loop South)

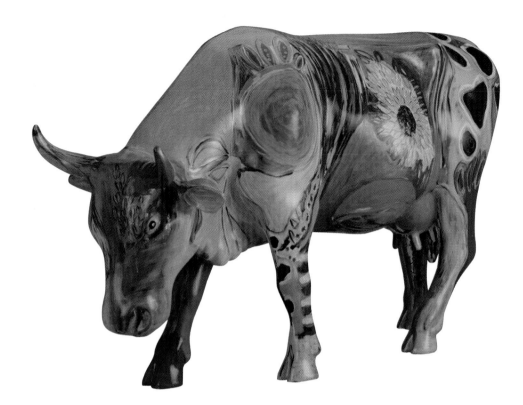

Moocedes
Artist: Sondra Mullenax
Patron: Mercedes-Benz of
Houston Greenway
Location: The Galleria
(Westheimer and Post Oak)

Greenway Plaza

Distinguished by its parklike setting, Greenway Plaza is located midway between Downtown Houston and Uptown Houston. Owned since 1996 by Fort Worth–based Crescent Real Estate Equities, the 50-acre complex is Houston's premier planned business development.

Greenway Plaza has come a long way since its rural beginnings. In the 1880s, the area was an expanse of farmland. Later in the 19th century, those farms saw the San Antonio and Aransas Pass Railroad built up around them. Following World War II, the area became suburban, as neighborhoods spread out from Downtown. In the late 1960s, developer Kenneth Schnitzer envisioned a commercial center on the site.

Today, more than half the total acreage of Greenway Plaza is devoted to landscaping, pools, fountains, and plazas. Ten office towers, totaling 4.3 million square feet linked by bridges and tunnels, dominate the plaza. Other points of interest include the 30-story Greenway Condominiums, two of the tallest residential structures in the Southwest; the 17,000-seat Compaq Center, home of the Houston Rockets and the Houston Comets; and the 389-room Renaissance Hotel.

I'm Houston Cowed
Artist: Ross Shegog, Ph.D.
Patron: Greenway Plaza/Crescent Real Estate Equities
Location: Greenway Plaza (Richmond between Timmons and Edloe)

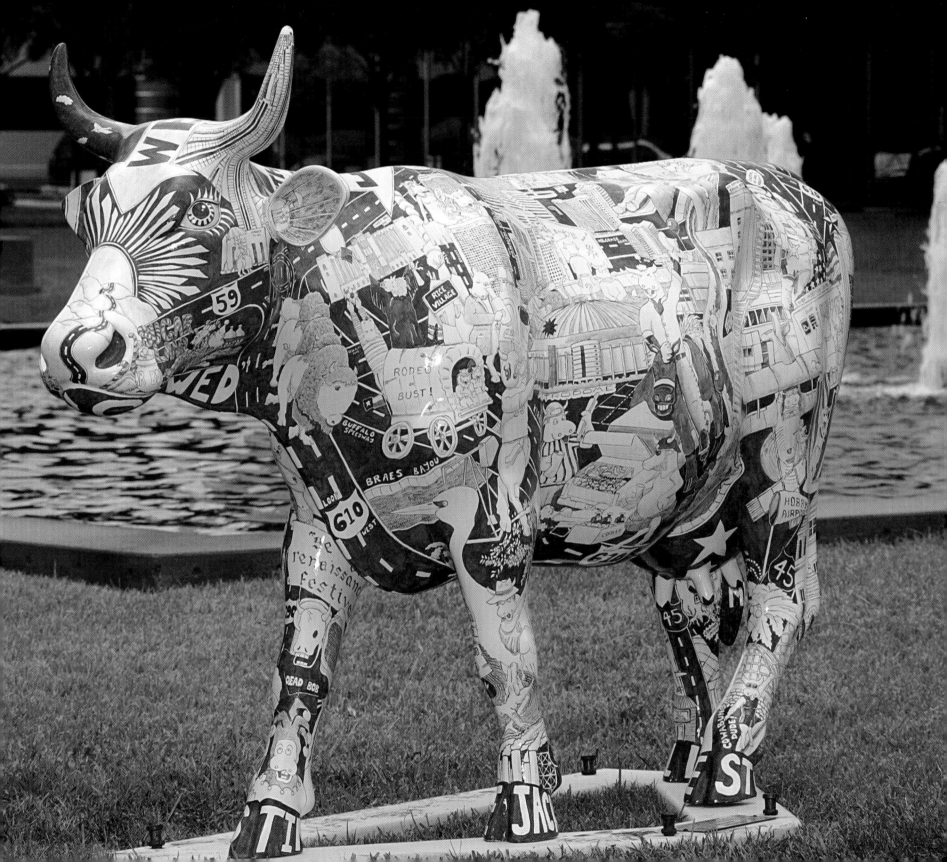

Destiny Moo
Artist: Windy Yows
Patron: AIM Funds
Location: Greenway Plaza
(Richmond between Timmons and Edloe)

Moosaic
Artist: Averil Gleason
Patrons: Dede and Clarence
Mayer/Sylvia, Ron, Zoe,
and Zach Baker/Laura and Jarrod Cyprow
Location: Greenway Plaza (Richmond and
Buffalo Speedway—Solvay America)

Mootual Cacti Cow
Artist: Gayle F. Boggess
Patron: AIM Funds
Location: Greenway Plaza
(Richmond between Timmons and Edloe)

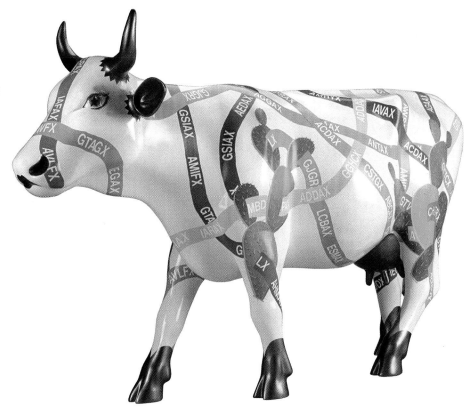

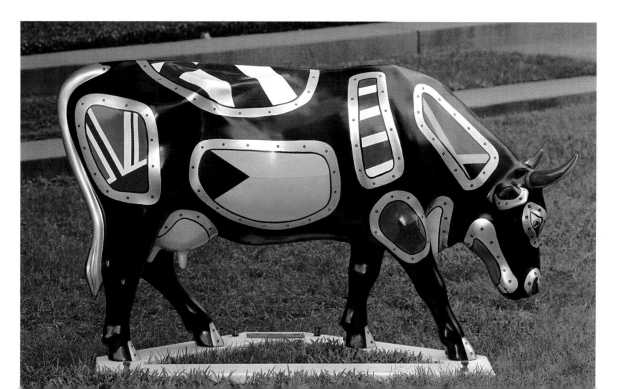

**Portholes on Whole
Different Cowntries**
Artist: Marieke H. De Waard
Patron: AIM Funds
Location: Greenway Plaza (Richmond
between Timmons and Edloe)

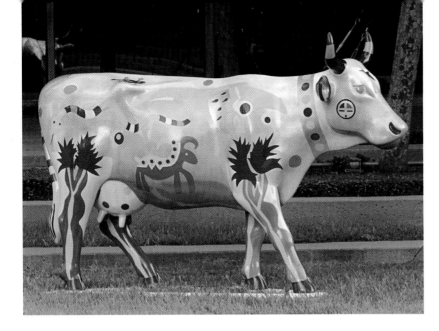

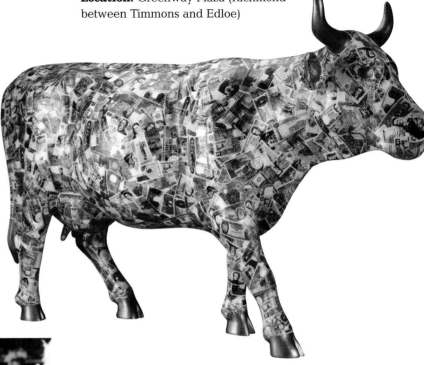

Cash Cow
Artist: Vicki Leigh Cook Stelmak
Patron: AIM Funds
Location: Greenway Plaza (Richmond between Timmons and Edloe)

Southwest Cow
Artist: David Moad
Patron: El Paso Corporation
Location: Greenway Plaza (Richmond between Timmons and Edloe)

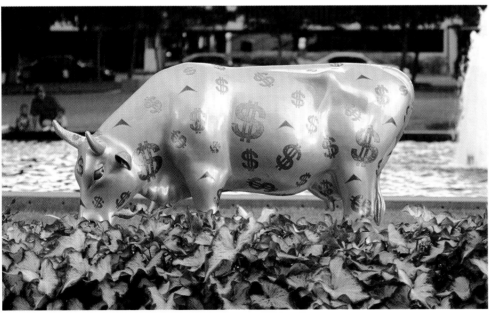

Mad Money Cow
Artist: Judith Ann Smith
Patron: AIM Funds
Location: Greenway Plaza (Richmond between Timmons and Edloe)

Cow Chip
Artist: John Robb
Patron: FKP Architects, Inc.
Location: Greenway Plaza (Richmond between Timmons and Edloe)

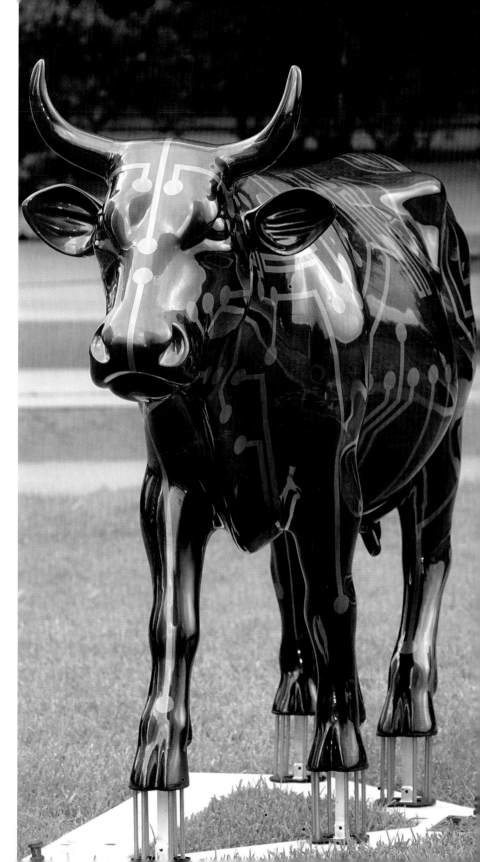

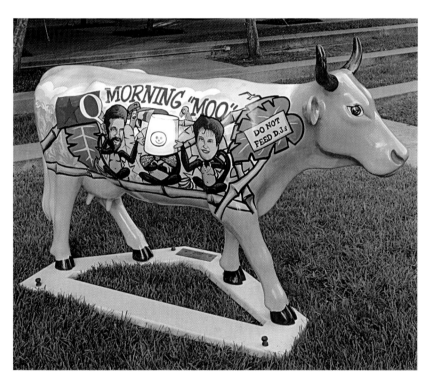

Q-Morning Moo
Artist: Nextwave Art/David C. James
Patron: The New 93Q
Location: Greenway Plaza (Richmond between Timmons and Edloe)

Museum District

Nestled in the shadow of the Texas Medical Center is Houston's multifaceted Museum District. More than a dozen destinations dedicated to art and science beckon visitors from around the world. Modern medicine takes center stage at the Museum of Health & Medical Science, while history is the focus at the Houston Fire Museum and Holocaust Museum Houston, the sixth largest institution of its kind in the United States. Worthy of a whole day's trip in itself, the Houston Museum of Natural Science features the Burke Baker Planetarium, the Wortham IMAX Theatre, and the Cockrell Butterfly Center.

Inspiration abounds at the ecumenical Rothko Chapel as well as at the Byzantine Fresco Chapel Museum, which houses two extraordinary 13th-century frescoes from a chapel in Cyprus.

Art lovers relish the Contemporary Arts Museum; the Museum of Fine Arts, Houston; and the Menil Collection. The Lawndale Art and Performance Center presents contemporary visual treats as well as performances, lectures, and readings.

Even the youngest visitors find their niche at The Children's Museum of Houston, where hands-on participation is encouraged.

Hermann Park contains the Houston Zoological Gardens, which is home to more than 3,000 animals; the Pioneer Memorial Log House Museum; and the Miller Outdoor Theater, a showcase for top-notch entertainment.

Camp for Allasaurus
Artist: Donna Lane Vadala
Patrons: Rhonda and Paul Gerson
Location: Hermann Park (Montrose and Fannin—Sam Houston Statue)

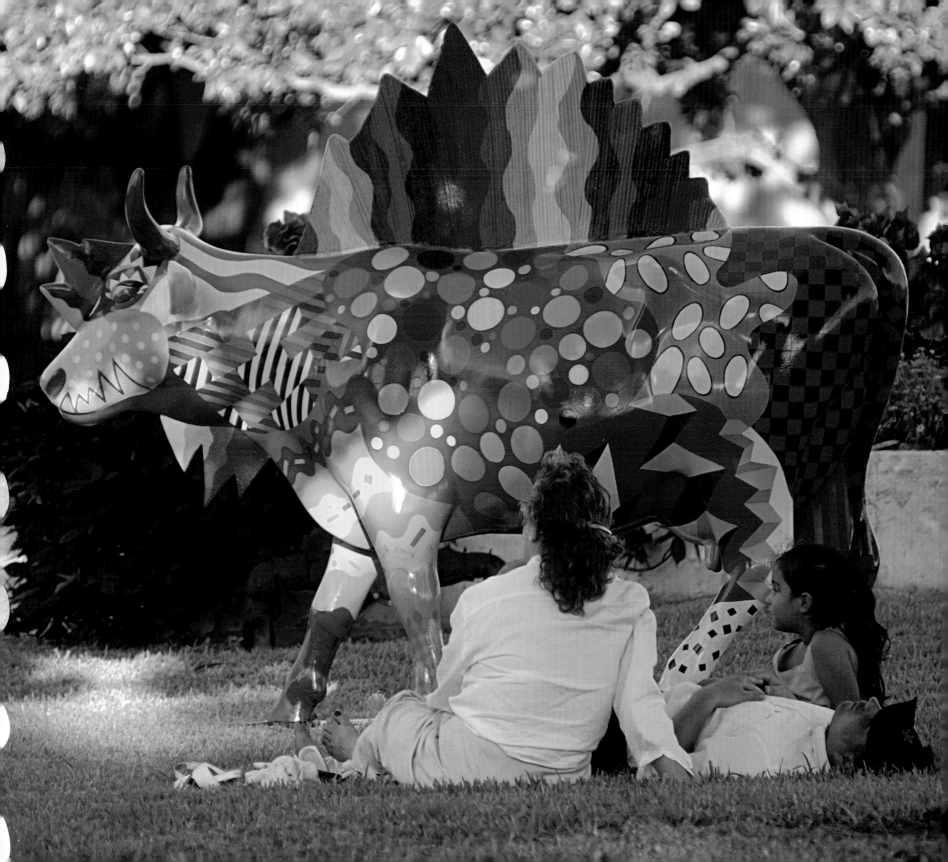

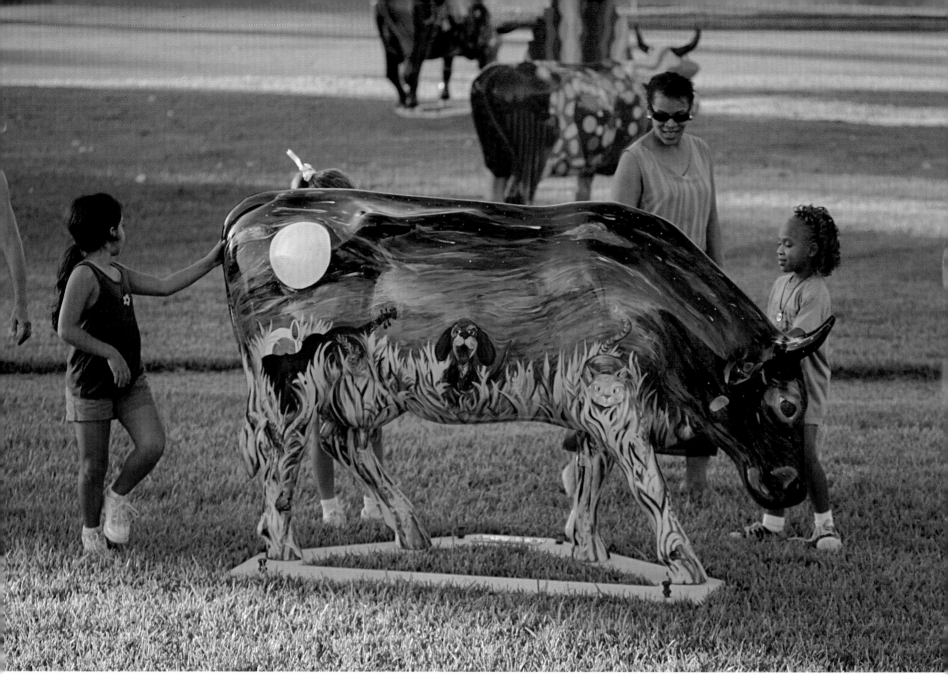

The Cow Jumped Over the Moon
Artist: Elisa Alvarado
Patron: Anadarko Petroleum
Location: Hermann Park (Montrose and Fannin—Sam Houston Statue)

Cowvis
Artist: Anne Lamkin Kinder
Patrons: Sally and Forrest Hoglund
Location: Museum of Natural Science
(Hermann and Fannin—inside)

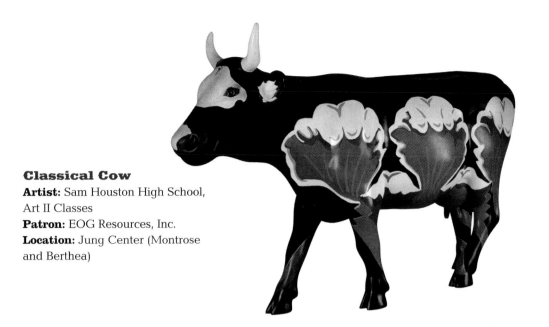

Classical Cow
Artist: Sam Houston High School,
Art II Classes
Patron: EOG Resources, Inc.
Location: Jung Center (Montrose
and Berthea)

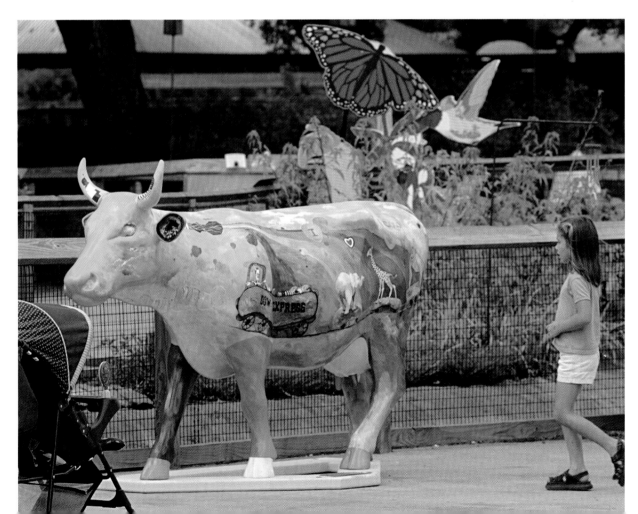

Cow Express
Artist: Shu-Inn Jenny Cheng
Patrons: Hughes and Betsy Abell
Location: Houston Zoo (Children's Zoo)

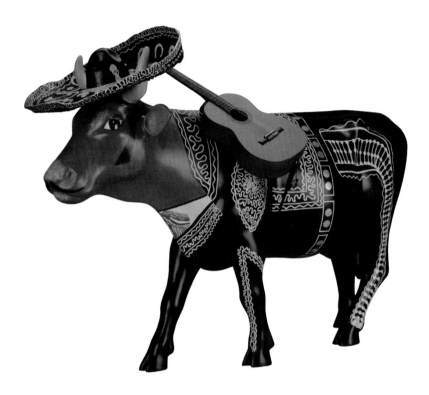

Mooriachi
Artist: Familia Masterson
Patrons: Karen and Gus Comiskey
Location: Museum of Natural Science
(Hermann and Fannin)

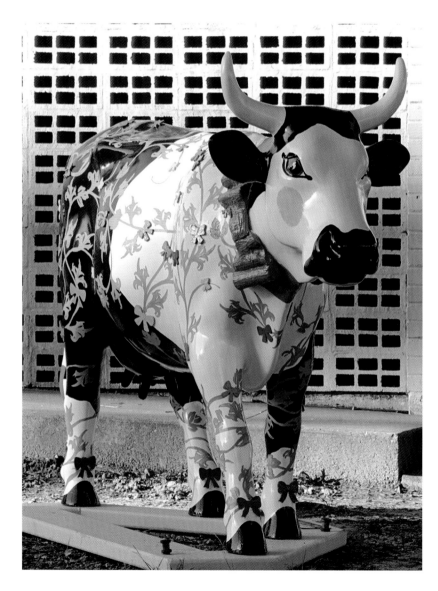

BoVine
Artist: Dottie Erwin
Patrons: Carolyn Light, Jackie McCauley,
Linda Walker, and Linda Denison
Location: Bo's Place (Austin and Calumet)

Cosmic Cow
Artists: Richard Flowers and Associates
Patron: Richard Flowers
Location: Museum of Health & Medical Science (Hermann and LaBranch)

Infinity Cow
Artist: Will Hughes
Patron: CowParade Houston 2001
Location: Holocaust Museum (Caroline and Calumet)

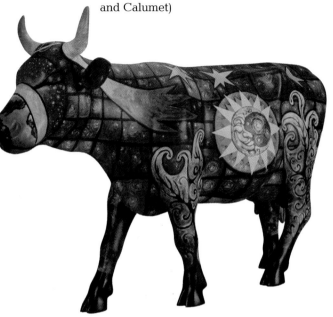

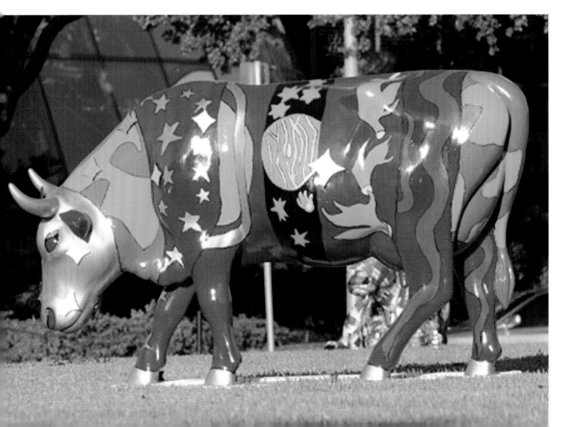

Astro Cow
Artist: Eastwood Academy Charter High School
Patron: EOG Resources, Inc.
Location: Hermann Park (Montrose and Fannin—Sam Houston Statue)

Mirrabell the LuMOOnary Cow

Artists: Cheryl Tamborello and Karen Nimon
Patrons: Sara and Bill Morgan
Location: Houston Center for Contemporary Craft (Main and Rosedale)

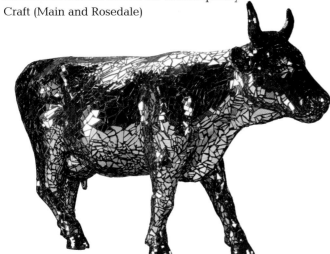

Space Moo

Artist: Sharpstown Magnet School for Graphic Arts and Architecture
Patron: EOG Resources, Inc.
Location: Lawndale Art Center (Main and Rosedale)

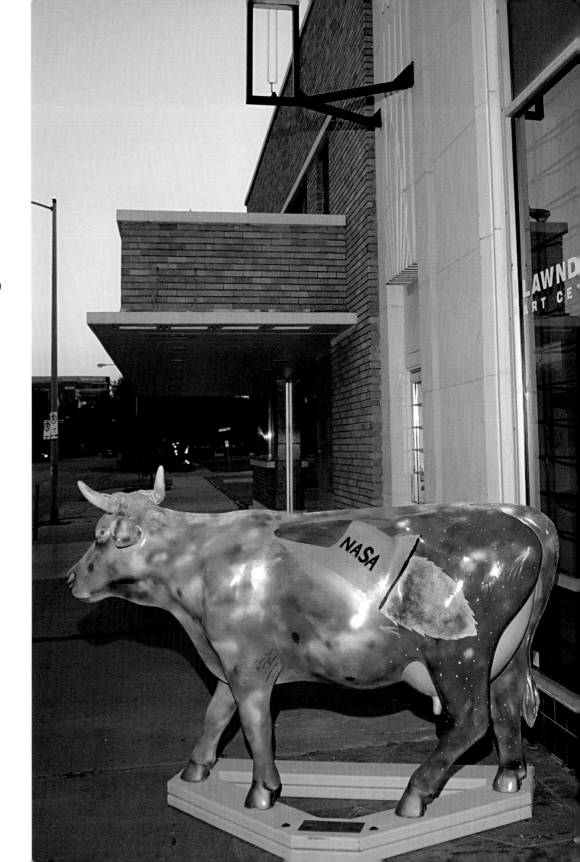

BRUCE MONICAL
Cowpernicus

Noted interior designer and artist Bruce Monical confirms that he is a cheerleader for the Bayou City. "I'm real proud of Houston; it's dynamic—a city of the future," he said. "CowParade Houston 2001 has been a trip. The people have been wonderful to work with, and I can't think of anything better than the cause."

Radiating a celestial aura, Cowpernicus made its debut at City Hall for the launch of the event. "This cow has a lot to do with the moo-vers in our city who were smart enough to put NASA here," Bruce said. "I grew up on Houston's East End and have always been fascinated by our space program."

The cow's deep blue background provides the backdrop for all the known planets in the Milky Way, plus the moon and sun. Bruce's favorite city is highlighted on the sides of Cowpernicus, one side flaunting a space platform, the other portraying the earth. Other galactic accents include spaceship-motif legs, a cometlike tail, and star-studded eyes.

∧ ➢
Cowpernicus
Artists: Bruce Monical and Art Square Studios
Patron: Mitchell Energy & Development Corp.
Location: Hermann Park (Montrose and Fannin—Sam Houston Statue)

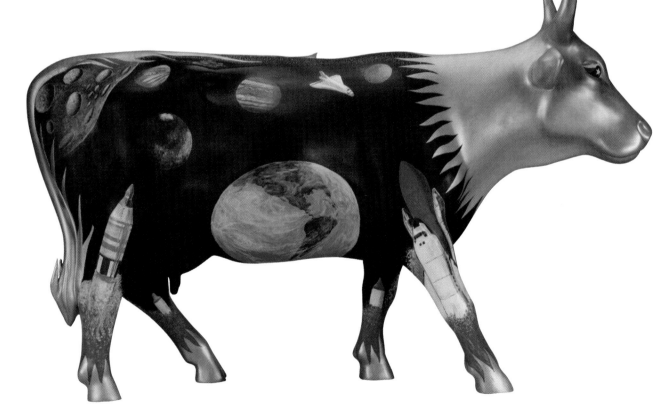

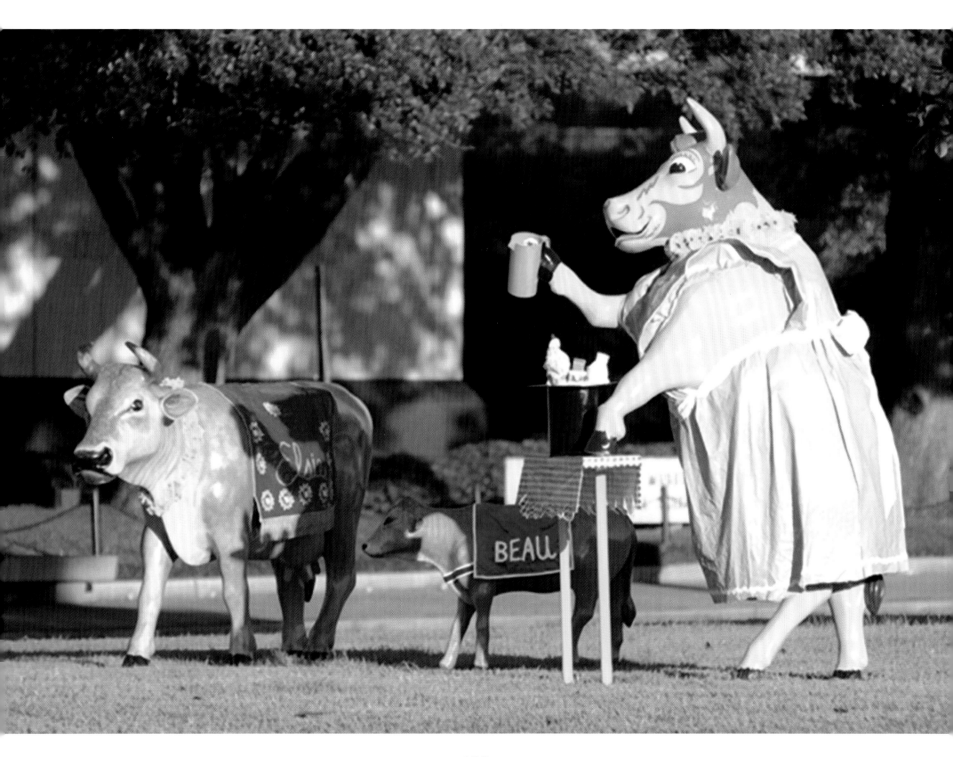

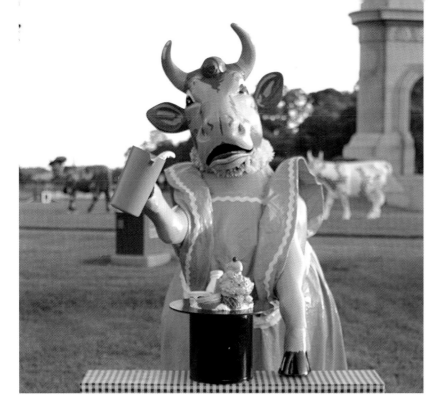

Beauregard
Artists: Bruce Monical and Art Square Studios
Patron: Borden Milk Products Houston, TX 2001
Location: Hermann Park (Montrose and Fannin—Sam Houston Statue)

Elsie's Udder Magic
Artists: Bruce Monical, Donna Durbin, and Art Square Studios
Patron: Borden Milk Products Houston, TX 2001
Location: Hermann Park (Montrose and Fannin—Sam Houston Statue)

Elsie
Artists: Bruce Monical and Art Square Studios
Patron: Borden Milk Products Houston, TX 2001
Location: Hermann Park (Montrose and Fannin—Sam Houston Statue)

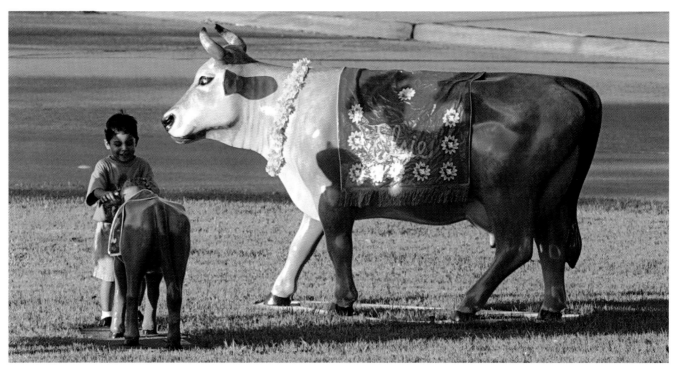

The Great Wall of NeheMOOah

Artist: Susan Kutzner
Patron: W. S. Bellows Construction
Location: First Presbyterian Church (Main and Binz)

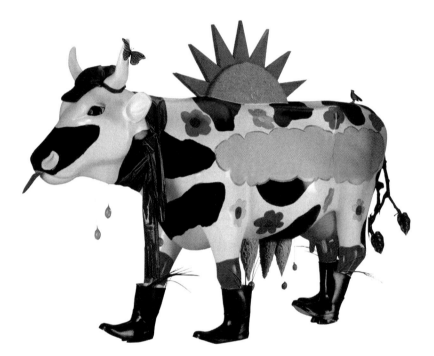

◄ ▲

Moother Nature

Artist: Travis Elementary School
Patron: EOG Resources, Inc.
Location: Holocaust Museum (Caroline and Calumet)

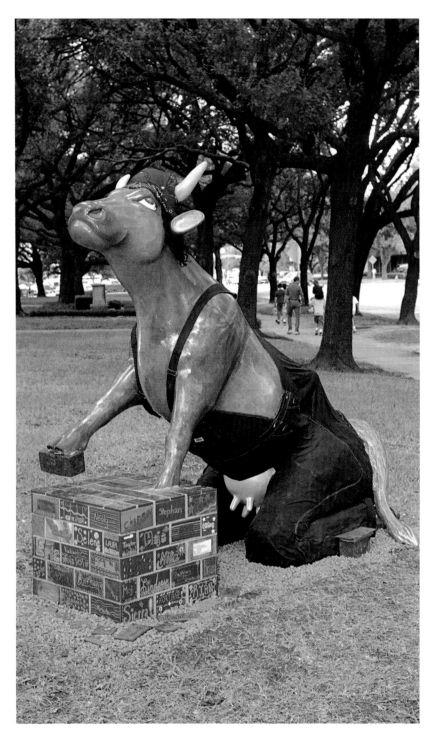

122

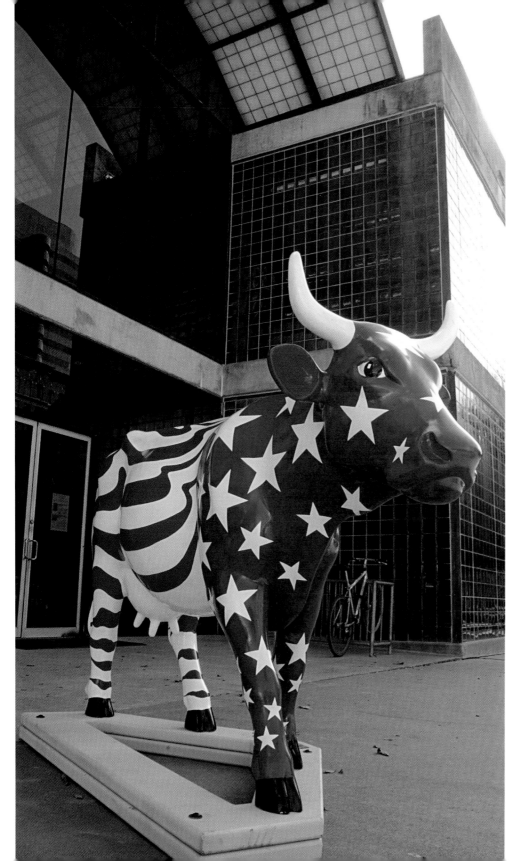

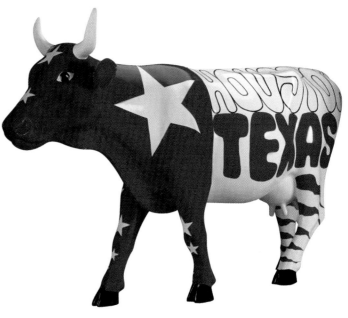

Half & Half
Artists: Peggy Hoekman/Duncan
Simmons
Patrons: Alfred and Clare Glassell
Location: Glassell School of Art, Museum
of Fine Arts (Montrose and Bartlett)

MICHELLE BARNES
Meadow Wreath Cow

Inspired by her Aunt Helen, a retired nurse with a passion for quilting, professional artist and educator Michelle Barnes adapted a traditional American quilt pattern, Wreath of Pansies, to decorate her cow.

"When my daughter was in the ninth grade, I started working on a quilt for her," Barnes explained. "I finished it the year she graduated from high school. That quilt was the first I ever made, and it won first prize for first quilts in the 1986 International Quilt Festival. I wanted to share my design and story with CowParade Houston and set a precedent for other quilters to get involved in public art."

For her canvas, Barnes selected the grazing cow, standing with head down. She said she "liked that position because the cow looks both humble and content."

Meadow Wreath's design features approximately 50 flowers, no two of which are alike. Stems and leaves form a circular shape, while the flowers—each of which uses three color combinations—are the connectors.

"I love to explore the function of quilting in contemporary times," said Barnes, the founding director of the not-for-profit Community Artists' Collective. "To me, a quilt is not just art on the wall or a bed covering. It's got to have new meaning."

Meadow Wreath Cow
Artist: Michelle Barnes
Patron: CowParade Houston 2001
Location: Hermann Park (Montrose and Fannin— Sam Houston Statue)

Moo-Earth Cow
Artist: Te-Jui Fu
Patrons: Harriet and Joe Foster
Location: Museum of Natural Science (Hermann and Fannin)

Cowfari
Artist: Te-Jui Fu
Patrons: Kathryn and David Berg for Boys & Girls Club of Houston
Location: Houston Zoo (MacGregor Entrance at Ben Taub)

Mooseum District Cow
(before, top; and after, bottom)
Artist: The Children of Museum District
Day 2001
Patron: EOG Resources, Inc.
Location: Contemporary Arts Museum
(Bissonnet and Montrose)

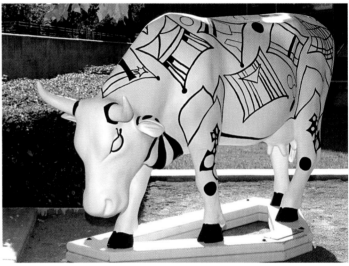

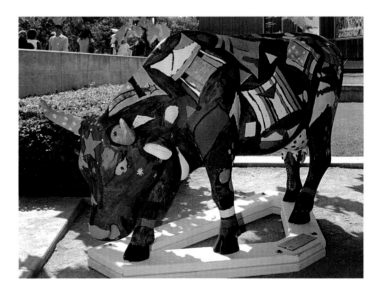

Crazy Cow-ilt
Artist: Julie Brook Alexander
Patrons: Drew, Julie, Kevin, and Amy
Alexander
Location: The Children's Museum (Binz
and LaBranch)

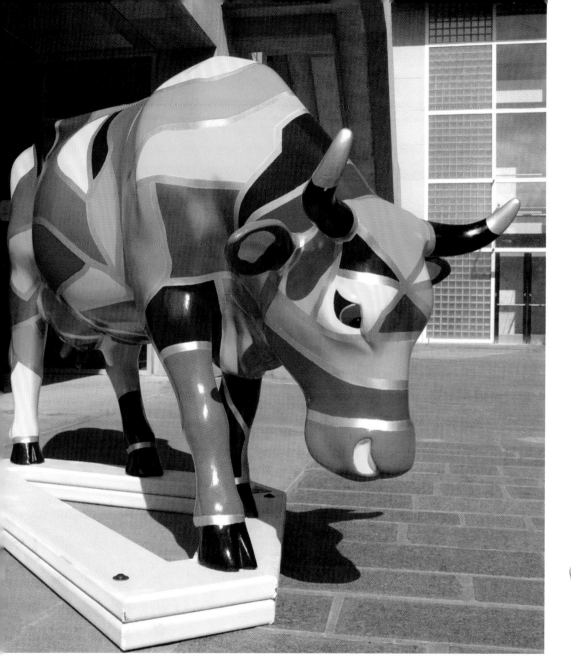

Cow Art
Artist: Glassell Junior School/Museum of Fine Arts, Houston
Patrons: Judy Margolis, Barbara Hurwitz, Rose Cullen, and Dede Weil
Location: Glassell Junior School, Museum of Fine Arts (Bayard and Bartlett)

Boris Cowloff Cowacature
Artist: Dan Dunn's Caricatures Ink
Patron: CowParade Houston 2001
Location: Hermann Park (Montrose and Fannin—Sam Houston Statue)

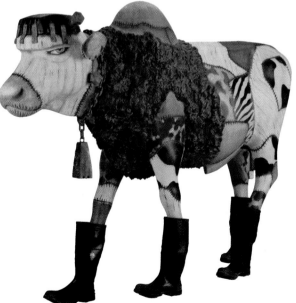

127

Cosmic Cow
Artist: Cynthia Scott-Johnson
Patron: Texas Aromatics LP
Location: Museum of Natural Science (Hermann and Fannin)

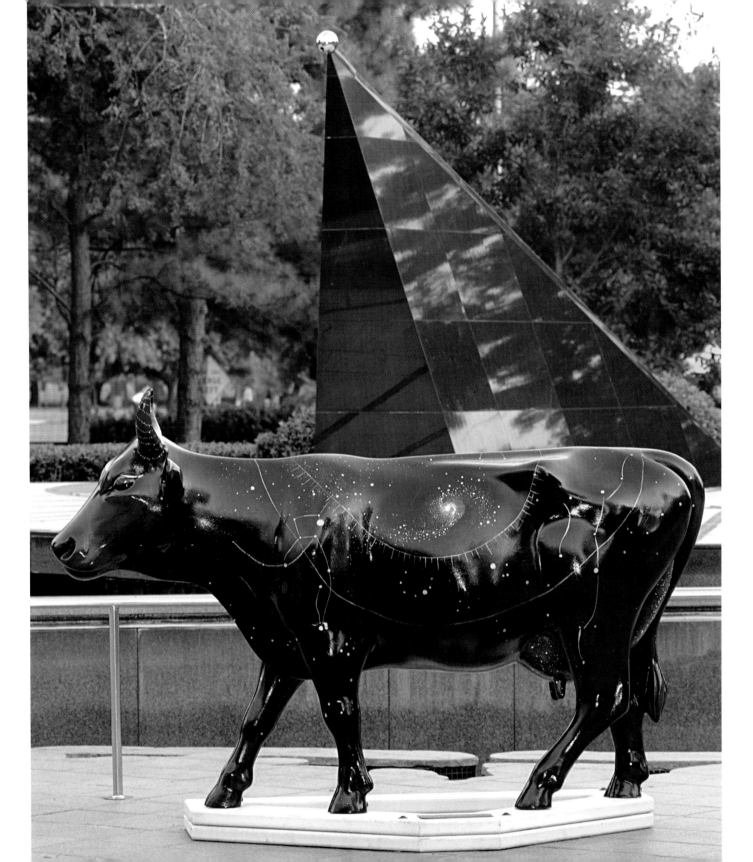

Maria Mooriachi
Artist: Stanley Bermudez Moros
Patron: KXLN TX Channel 45 UNIVISION
Location: Hermann Park (Montrose and Fannin—Sam Houston Statue)

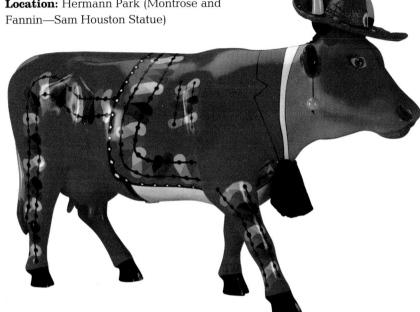

Mother Moose
Artist: Eva Felder
Patrons: Judy and Frank Lee and Family
Location: Joy School (One Chelsea Place and Louisiana)

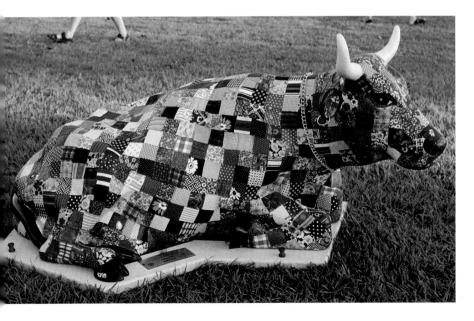

Cowalico
Artist: Tiny Pauline Albert
Patron: CowParade Houston 2001
Location: Hermann Park (Montrose and Fannin—Sam Houston Statue)

Belle
Artist: Randy Gillman
Patron: CowParade Houston 2001
Location: Hermann Park (Montrose and Fannin—Sam Houston Statue)

Lichtenholstein
Artist: Christopher Olivier
Patrons: Hanna, Oliver, and Rita Herzog
Location: Hermann Park (Montrose and Fannin—Sam Houston Statue)

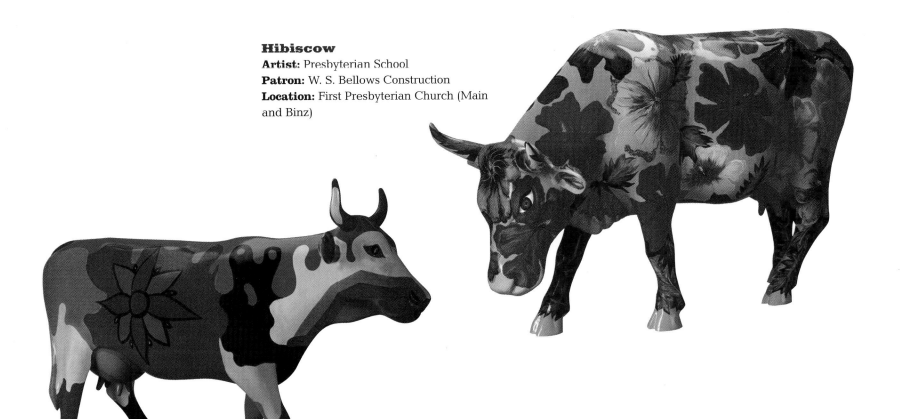

Hibiscow
Artist: Presbyterian School
Patron: W. S. Bellows Construction
Location: First Presbyterian Church (Main and Binz)

Spilt Milk
Artist: Glassell Junior School/Museum of Fine Arts, Houston
Patron: Family Sauer Foundation
Location: Glassell Junior School, Museum of Fine Arts (Bayard and Bartlett)

Moogritte
Artist: Linda Jaynes Schmer
Patrons: Hughes and Betsy Abell
Location: Museum of Fine Arts, Houston Visitor's Center (Fannin and Binz)

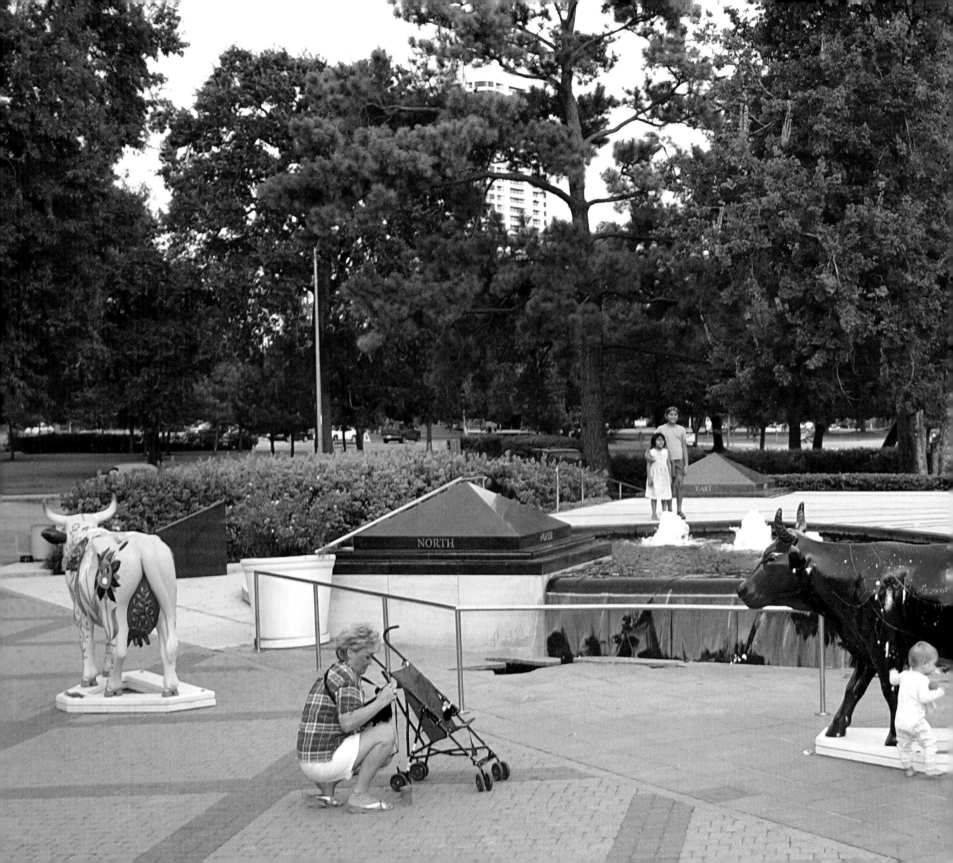

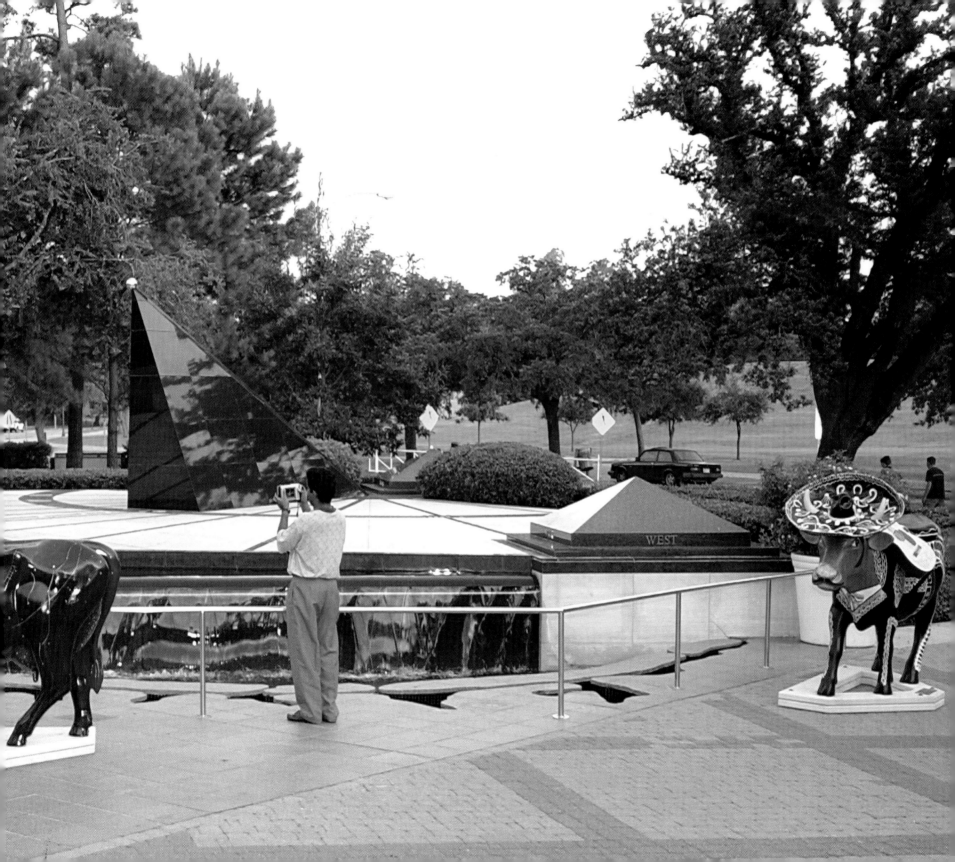

Texas Medical Center

The largest medical center in the world began with a gift from an unpretentious bachelor who wanted to help his fellow citizens. Thanks to the trust established by cotton merchant Monroe Dunaway Anderson, a 134-acre site was purchased in 1945 for the development of a hospital.

Today, the campuses of the Texas Medical Center encompass 725-plus acres, adjacent to Hermann Park and Braes Bayou in southwest Houston. Virtually every type of illness and injury is treated within the sprawling development, which contains more than 40 member institutions, including two medical schools, four nursing schools, and 13 hospitals with more than 6,000 beds. Five million patients are seen at the center each year.

Among these institutions is Texas Children's Hospital, the nation's largest freestanding pediatric hospital. Since its opening in 1954, the hospital has made its mark as the primary pediatric training site for Baylor College of Medicine. Three percent of all pediatricians in the United States trained at Texas Children's, and 60 percent of those who practice in Texas have trained there.

Wildflower
Artist: Laurie N. Svec
Patron: Personix
Location: Institute of Religion (Bertner and Wilkins)

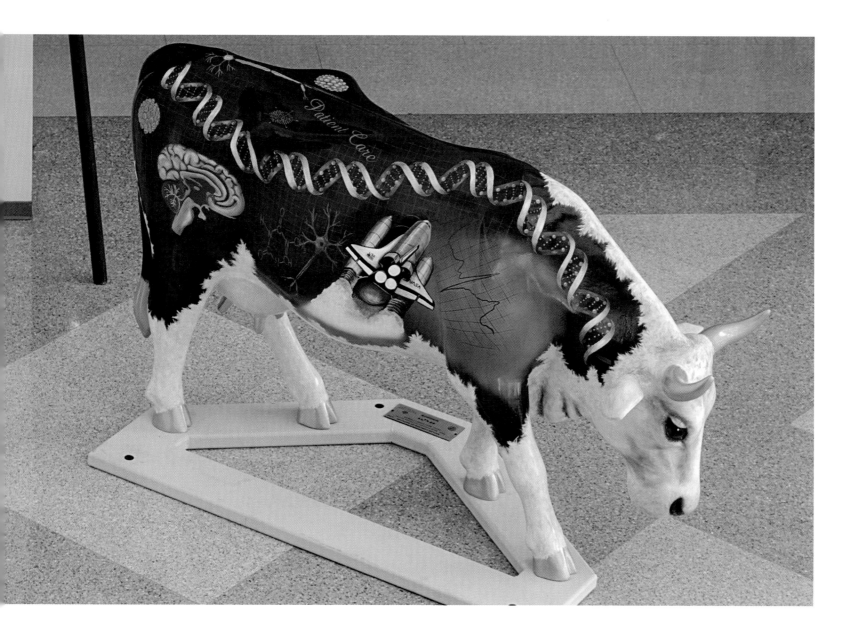

Baylor Cowlege of Medicine
Artist: Baylor Publication and Creative
Services
Patron: Baylor College of Medicine
Location: Baylor College of Medicine
(John Freeman and Cullen)

Winnie the Moo
Artist: Donna Lane Vadala
Patron: Texas Children's Cancer Center
Location: Jesse H. Jones Library
(John Freeman and Cullen)

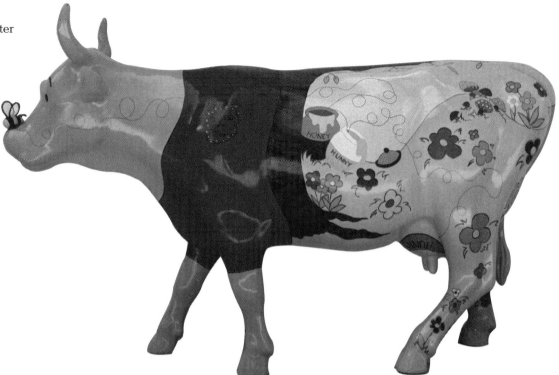

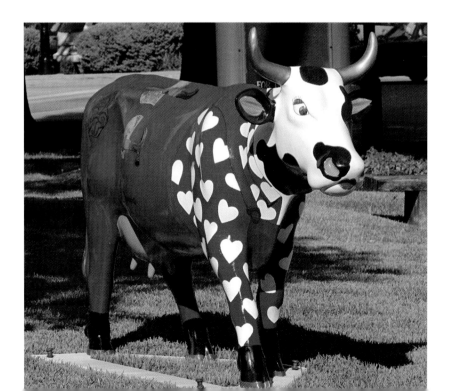

Hearts and Ham"moo"ers
Artist: Dulles High School
Sugar Land, FBISD
Patrons: Judy and Charles Tate
Location: Institute of Religion
(Bertner and Wilkins)

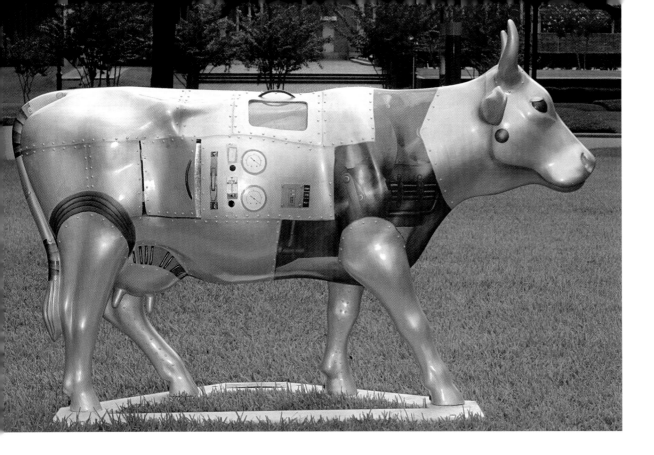

Ocsiban Cow
Artist: Wing Wong
Patron: Texas Medical Center/
Ocsiban Design Group
Location: Jesse H. Jones Library
(John Freeman and Cullen)

Animoo Crackers
Artist: Sheila Hetherington
Patrons: Nancy and Rich Kinder/
Kinder Foundation
Location: M. D. Anderson Cancer Center
(Bates and Bertner—Lobby)

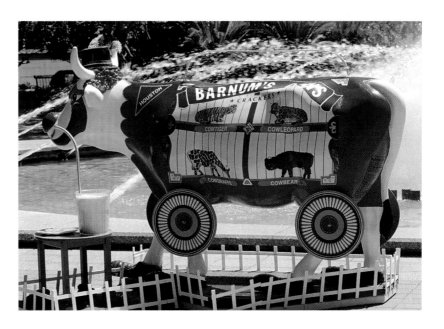

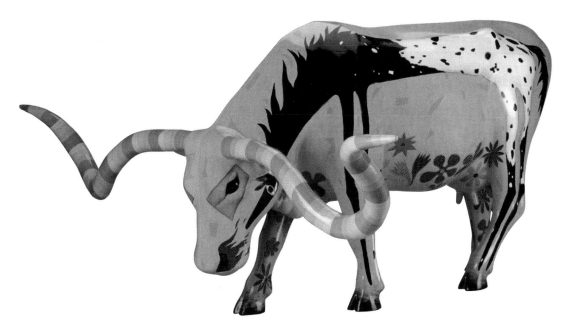

Ciscow
Artist: Cisco Tucker Kolkmeier
Patron: KPMG LLP
Location: M. D. Anderson Cancer Center
(Bates and Bertner—Lobby)

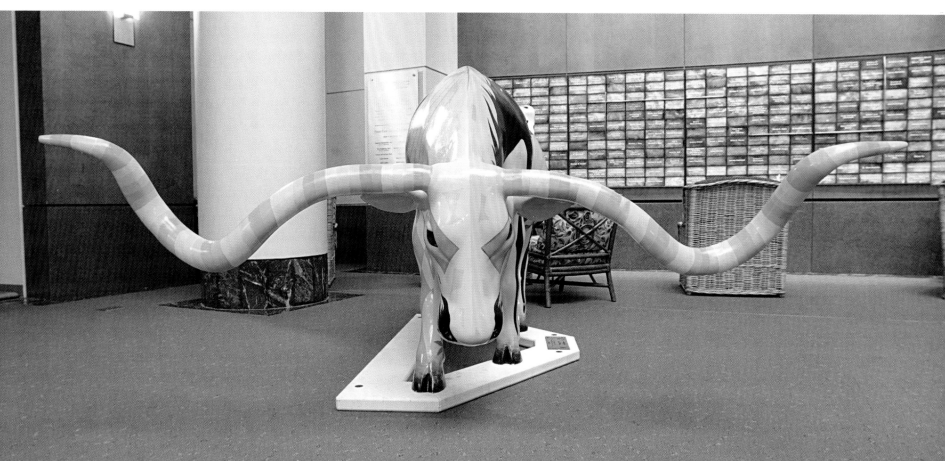

Everything's Cowming Up Roses

Artist: Michelle Jackson
Patrons: Elyse and Bob Lanier
Location: St. Luke's Rose Garden (Bates and Richard J. V. Johnson)

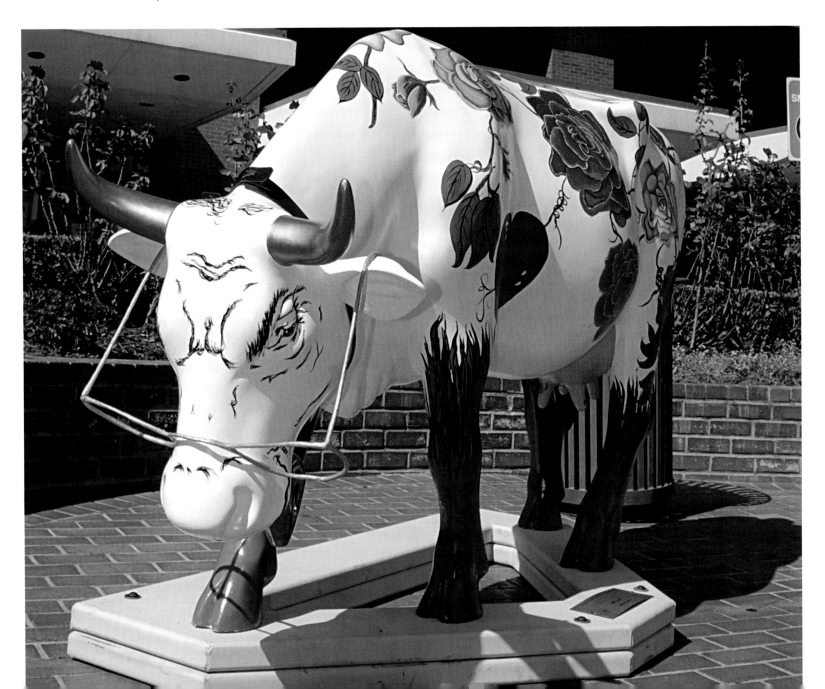

Moovelous Miss Rhinestone Cow Girl

Artist: P. McGowan Johnson (MAC)
Patrons: Dede and Clarence
Mayer/Sylvia, Ron, Zoe, and Zach
Baker/Laura and Jarrod Cyprow
Location: M. D. Anderson Cancer Center
(Bates and Bertner)

Denton A. Cowley, M.D.

Artists: John Nguyen, St. Luke's
Episcopal Hospital, and Party Props, Inc.
Patron: St. Luke's Episcopal Hospital,
Home of the Texas Heart Institute
Location: St. Luke's Rose Garden (Bates
and Richard J. V. Johnson)

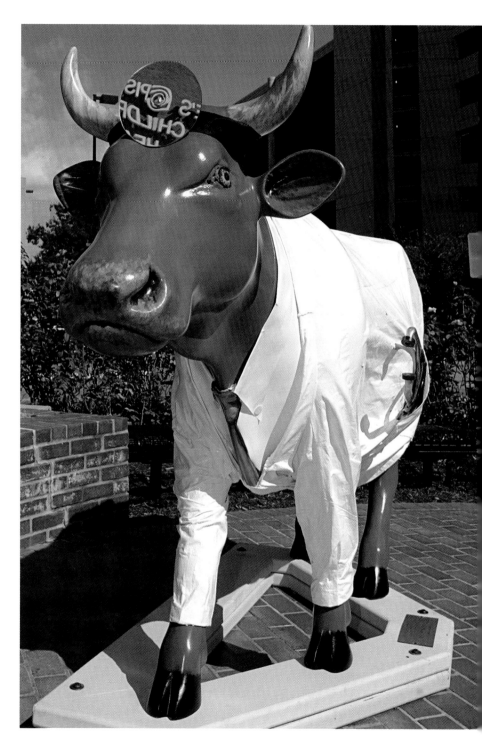

141

Bovineasaurus
Artists: Mike Lyons and Roland Hartzog
Patron: The Auxiliary to Texas Children's Hospital
Location: Texas Children's Hospital (Bates and Fannin)

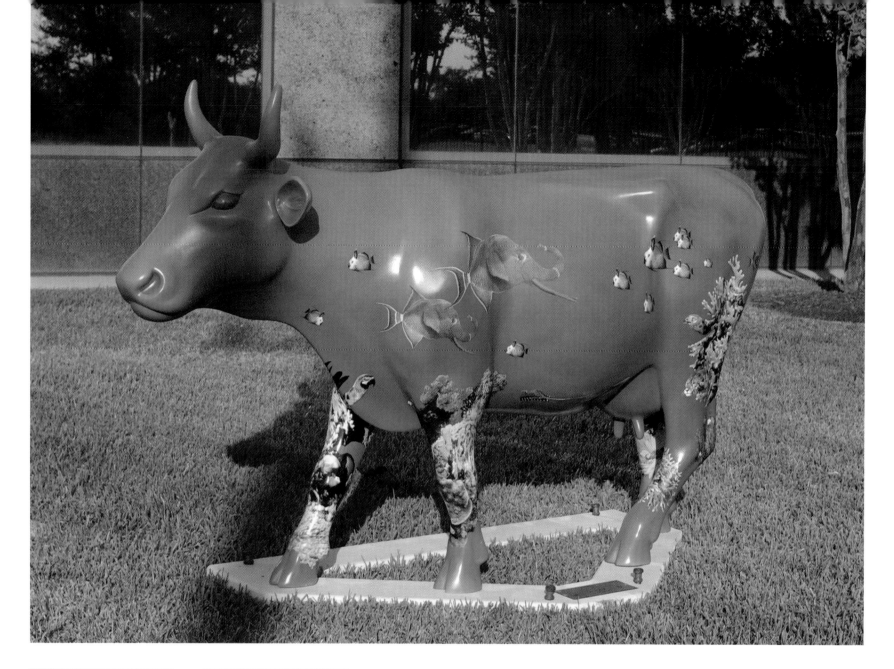

Cowarium

Artists: Robert Shniderson and
Glenn Eldridge
Patrons: Emily and Holcombe Crosswell
Location: Texas Children's Hospital—
Meyer Building (Braeswood and
Greenbriar)

TEXAS CHILDREN'S CANCER CENTER PATIENTS

Courageous Cowlage

Of the more than 320 cows in CowParade Houston 2001, a handful had "hooves-on" contact with the children they would benefit. These cows were brought to life in the Texas Children's Cancer Center by the patients and their families.

"Unfortunately, some kids will not be able to get out of the hospital and see the cows, so having the cows come here was really special," explained Carol Herron, who coordinates the Texas Children's Cancer Center Arts in Medicine Program.

"The participation of youngsters 7 months to 17 years of age," Herron said, addressed the four basic goals of the program. "First, they gave children an opportunity to express themselves through art. Next, the cows empowered patients to make decisions—they can say 'no' and have that decision honored. Third, art allows a level playing field for patients and siblings. With art, they are all just kids and artists who can create and play. Fourth, art enriches lives. We want to educate children about art and art opportunities here in Houston."

One such lucky bovine was *Courageous Cowlage,* made possible through the collaborative efforts of the Arts in Medicine Program and the Museum of Cultural Arts Houston's Art Angels Healing Arts Program. The vivid yet gentle creature also was displayed in the hospital's 11th annual "Making a Mark" show, which features original art by children with cancer and blood diseases.

The coat of *Courageous Cowlage,* designed by children during clinic visits, combined more than 100 bandages displaying patients' numerous poetic and inspirational writings. Workshops were conducted to involve Arts in Medicine team members and volunteers in the final fabrication and collage process.

"I hope those viewing the cow will receive a sense of what the patients are experiencing and the treatment challenges they face," said Rhonda Adams, Art Angels founding artist. "Children come from all over the world to be treated at Texas Children's. It's a beautiful thing to see the line of communication open through art, which is universal. I find it so fulfilling that children have an opportunity to be involved with the creative process so they can access art as a healing tool."

Courageous Cowlage
Artists: Rhonda Radford Adams and Reginald Adams
Patron: Texas Children's Cancer Center Advisory Board
Location: Texas Children's Hospital (Bates and Fannin—Feigin Center)

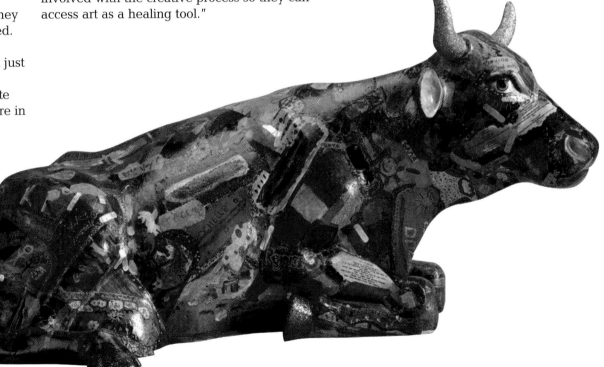

144

Rainbovine

Artists: Employees of Texas Children's Hospital
Patrons: Merrell Athon, Brad Tucker, and Mark Wallace
Location: Texas Children's Hospital (Bates and Fannin—Abercrombie Building)

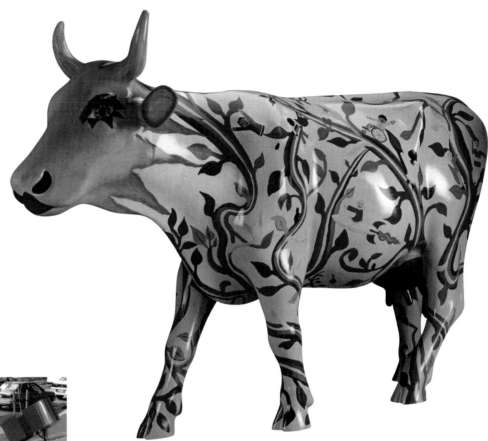

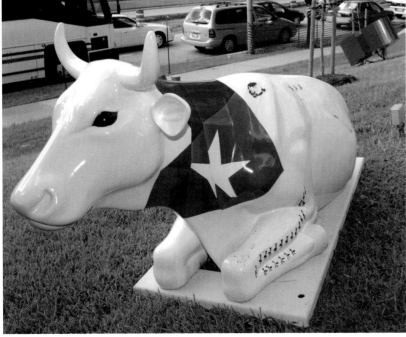

Texas Ant Hill

Artist: Deborah Walsh
Patrons: Nancy Epley, Nancy Reynolds, and Shelley Brazelton
Location: Texas Children's Hospital (Bates and Fannin—Feigin Center)

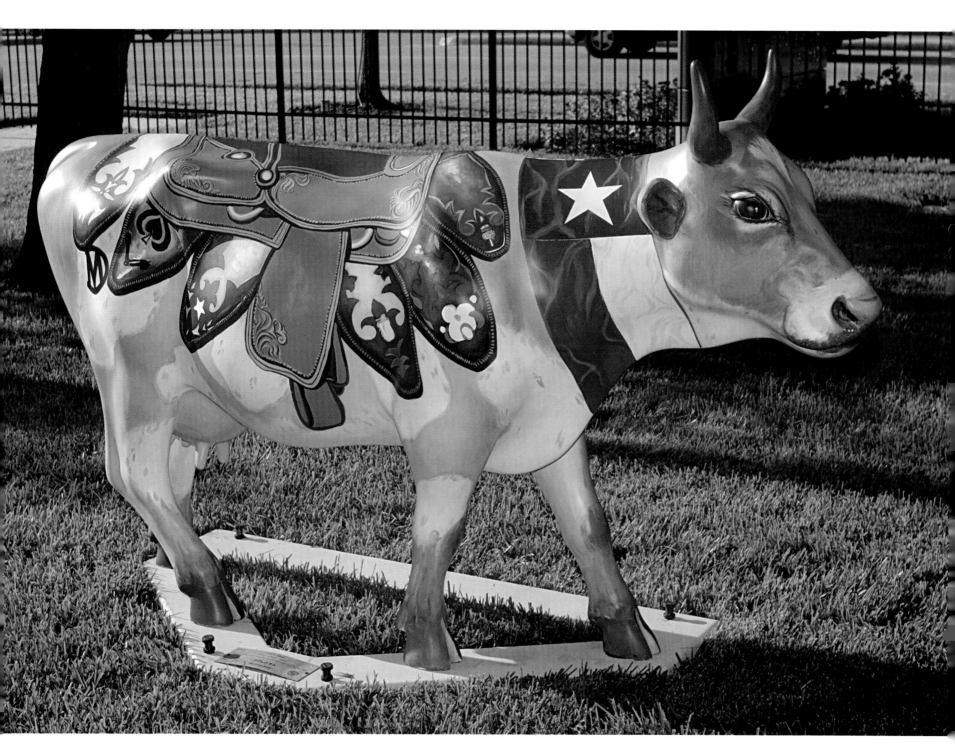

146

Moo Y'all

Artist: Onofre Fajardo
Patrons: Dede and Clarence
Mayer/Sylvia, Ron, Zoe, and Zach
Baker/Laura and Jarrod Cyprow
Location: Ronald McDonald House
(Holcombe and Cambridge)

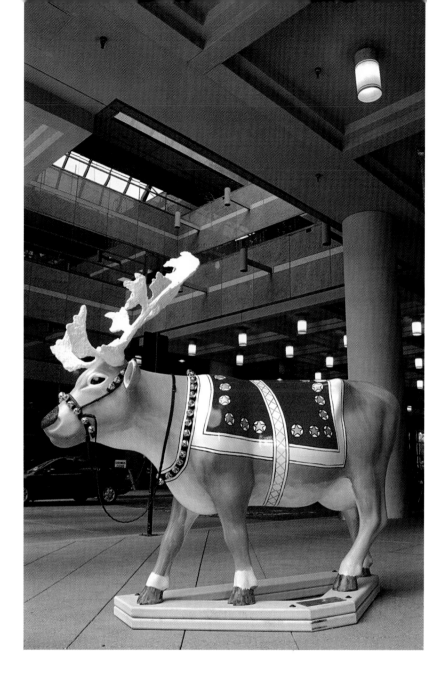

Moodolph

Artist: Familia Masterson
Patrons: Lynn and Sam Baird
Location: Texas Children's Hospital (Bates
and Fannin—West Tower Lobby)

Cash Cows

An empty shopping bag is a rare sight in Houston, where consumers engage in the retail sport year round. The hunt takes place in every quadrant of the city, from the stately Foley's in the heart of Downtown to Uptown's glittering Galleria complex to more than 15 suburban malls and hundreds of centers and freestanding stores.

Houston ranks high as both a shopper's—and retailer's—dream. Every year since 2000, more than $55 billion has been spent in an industry responsible for almost 350,000 jobs. During CowParade Houston 2001, bovines entertain customers at an assortment of popular retail spots, including Houston's first shopping center, River Oaks Shopping Center at West Gray and McDuffie; The Shops on River Oaks Boulevard; Highland Village, in the 4000 block of Westheimer; the Centre at Post Oak and the Post Oak Shopping Center in Uptown Houston; the Upper Kirby District between Westheimer and Richmond; The Village Arcade at Kirby and University; I. W. Marks Jewelers on Bellaire Boulevard; and Memorial City Mall at Interstate 10 and Gessner.

What cow wouldn't be proud to call Houston her pasture?

Ms. Moolevard on the Boulevard
Artist: Amber Felts
Patron: The Shops on River Oaks Boulevard
Location: River Oaks Boulevard (between Westheimer and Locke Lane)

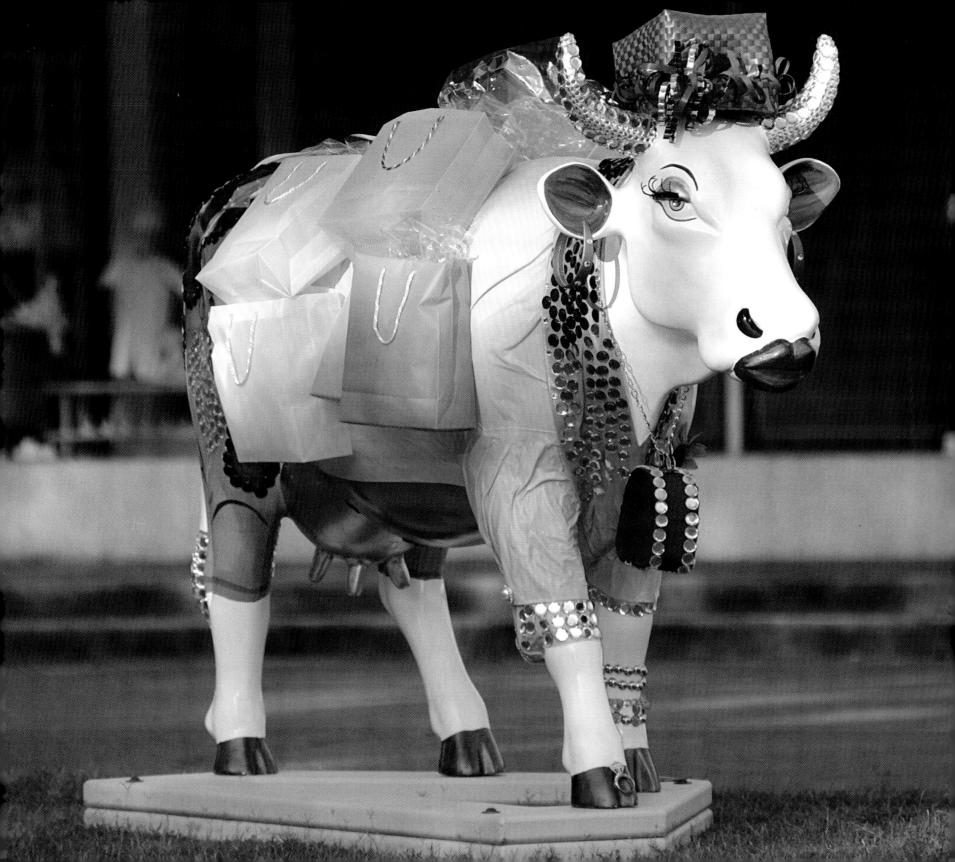

JUDY BREITENBACH/ MADILYN STEIN
Padilla, the Cultured Cow

Judy Breitenbach admitted that *Padilla, the Cultured Cow* is unlike any project she has ever undertaken. "She's been great fun and a labor of love," said the mixed media sculptor, who worked with artist Madilyn Stein. The twosome created an entry that illustrated—from head to hoof—Houston's rich performing art offerings.

Padilla was affectionately named for Pat Padilla, the longtime wardrobe director of the Houston Ballet, whose assistance proved to be invaluable.

The cow's dancewear presented an interesting dilemma. "I originally made her cloth tutu out of canvas and fiberglass," Breitenbach said. "Unfortunately, I had measured the resin for 72 degrees. The air conditioning broke and so I worked in 95-degree weather. Normally, this would cause the resin to dry faster, but I hadn't added enough hardener. It was a mess. I threw out the tutu and went to polyester and fiberglass." Beneath the tutu are red, white, and blue udders, which Breitenbach painted to symbolize the patriotic nature of Houstonians.

"My biggest challenge in doing the face was to fit the mask so it looked like it was from *Phantom of the Opera*, instead of just a mask," Stein said. "I had to stuff it in certain places because the cow's face has an odd contour. As a final touch, I fit the saxophone into the mouth with a big strand of red pearls."

Standing on a patch of bluebonnet-studded grass, even Padilla's feet represent arts and entertainment. The bovine sports a ballet toe shoe, a cowboy boot, a *barefoot-in-the-park* hoof, and a size 15D jogging shoe that came from a friend in Breitenbach's exercise class. "It fit perfectly!" the artist said.

Padilla, The Cultured Cow
Artists: Judy Breitenbach and Madilyn Stein
Patron: River Oaks Shopping Center/ Weingarten Realty
Location: River Oaks Shopping Center (West Gray and McDuffie)

Horn-o-copia
Artist: Janice Freeman
Patron: Memorial City
Location: Memorial City Mall (Gessner and I-10—Guadalajara Restaurant)

Texas Landscape
Artist: Earl Staley
Patrons: Downing Street, Sterling Bank, Taco Milagro
Location: Upper Kirby District (Kirby between Westheimer and Richmond)

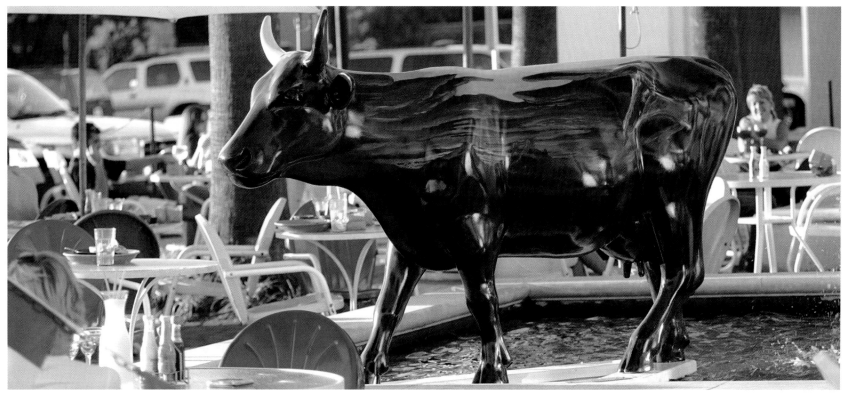

Cavalon
Artist: Rajan Sedalia
Patron: Avalon Center/Upper Kirby District
Location: Upper Kirby District (Kirby between Westheimer and Richmond)

Bovina at the Ice Cowpades
Artists: Kielly Yates, Brian Lardi, and Nancy Ohanian
Patron: Memorial City
Location: Memorial City Mall (Gessner and I-10—inside)

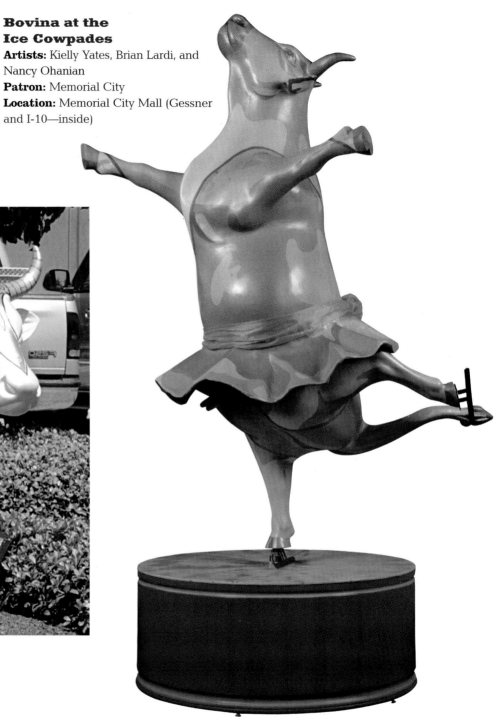

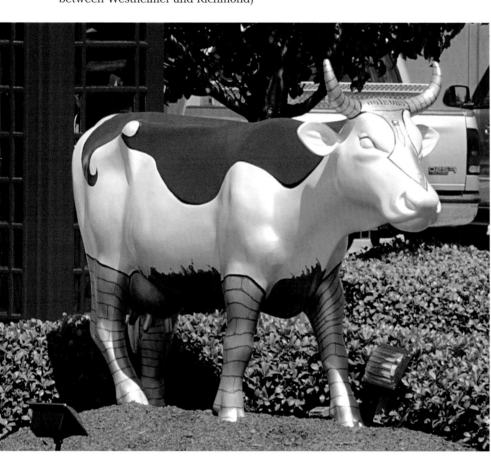

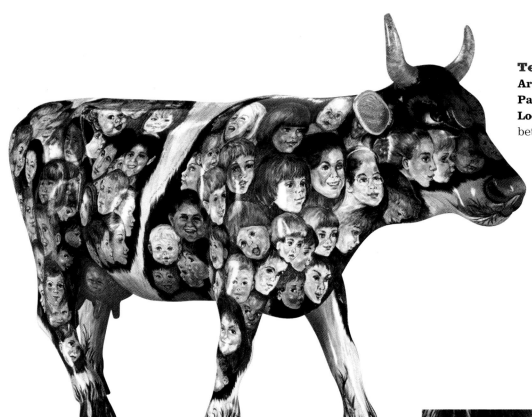

Texas Children Cow
Artist: Eve Myles
Patrons: Barbara and Temple Webber
Location: Highland Village (Westheimer between Drexel and Suffolk)

Cow'rrabba's
Artist: P. McGowan Johnson (MAC)
Patron: Carrabba's/Upper Kirby District
Location: Upper Kirby District (Kirby between Westheimer and Richmond)

153

Mr. Swatches Fall Collection

Artist: Lisa F. Pliner
Patron: Mr. Patches Fall 2001 Collection by Lisa Pliner
Location: Highland Village (Westheimer and Drexel—Donald Pliner)

So Udderly Georgia O'Beefe

Artist: Beverley A. Whitworth
Patron: Memorial City
Location: Memorial City Mall (Gessner and I-10—outside)

Diamond Daisy
Artist: Averil Gleason
Patron: I. W.'s Diamond Daisy
Location: I. W. Marks Jewelers
(3841 Bellaire)

Udder Cowstruction
Artist: K8 Kreations, L.L.C.
Patron: Center at River Oaks/Upper Kirby
District
Location: Upper Kirby District (Kirby
between Westheimer and Richmond)

Haute Cowture
Artist: Deborah R. Mansfield
Patron: The Village Arcade
Weingarten Realty
Location: Village Arcade (Kirby and
University)

Ramblin' Cows

T he 19th-century American writer Henry David Thoreau once suggested that "if a man does not keep pace with his companions, perhaps it is because he hears a different drummer. Let him step to the music which he hears, however measured or far away."

A similarly freespirited mindset applies to some members of the CowParade Houston 2001 herd. Almost three dozen bovines have chosen to break away from the pack to experience escapades far from the madding crowd.

Although most of the lonesome cows find their fields of dreams, others continue to frolic around the city, traveling from location to location throughout the show, bound and determined to show up in the most unlikely places.

Beaux Vines
Artist: Mary Cooley Craddock
Patron: H-E-B Grocery Company
Location: H-E-B Grocery Company (various store locations)

Moonsoon—Raining Cats and Dogs
Artists: Holly Lewis and Caroline Graham
Patron: City of West University Place
Location: West University Place City Hall (University and Auden)

"Rose" the Yellow Cow of Texas
Artist: Lindy Wyatt-Brown Neuhaus
Patrons: Flo McGee, Barbara Kraft, Bette Thomas, and Missy McInnes
Location: St. Martin's Episcopal Church (Sage and Woodway)

Cowicature Cow
Artist: Dan Dunn's Caricatures Ink
Patron: Beth Lee, Janet Walker, and Laurie Dorfman
Location: Greater Houston Cow Sightings (traveling)

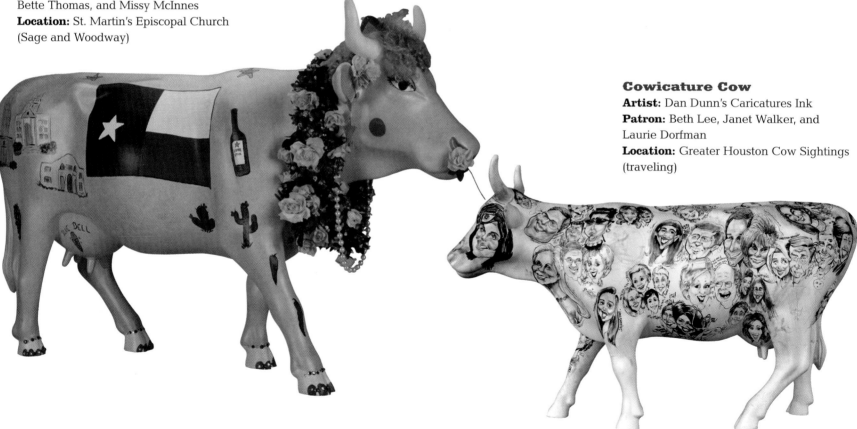

The Texas ARTist
Artist: Christian J. Navarrete
Patron: Texas Art Supply
Location: Texas Art Supply
(Montrose and Welch)

Deli-cow-tessen
Artist: Bonnie Lambourn
Patron: Katz's Deli and Bar
Location: Katz's Deli (Westheimer and
Crocker)

159

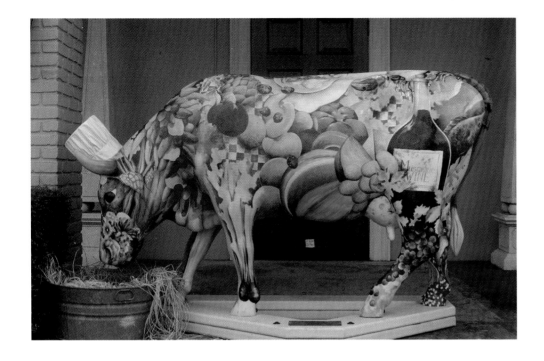

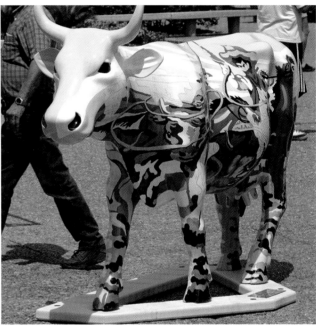

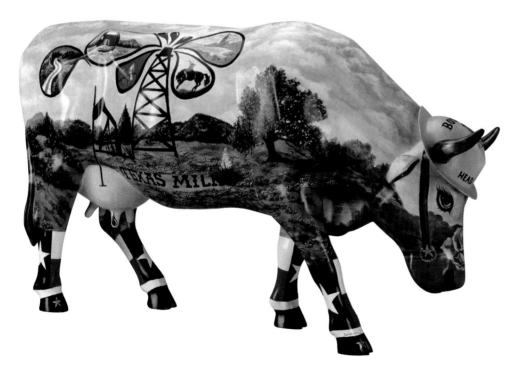

Texas Take Cow't
Artist: Suzanne Morriss
Patrons: Susan and Jack Mayfield
Location: Susan Mayfield Catering
(Fountainview between Richmond and Westheimer)

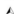
Texas Landscape
Artists: St. John's School
Patron: Lane, Mary S., Margaret, Jim, Buck,
John, Harry, Sam, and Lucy
Location: St. John's School (Westheimer and
River Oaks Boulevard)

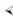
Texacow Gusher
Artist: Janet Pollard Burton
Patron: Houston Producers' Forum
Location: Bush Intercontinental Airport
(Terminal A)

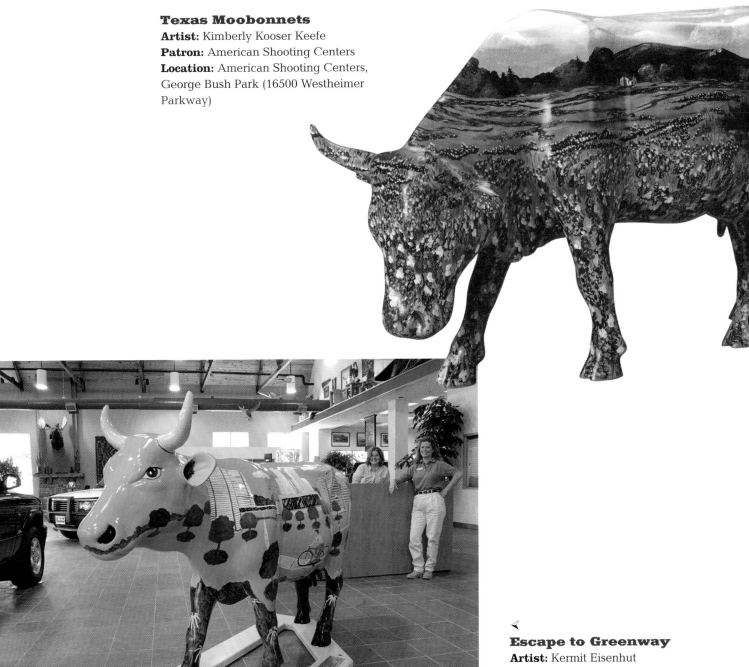

Texas Moobonnets
Artist: Kimberly Kooser Keefe
Patron: American Shooting Centers
Location: American Shooting Centers, George Bush Park (16500 Westheimer Parkway)

Escape to Greenway
Artist: Kermit Eisenhut
Patrons: Joan Weingarten Schnitzer and Family
Location: Land Rover Houston North (18205 I-45 North Freeway)

Beef Stew
Artist: Diana Selby
Patron: H-E-B Grocery Company
Location: Central Market (Weslayan and Westheimer—inside)

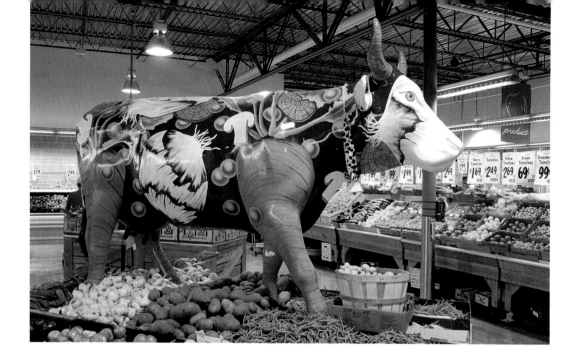

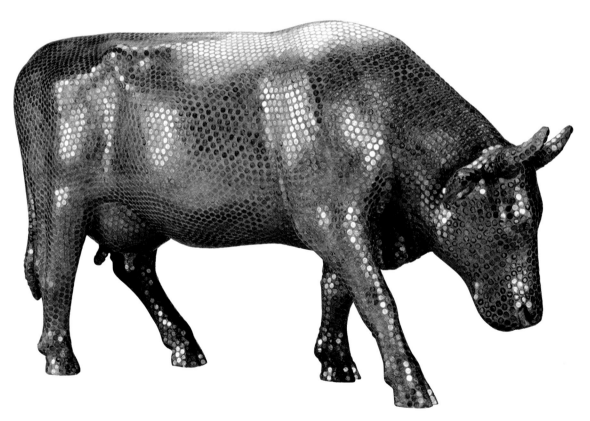

Change and Scents
Artists: Beverly A. Whitworth and James Whitworth
Patrons: Meg Goodman and Mike Bonini
Location: Greater Houston Cow Sightings (traveling)

Ice Cream Lover
Artist: Kristal R. Edwards
Patron: H-E-B Grocery Company
Location: H-E-B Grocery Company
(various store locations)

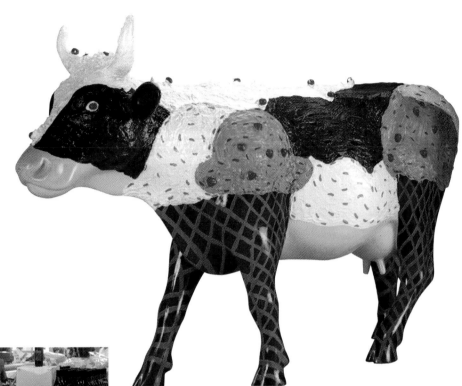

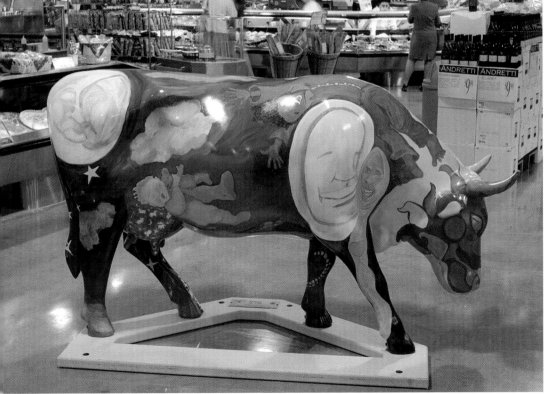

**The Moon Jumped
onto the Cow**
Artist: Bonnie Lambourn
Patron: H-E-B Grocery Company
Location: H-E-B Grocery Company
(various store locations)

The Gumball Machine
Artist: Dura Dittmar
Patron: H-E-B Grocery Company
Location: H-E-B Grocery Company
(various store locations)

Texas Wildlife
Artist: T. Colleen Letchford
Patron: H-E-B Grocery Company
Location: H-E-B Grocery Company
(various store locations)

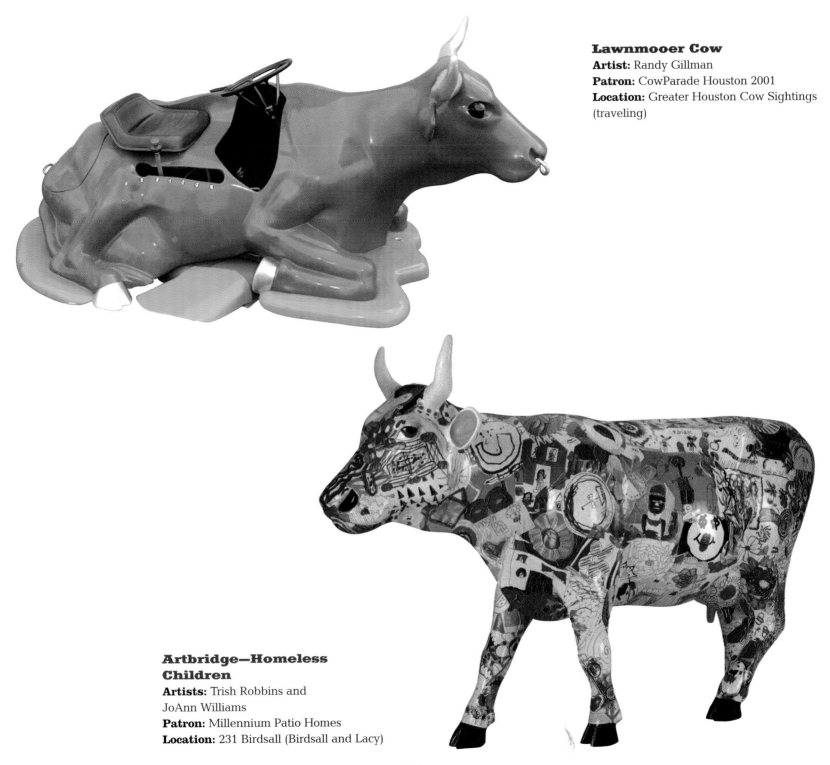

Artbridge—Homeless Children
Artists: Trish Robbins and
JoAnn Williams
Patron: Millennium Patio Homes
Location: 231 Birdsall (Birdsall and Lacy)

Livin' La Vaca Loca
Artist: Georges Le Chevallier
Patron: H-E-B Grocery Company
Location: H-E-B Grocery Company
(various store locations)

How Now Green Cow
Artist: Marketing Plus/XFactor Design
Patron: BP America, Inc. An energy
company going beyond.
Location: BP America Building
(505 Westlake Park)

La Dolce Vida (The Sweet Life)
Artist: Suzanne E. Sellers
Patrons: Mr. and Mrs. William James Miller
Location: Tanglewood Center
(Woodway and Chimney Rock)

Cownt on Us
Artists: Ken Bullock, Anthony D. Hill,
and James Hughes
Patron: Andersen
Location: Bush Intercontinental Airport
(Terminal B)

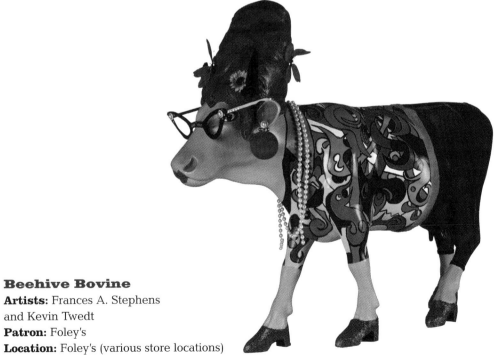

Beehive Bovine
Artists: Frances A. Stephens
and Kevin Twedt
Patron: Foley's
Location: Foley's (various store locations)

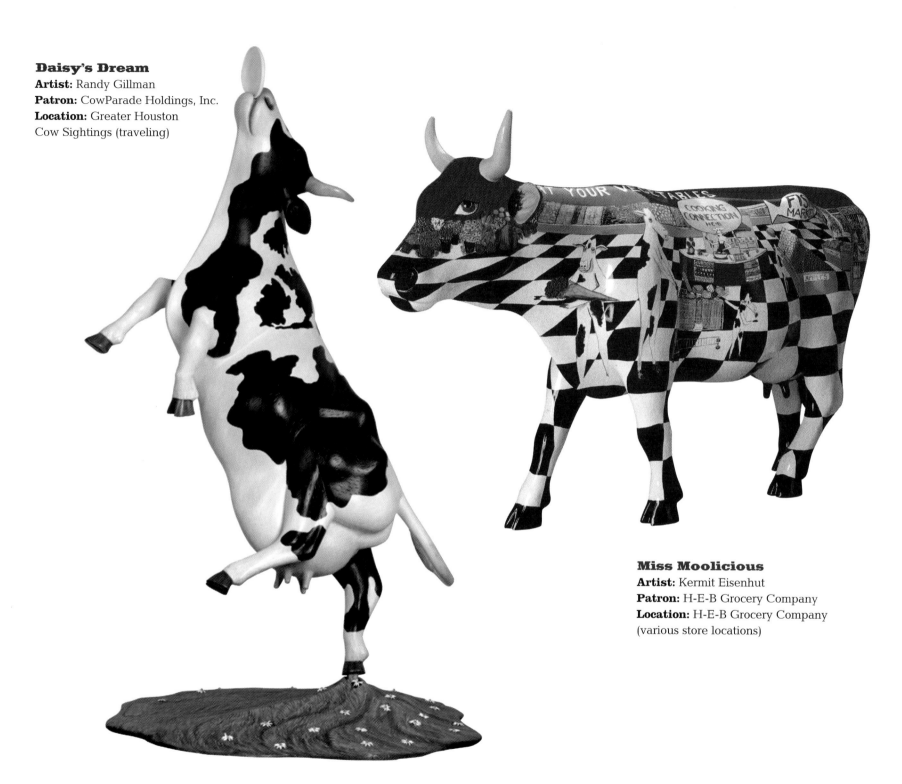

Daisy's Dream
Artist: Randy Gillman
Patron: CowParade Holdings, Inc.
Location: Greater Houston
Cow Sightings (traveling)

Miss Moolicious
Artist: Kermit Eisenhut
Patron: H-E-B Grocery Company
Location: H-E-B Grocery Company
(various store locations)

Texas Hillcountry Armoodilla

Artist: Tommy Hughes
Patron: H-E-B Grocery Company
Location: H-E-B Grocery Company
(various store locations)

Supa Cow!

Artist: Taylor High School/
Byron Beaubren
Patron: Community Bank, Katy, Texas
Location: Community Bank,
Katy (20045 Katy Freeway)

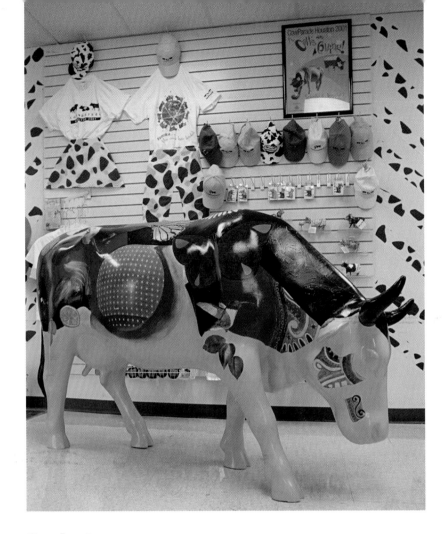

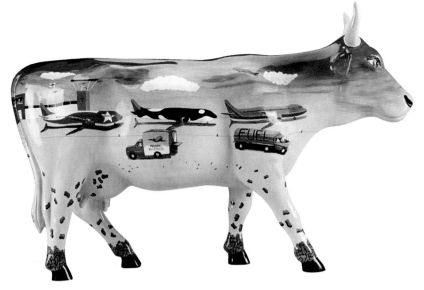

Cow with Altitude
Artist: Kermit Eisenhut
Patron: Southwest Airlines
Location: Hobby Airport (Broadway and
Airport Boulevard—Terminal)

Cowiente
Artists: Chris Clark and Miguel Alvarez
Patron: Cow Brands LTD
Location: CowParade Merchandise Central
(230 T. C. Jester at Washington)

Mooon Dreams
Artists: Lucy Wiley and Juicy Lucy
Studio.com
Patron: GHBA Benefit Homes Project
Location: Greater Houston Builders
Association Building
(9511 W. Sam Houston Parkway N.)

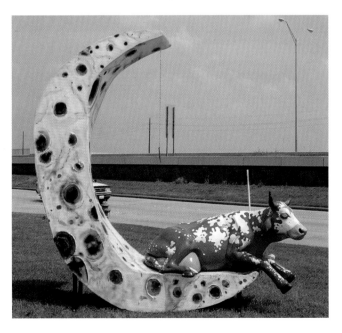

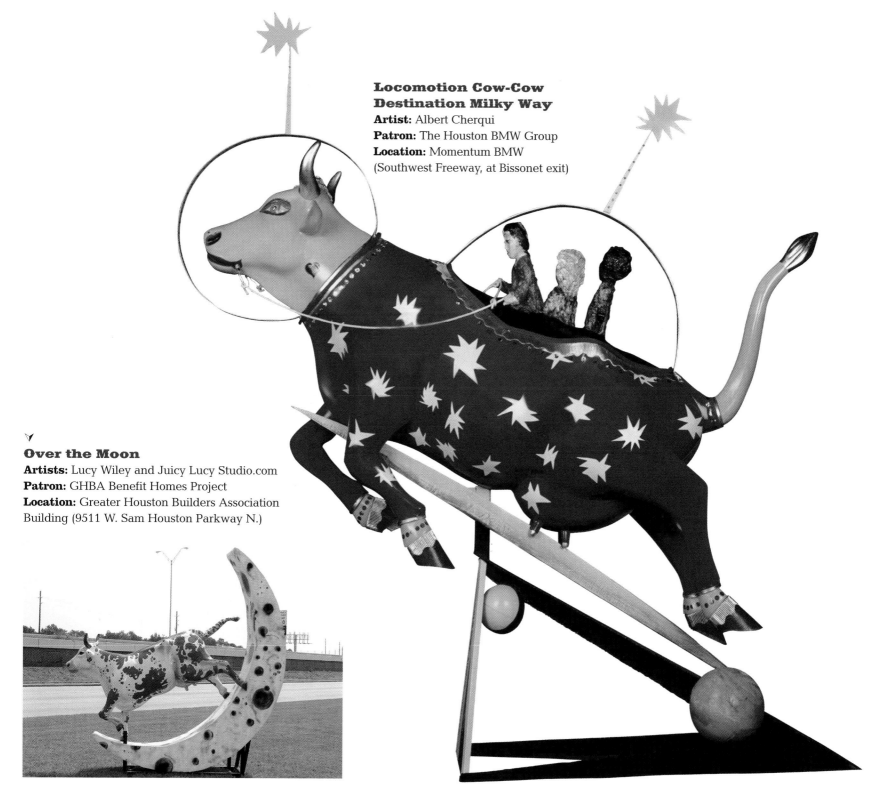

**Locomotion Cow-Cow
Destination Milky Way**
Artist: Albert Cherqui
Patron: The Houston BMW Group
Location: Momentum BMW
(Southwest Freeway, at Bissonet exit)

Over the Moon
Artists: Lucy Wiley and Juicy Lucy Studio.com
Patron: GHBA Benefit Homes Project
Location: Greater Houston Builders Association
Building (9511 W. Sam Houston Parkway N.)

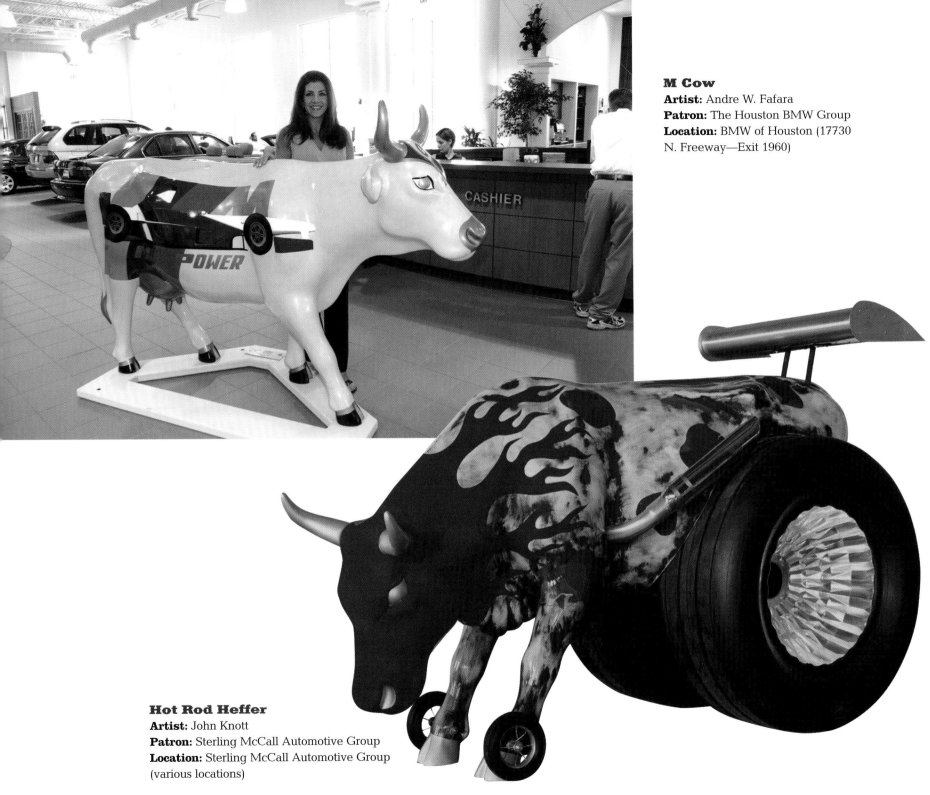

M Cow
Artist: Andre W. Fafara
Patron: The Houston BMW Group
Location: BMW of Houston (17730
N. Freeway—Exit 1960)

Hot Rod Heffer
Artist: John Knott
Patron: Sterling McCall Automotive Group
Location: Sterling McCall Automotive Group
(various locations)

Power to MOOve
Artist: H. Kathleen Gresham
Patron: BP America, Inc. An energy company going beyond.
Location: BP America Building (505 Westlake Park)

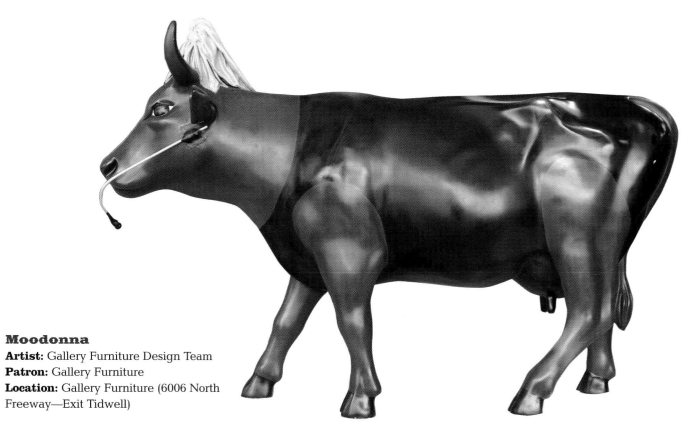

Moodonna
Artist: Gallery Furniture Design Team
Patron: Gallery Furniture
Location: Gallery Furniture (6006 North Freeway—Exit Tidwell)

173

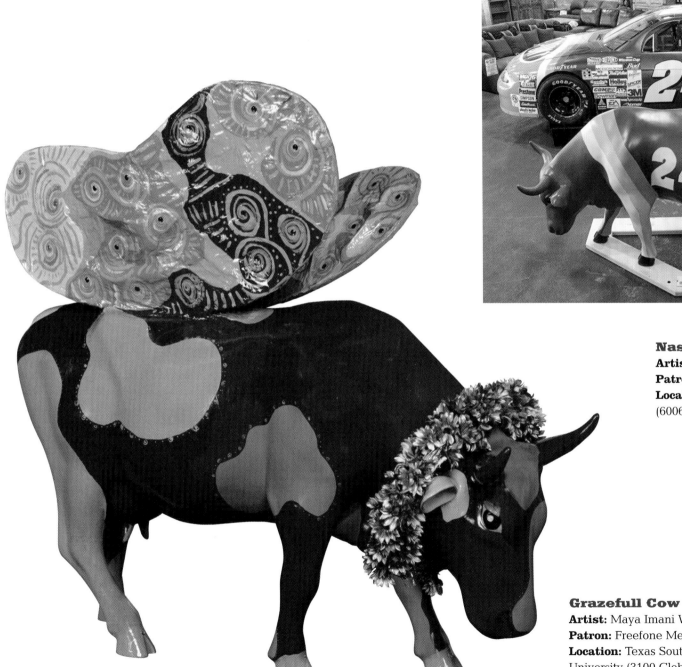

Nascow
Artist: Gallery Furniture Design Team
Patron: Gallery Furniture
Location: Gallery Furniture
(6006 North Freeway—Exit Tidwell)

Grazefull Cow
Artist: Maya Imani Watson
Patron: Freefone Media, Inc.
Location: Texas Southern
University (3100 Cleburne
Avenue—TSU Museum)

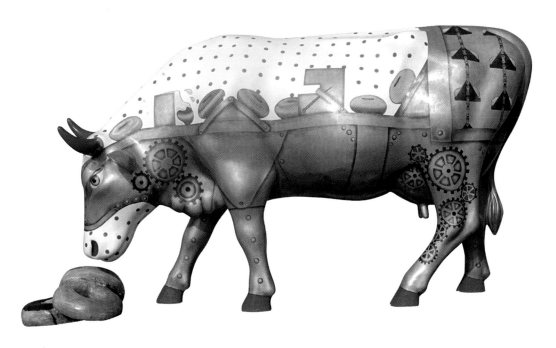

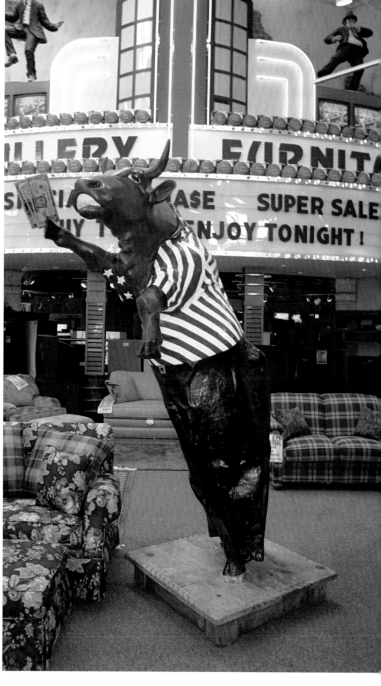

Udderly Glazing
Artists: Diana Selby and Karin Weindorff
Patron: Krispy Kreme Doughnuts, Houston
Location: Krispy Kreme Doughnuts
(Richmond and Fountainview)

Keep On Moooving
Artist: Dave Maloney
Patron: Equity Office Properties Trust
Location: Equity Office Properties Trust
Building (5847 San Felipe)

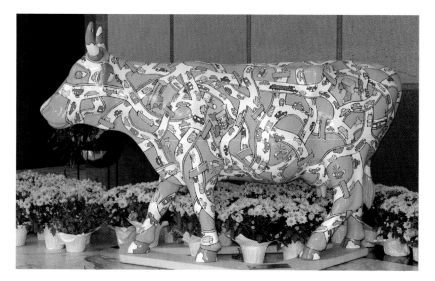

Save You Moolah
Artist: Gallery Furniture Design Team
Patron: Gallery Furniture
Location: Gallery Furniture (6006 North
Freeway—Exit Tidwell)

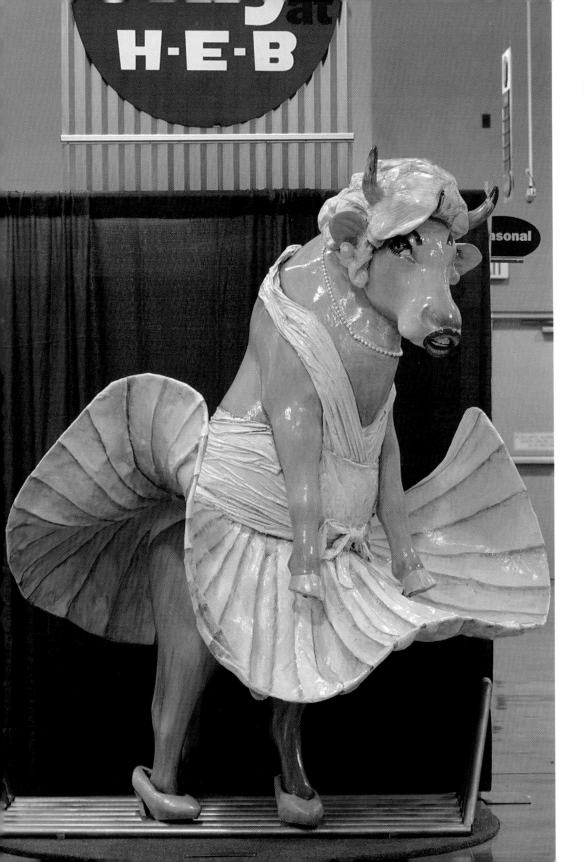

DAN DUNN
Marilyn Mooviestar

With a bovine face, I don't think just anyone can be made into a cow," said award-winning caricature artist Dan Dunn. "I started playing with 'punny' names, and that's how *Marilyn Mooviestar* got her start. Getting the right idea for art can take ten minutes in the shower. After that, it's all work."

Moviegoers will recognize *Marilyn Mooviestar*—actress Marilyn Monroe, billowing skirt and all, in the 1950s hit *The Seven Year Itch*. Instead of standing over a sidewalk grate, Dunn's Marilyn is poised on a cattle guard.

To achieve the upright stance, Dunn had to "completely cut off her four legs and head, then reattach them in a standing pose." He said that crafting the fiberglass in his carport during the summer months also involved "a lot of standing and itching." With the addition of high heels, the 10-foot-tall sculpture presented a logistical problem—which Dunn solved by poking her horns right through his carport roof.

Marilyn Mooviestar
Artist: Dan Dunn's Caricatures Ink
Patron: H-E-B Grocery Company
Location: H-E-B Grocery Company, Fountainview (Fountainview and Westheimer—inside)

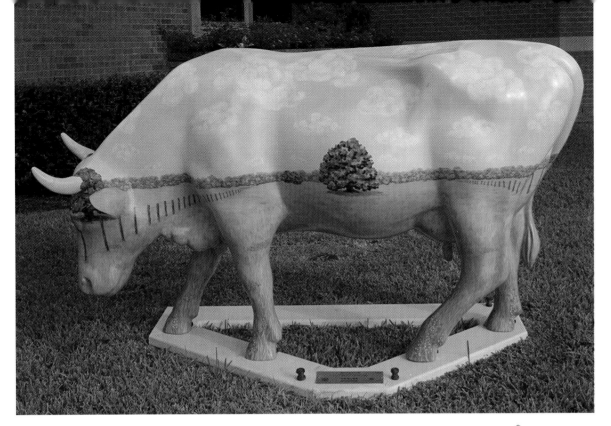

Invisible Cow
Artist: Barbara Jones
Patron: Robert H. Graham Family
Location: West University Place City Hall
(University and Auden)

Lascow
Artist: Episcopal High School
Visual Arts Department
Patron: The Brown Foundation
Location: Episcopal High School
Learning Resource Center
(4650 Bissonet at Loop 610)

COWS IN SCHOOLS

To lasso the imagination of children, the volunteers of CowParade Houston 2001, benefiting Texas Children's Hospital and the Texas Children's Cancer Center, tackled the awesome task of contacting 13 public school districts as well as several private campuses in the greater Harris County vicinity to participate in the Cows in Schools program.

Students of Travis Elementary School stand united with their cow, *Moother Nature.*

"We gave every school—elementary, middle and high school—the opportunity to submit a design," explained Kathy O'Neil, a former teacher turned volunteer who cochaired the local Cows in Schools initiative with Linda Evans. "We wanted to give the kids a chance to be involved in something whimsical and exciting. The response was incredible! Not only did students have fun, but they learned a lot about Texas Children's Hospital."

"We wanted to give the kids a chance to be involved in something whimsical and exciting."

A panel of judges, consisting of artists in the community, made selections from 115 submissions and ensured that all of the districts were represented. EOG Resources, Inc., Reliant Energy, and The Cow Parade Foundation, Inc., graciously volunteered to underwrite the Cows in Schools program. Next, the list of participating schools was divided among 10 Cows in Schools committee members who became mentors.

Volunteer Linda Ligon described her experience with Cows in Schools as uplifting. "As a mentor, my job was to take pictures, offer encouragement, check on progress, and make certain the students realized that this was a lot more important than just an art project—it was going to make money for kids who really needed their help. Although I'm sure the students had heard it before, when an outside person explained what the end result was going to be, their eyes widened. They were just amazed."

Aside from moving the cow's artful identity to fruition, each school faced its own challenge concerning transportation. "Every teacher was expected to pick the cow up and take it back," O'Neil said. "We saw many imaginable methods, including Suburbans with seats taken out, and minivans with cows sticking out of the back. Some participants came with video cameras to film the process, or photographed the cow in various stages."

Once the form arrived on campus, storage was another hurdle. At Spring Branch Independent School District's Valley Oaks Elementary, an enterprising parent built a mobile platform so the surfing *Cowabunga* could be wheeled from the work area back to a safe spot. Youth at Robert E. Lee High School in the Houston Independent School District were unhampered by close quarters. Students worked in the equivalent of a large broom closet to create *Veggie Cow,* which was designed by a vegetarian student.

Inspiration grew from a variety of sources. At Ross S. Sterling High School in the Goose Creek Independent School District, an art class field trip to St. Paul's United Methodist Church in the Museum District provided the idea for *Holy Cowthedral.* Perched atop the bovine is a miniature cathedral, illuminated by solar panels

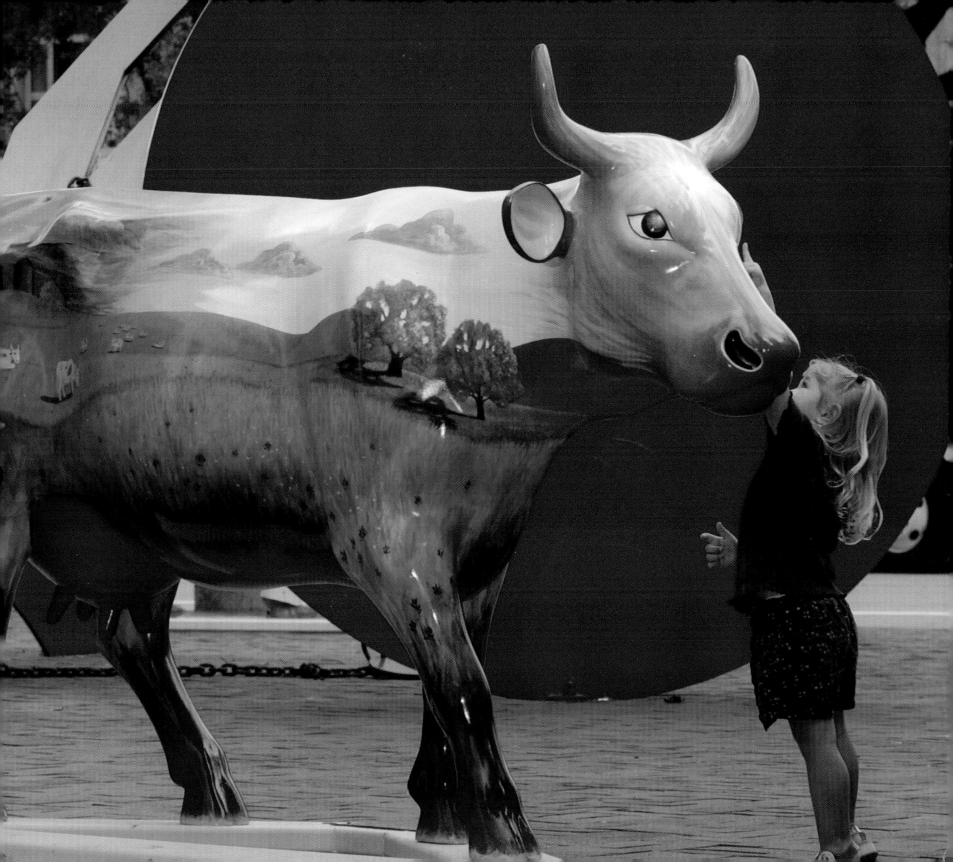

Super Cow

INDEX OF ARTISTS

MooBuffet's Mootif

King Investment Advisors, Inc. • Sylvia Angeli, 68

KLOVE 93.3 FM/104.9 FM • Jose Figueroa, 45

KLTN Estereo Latino 102.9 • Jose Figueroa, 45

KPMG LLP • Cisco Tucker Kolkmeier, 139

KPRC Channel 2 NBC • Julianna Bray Hernandez, 34

Barbara Kraft • Lindy Wyatt-Brown Neuhaus, 158

Krispy Kreme Doughnuts, Houston • Diana Selby and Karin Weindorff, 175

KRIV Channel 26 Fox • Bellaire High School with Rebecca Bass, teacher, 93

KTRK Channel 13 ABC • Elizabeth F. Hornik, 37

KXLN TX Channel 45 UNIVISION • Stanley Bermudez Moros, 129

Lane, Mary S., Margaret, Jim, Buck, John, Harry, Sam, and Lucy • St. John's School, 160

Elyse and Bob Lanier • Michelle Jackson, 140

Linda and Ken Lay Family • Donna Lane Vadala, 28

Jack G. Lee • Angie Watson and Karen Sachar, 37

Judy and Frank Lee and Family • Eva Felder, 129

Carolyn Light • Dottie Erwin, 116

Sara and John H. Lindsey • Patricia A. Hilton, 41

Lance and Pat Livingston, Lance Livingston Productions • Marilyn Guerinot and Spring Woods High School Art Department, 47

The Lowe Foundation • Randy Yost and Michael Goodner, 75

Luther's Bar-B-Q • Don Edelman, 34

Judy Margolis • Glassell Junior School/Museum of Fine Arts, Houston, 127

Judy O. and Kenneth Margolis • Donna Lewis, 93

Dede and Clarence Mayer • Kermit Eisenhut, 98

Dede and Clarence Mayer • Onofre Fajardo, 147

Dede and Clarence Mayer • Averil Gleason, 108

Dede and Clarence Mayer • P. McGowan Johnson (MAC), 141

Dede and Clarence Mayer • Chad Thome, 94

Susan and Jack Mayfield • Suzanne Morriss, 160

Jackie McCauley • Dottie Erwin, 116

Dr. McClellan • Deborah Horwitz, 31

McCord Development, Inc. • Meredith J. McCord, 58

McCoy Workplace Solutions • Collaboration of Designers, 24

Flo McGee • Lindy Wyatt-Brown Neuhaus, 158

Missy McInnes • Lindy Wyatt-Brown Neuhaus, 158

Memorial City • Janice Freeman, 151

Memorial City • Beverley A. Whitworth, 154

Memorial City • Kielly Yates, Brian Lardi, and Nancy Ohanian, 152

Mercedes-Benz of Houston Greenway • Sondra Mullenax, 105

John and Triphene Middleton • Cisco Tucker Kolkmeier, 51

Millennium Patio Homes • Trish Robbins and JoAnn Williams, 165

Mr. and Mrs. William James Miller • Suzanne E. Sellers, 167

Mitchell Energy & Development Corp. • Bruce Monical and Art Square Studios, 119

The Mithoff Family Foundation • Project Row Houses, 99

Sara and Bill Morgan • Cheryl Tamborello and Karen Nimon, 118

Mr. Patches Fall 2001 Collection by Lisa Pliner • Lisa F. Pliner, 154

The New 93Q • Nextwave Art/David C. James, 111

Ocean Energy, Inc. • Kermit Eisenhut, 40

Oldies 107.5 KLDE • Nextwave Art/David C. James, 41

Ownership One & Two Shell Plaza • Deborah Horwitz, 31

Personix • Laurie N. Svec, 134

The Plank Companies, Inc. • Ron Gordon, 20

Prime Asset Management, Owner Chase Tower • Jose, Christy, Pam, Nick, and Gabe Dumlao, 25

Ray C. Fish Foundation • J. Seyler, 77

The Readers of maximumcrowe.com • BeverlyHillSmith.com, 54

The Reckling Family • Eva Felder, 90

The Reckling Family Francophiles • Sondra Mullenax, 100

Reliant Energy • Blackshear Elementary School, 62

Reliant Energy • Browning Elementary School, 61

Reliant Energy • Clear Lake High School, 53

Reliant Energy • DeBakey High School for Health Professionals, 60

Reliant Energy • Elkins High School, 81

Reliant Energy • Herod Elementary School, 39

Reliant Energy • Hogg Middle School, 33

Reliant Energy • Jesse Jones High School, 52

Reliant Energy • Lanier Middle School, 60

Reliant Energy • McNamara Elementary School, 42

Reliant Energy • Pasadena High School, 23

Reliant Energy • Pearland Junior High School, 61

Reliant Energy • Riverwood Middle School, 29

Reliant Energy • Spring Branch Middle School, 42

Reliant Energy • Sterling High School–Baytown Art Department, 55

Reliant Energy • Stratford Senior High School, 60

Reliant Energy • T. H. Rogers School, 48

INDEX OF SPONSORS

Lisa Hopkins

Interfin and Helaine Abramson

Frances Jeter

Elise Joseph

Kwik-Kopy and Mike Lincoln

Beth Lee

Rhonda Lester

Keith Lindloff

Carolyn Light

Bob Livermore

Jean Mann

Tina Marlow

Scott McCool

Flo McGee

Linda McReynolds

Seliece Mignogna

Bruce Monical

Holly Montalbano

Museum of Fine Arts, Houston,
and Peter Marzio

Cathy Odom

Cindy Owen

Kim Pinto

Joan Schnitzer Levy

Lisa Simon

Beverly Hill Smith

Ed Smith

Jack Sweeney

Virginia Tomlinson

Vikki Trammell and Benton Russell III

Donna Lane Vadala

Janet Walker

Rob Walls

Beverley A. Whitworth

Mark Yanke

Corral Central

O. Holcombe Crosswell

Anne Hendrex

Cows in Schools

Linda Evans

Kathy O'Neil

Official Print Partner

Houston Chronicle

Official Host Hotel

The Houstonian Hotel, Club and Spa

City of Houston

City of Houston Parks and Recreation
Department and Susan Christian and
Pam Ingersoll

Greater Houston Convention and Visitor's
Bureau and Jordy Tollett, Terry Leibowitz,
and Sarah Turner

Major Cow Pardners

Herd Sponsors

Duke Energy

H-E-B Grocery Company

Cows in Schools Sponsors

EOG Resources, Inc.

Reliant Energy

Cow Corral Sponsors

Betsy and Hughes Abell

AIM Funds

American General

BP America, Inc.

Meg Goodman and Mike Bonini

Carroll and John Goodman

Dede and Clarence Mayer

Cow Hand Sponsors

Bob and Vivian Smith Foundation

Borden Milk Products

Gallery Furniture

The Houston BMW Group

Memorial City

Upper Kirby District

Weingarten Realty

Williams

Text Resources

Houston Downtown Management District

Houston Public Library

Uptown Houston Association

Texas and Southwestern Cattle Raisers
Association

Houston Livestock Show and Rodeo

Crescent Real Estate Equities, Ltd.

The Institute for Regional Forecasting at the
University of Houston Center for Public Policy

Greater Houston Convention and Visitors
Bureau

City of Houston Parks and Recreation
Department

Texas Medical Center

ACKNOWLEDGMENTS

Herding more than 320 extraordinary bovines around the nation's fourth largest city would not be possible without a corral of enthusiastic supporters. CowParade Houston 2001 bears the brand of hundreds who responded with gusto and unselfishly gave their time, energy, and ideas. The following individuals and entities—and many more behind the scenes—are to be commended for the roundup of a lifetime.

CowParade Houston 2001 Executive Committee

Emily Crosswell, Chairman

Lynn Baird, Cochairman

Flo Crady, Cochairman

Kirby Cohn McCool, Sponsorship Cochairman

Jessica Younger, Sponsorship Cochairman

Laura Walls, Artist Chairman

Julie Bergen

Allison Morgades

Logistics

Texas Medical Center and Dr. Richard E. Wainerdi and Andy Icken

Mustang Tractor & Equipment Co. and Brad Tucker

W. S. Bellows Construction Co. and Tom Bellows

McCoy

Official Wranglers— JWProductions, Inc.

Jeff and Connie Pinkerton

Lynn Alexander

Sandi and Cheri Billings

Leigh Anne McQuitty

Wendy Paynter

Official Mooos Agency— Dancie Perugini Ware Public Relations

Dancie Perugini Ware

Marta Fredricks

Jennifer Elizardo

Cow Friends

Dr. David Poplack

Dorothy Ables

Steven Arnold

Nancy Beck

Susan Bischoff

Laurie Bricker

Mick Cantu

Emily Cohen

Liora and Jerry Cohen

Karen Comiskey

Nancy Conrad

Contemporary Arts Museum and Marti Mayo

Nancy Dinerstein

Norma Dolcator

Laurie Dorfman

Dan Dunn

Kermit Eisenhut

Dr. Ralph D. Feigin

Charlene Floyd

Dr. Paul Gerson

Katy Gill

Tracy Gill

Cowers of Mooston in Memory of R. E. Blohm

Glassell Junior School Museum of Fine Arts, Houston, and Norma Dolcater

Glassell School of Art and Joseph Havel

Lainie Gordon

Tina Harlow

Chris Hedrick

Bruce Herzog

Artie Lee Hinds

Shelby Hodge

Sally and Forrest Hoglund

The Warrior

Gazing in the mirror
I see a warrior's face.
Fully clothed in armor;
No fear and no disgrace.

A tear it never offers,
A smile it always gives,
No sadness does it show,
But what a life it lives.

Needles going in
As blood is taken out,
But still no sign of pain,
No cries to make you doubt.

Each day you see this person,
And think that they're so brave,
Each day you see us laughing,
The tears are ours to save.

So when you see our armor,
And think we're calm and mild,
Remember this one thing,
The warrior is a child.

Crazy Cow-ilt

TEXAS CHILDREN'S *BUILDING FOR CHILDREN* CAPITAL CAMPAIGN AND TEXAS CHILDREN'S CANCER CENTER

A multicolored herd of more than 320 fiberglass bovines will play a part in the future of children's health thanks to CowParade Houston 2001, which will benefit Texas Children's *Building for Children* capital campaign and the Texas Children's Cancer Center.

Tragically, childhood cancer is the leading cause of nonaccidental death for children in our country. However, Texas Children's Cancer Center, an internationally recognized center for patient care, research, and education, is dedicated to its eradication. The largest pediatric cancer center in Texas, the facility offers treatment for every form of childhood cancer, including leukemia, brain tumors, lymphoma, neuroblastoma, and bone and soft-tissue tumors.

"We are extremely gratified by the support of the CowParade Houston organizers and volunteers," said Dr. David G. Poplack, center director. "We are committed to finding a cure for childhood cancer, and we appreciate the tremendous community backing of our efforts."

Because Texas Children's is the pediatric teaching facility for the world-renowned Baylor College of Medicine, more than 65 full-time Baylor faculty members are among the center's 430 employees. These expert physicians and scientists, distinguished national leaders in the clinical and laboratory research of childhood cancer, ensure that patients receive the most advanced treatments.

Texas Children's Cancer Center physicians work in multidisciplinary teams with specialized nurse practitioners, nurses, pharmacists, and other pediatric care experts to administer state-of-the-art care. And because Texas Children's Cancer Center knows health is about more than medicine, child-life specialists, psychologists, and social workers offer programs to ensure that patients and families receive optimal psychosocial support, including a school reentry program, parent support groups, an Arts in Medicine program, and a recreational camp.

In addition to Texas Children's Cancer Center, proceeds from CowParade Houston 2001 will benefit *Building for Children,* Texas Children's $80 million capital campaign that was launched in 1999 in support of Texas Children's Hospital's $345 million expansion, which is partially funded by $265 million in tax-free bonds. The expansion, scheduled for completion in 2003, will double the size of the facility—already the largest freestanding children's hospital in the nation—to keep pace with the demands of its rapid growth.

Texas Children's Hospital, which opened in 1954, provides medical care in more than 40 pediatric specialties and subspecialties. Sixty percent of Texas pediatricians and one in 33 pediatricians across the country trained at Texas Children's. More than one million patient visits are recorded annually throughout the hospital's integrated delivery system.

Spearheaded by Texas Children's Hospital board members Holcombe Crosswell and Nancy Gordon, the *Building for Children* Capital Campaign enlists the assistance of more than 100 individuals—primarily volunteers—who serve on leadership committees. However, its success largely depends on the generosity of Houston and surrounding communities. The campaign has been embraced heartily by the private and public sectors and unanimously supported by the employees of Texas Children's Hospital.

The real heroes of Texas Children's Hospital are the patients. During her treatment for leukemia, Texas Children's Cancer Center long-term survivor Terra Philips expressed her bravery and hope:

Rainbovine

and intricately detailed with stained-glass windows.

"Participation in the creation of *Holy Cowthedral* was not limited to my class," art teacher Cheryl Evans explained. "The cow became an interdisciplinary activity for the community as well as the entire school. It was a great fun way to support our department and do something with incredible ramifications throughout the Houston area."

One parent, an Exxon engineer, designed the workings of the cathedral—right down to the cowbells welded by the agriculture students that ring in the cow's udders. Senior citizens in the community volunteered to run much-needed errands. For a $10 art supply donation, "patron saints" received an angelic cow pin and certificate and had their personal gargoyles installed on the cathedral. A local business donated its services to spray the cathedral with her final protective coat.

The bovine was roped into the academic curriculum as well. "As an assignment for English class, students came up with the 'Top 10 Reasons to Paint a Cow' and developed a 'vocowbulary' list," Evans said. "The math department did 'cowculations.'"

A festive Cowciñiera party marked the cow's completion. The school's jazz ensemble performed, while the home economics and counseling departments helped with organizing and serving food. Pete Alfaro, the mayor of Baytown, arrived to read a proclamation to the crowd.

A patriotic entry entitled *The Few, The Proud, The Moorines,* submitted by Houston Independent School District's R. P. Harris Elementary School, also received a memorable send-off. "When their cow was finished and ready to go the warehouse, the school had a big party—complete with an actual U.S. Marine," O'Neil said. "Everyone sang patriotic songs and waved flags. The students held cartons of milk and wore milk moostaches. It was the most wonderful sight to see that sense of community

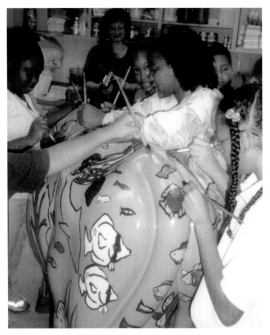

Sea Cow was created by students of Valley West Elementary School.

within a school, supporting an effort on the behalf of other kids."

At Herrod Elementary School, also part of the Houston Independent School District, Ligon met two enthusiastic seven-year-olds with autism who joined their mom in the painting process. "It was a wonderful example of children helping children," she said.

Like any project in which youngsters assist others, those who worked with Cows in Schools developed a deep friendship and shared a bond they will always remember, Linda Evans observed. "I think Cows in Schools gave kids an artistic forum like no other—it gave them not only a sense of accomplishment emotionally, but a wonderful sense of visual accomplishment because the finished products would bring joy and smiles to lots of faces," she said. "They felt that they were part of the healing process at Texas Children's Hospital."

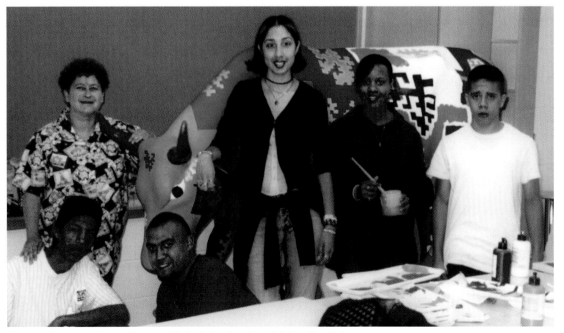

The students of Cesar Chavez High School painted *Moocho Colores.*